Passenger on Earth

A discourse about realities
Political, Financial and Environmental Challenges

JAMES BURK

authorHOUSE®

AuthorHouse™
1663 Liberty Drive
Bloomington, IN 47403
www.authorhouse.com
Phone: 1-800-839-8640

Published by AuthorHouse 05/29/2013

ISBN: 978-1-4817-0025-2 (sc)
ISBN: 978-1-4817-0024-5 (e)

Political, Financial and Environmental Challenges

Realities, Views, Interpretations, Hypocrisy, and possible Political and Financial Apocalypse

Part 1 and 2

A discourse about realities

This book is dedicated to all citizens
On this planet that have the courage and will
To build better nations and a peaceful world,
To make life
For everybody free and pleasant.

The old days are not coming back
And they shouldn't! *

* Read the history of 18th and 19th Century with all the wars and power
 hunger of the royalties and politicians alike.(38)

"We are Passengers on Earth
for
only a short while;
Let's make the best out of it together".

A special thanks to my parents
who passed to a better world.

Motto

Be happy, compassionate,
Respectful, tolerant, loving, fair, moderate, helpful,
Generous, but vigilant and do not accept that
Your peace, freedom, and happiness are taken away.
Trust… but verify… you will be less disappointed!

Part 1:

In View of a possible "Political and Financial Apocalypse"

A discourse about realities

"We are but a small entity in nature and society; but strong united; let us to take charge of our destiny!"

0. Table of Contents: Part 1

I. Notes

I. This book contains quotes and interpretations from the URANTIA Book. Any interpretation, opinions, or conclusions, whether stated or implied, are those of the author and may not represent the views of the URANTIA Foundation or its affiliates.

II. The quotes contained in this book are by permission of URANTIA Foundation, which owns the copyrights.

III. The quotes from the book of Charles Scheideman, 'Without Fear, Favour, or Affection' are copied by permission from the Author who owns the copyrights. New Edition: "Policing the Fringe". Harbour Publishing.

IV. Oprah Winfrey; The Oprah Magazine, Breakthroughs! October 2011, Vol. 12, Nr. 10: "What I Know for Sure"; www.Oprah.com; requested permission and copied from Oprah Magazine which owns the copyrights.

II. Acknowledgment

Without engaging in the most interesting discussions with a colorful palette of people all over the globe, following closely the news reports of the mass media, reading uncountable books from renowned Authors and listening to different opinions, this book would have missed a very important ingredient, which is: Variety. The world is rich in culture, ethnicities and religions and opinions vary accordingly.

There are so many citizens who know and despise the world we are living in. Naming such humans would put them in danger of possible repercussions.

Nevertheless, without question of danger, I do acknowledge Pavel Havlak, former Prime Minister of Czechoslovakia, who showed the world that we can without force and violence change an oppressive system.

The Chinese of the Leaping Tiger Gorge are a good example of how we can change a system that lacks human rights and freedoms. They had to overcome the rigid, forceful communistic system and beat it at its own game.

Many more could be mentioned here, people or groups that contributed to the betterment of society, the environment and life in general.

Deep heartfelt thanks to my wife for her support for such a difficult task and for her patience to endure the endless discussion about the subject. To the editor for all the advice, and for the friendship, I would like to express my highest respect and heartfelt thanks.

III. *Preamble*

The Mass Media of Radio, TV, Press, Movies, and books informs us about the History of our Globe. The information given to us, if we can listen, contemplate, analyze, comprehend, and combine, encourages us to draw our own conclusions. The text is only in fragmented form, but all information is there for us to absorb. It is a word puzzle; we have to solve it to find the real and complete picture.

In society there will always be citizens with the conviction and the courage to dig deep into the working of society, governments, and administrations, and to analyze the system in the light of unpleasant realities. Once they realize the irregularities and illegalities they cannot avoid bringing the facts to light. Sometimes that is unpleasant and can cause trouble for the established system. Can we or should we give to the governments, administrations, politicians, the banks, and the industries the right to do whatever pleases and satisfies them? We are together, confined on our planet. We must live side by side and share our rights and responsibilities based on our nations' constitutions, by which everybody must abide. Life is not a free ride, and each mentally and physically able citizen must contribute his/her part to the society in which he/she lives.

With the Freedom of Information Act which exists in some nations, we the people can peruse pertinent documents from the government (e.g. in CDN) and society, if the documents are not (and unfortunately this happens more often than not) shredded or redacted to avoid conflicts of interest of security or for personal reasons. There exists in our society no absolute security against information leaking to the public, as the Wiki Leak incident demonstrated in the USA. That's the good side of a society having *'watchdogs'*, who realize and analyze the

irregularities committed in governments and administrations, and who have moral standards and the courage to stand up against the conduct of an elected body and how it deals in public affairs and business. The world would be a much better place if, especially in dictatorial nations, all the ill-found conduct of the nation's leaders and administration were known.

However, the governments think otherwise and prosecute the persons who leak information to such conduits as Wiki Leaks, or other publicists. If the conduct of government is fair, honest, constitutional, and legal, it should have nothing to fear.

There is a strong opinion in the citizenry that the government cannot have such freedom to do whatever pleases the politicians, especially when laws are broken. The citizens condemn such methods of conducting government affairs. In a democratic system the government must be open to the public as far as possible and not hide behind closed curtains. We, the citizens of all nations, do not need an *'iron curtain'*. The elected body must represent its citizens and fulfill the wishes of the citizenry.

Today, citizens of the great powers are taxed by their governments, regulated, and controlled almost oppressively, and much of this present interference with individual liberties will vanish when national governments are willing to place their sovereignty, as regards international affairs, that is, its international powers, into the hands of global government.

Knowledge is strength and it provides the capacity to execute actions wisely. But by over zealousness we can do more damage than good. How can we overcome our shortfalls and make sensible decisions? Simply, we have to become more ethical, more sensible, and more compassionate and respectful toward both the individual and mankind.

The worst thing about politics is that it inevitably, being politics, loses its ability to be mobile, controversial, cheerful and humorous and becomes simply a regulatory system for common

issues. It succumbs to the confining goals of administration. Our society has become too complex to be governed by free, consensual decisions. Any political system, be it democratic or dictatorial, becomes afflicted with the inflexibility of administration. The worst consequence, however, is that people accept defeat. They feel powerless and alienated. A systemic chaos is perfected and well manipulated. People don't know where they are or where their leadership is taking them.

Is the citizenry ignorant and apathetic or afraid to talk either about politics or religion that gives cause for great concern? Do citizens close their minds and hearts to anything that could make them uncomfortable or challenge their mental state? They may even fear that it challenges, or goes beyond, their scope of comprehension or interest. They are afraid of facing reality, a reality that they don't want to know or face. The 'ostrich syndrome', putting one's head in the sand, is prevalent. Even when they realize that religion or politics presents a determining factor in their lives, they disregard all realities; perhaps this is due to the complexity and difficulties of understanding as well as due to the implications thereof.

It is a fact that the challenges of religion and politics become too complicated, and the complexity of legal matters as well as powerful manipulation take away individual will and effort. Personal resignation is the consequence. The system has done its work perfectly.

One possible tool to remedy the difficulties of understanding politics and religion would be the teaching in schools of these subjects by competent teachers. However, these teachings would have to go beyond the controlled curriculum of the government. Reality and how the system really works behind closed doors, party meetings and representatives who have been influenced by lobbyists are what need to be revealed.

A big deterrent is that humans are prone to emotionalism, and thence to fanaticism and fatalism. The consequence of emotionally governed behavior, fanaticism, is often terrible, morally unbearable. It is, for the victim, devastating. If one opposes the system it results in fear of retaliation, alienation, estrangement, aggression, frustration, and stress. As in the case of the breakdown of the family, drugs and alcohol become the golden rule (panacea), the savior. They offer, however, false and temporary relief, a false hope. They damage our social sanity. They create only weak, handicapped, overcharged, and immature people who are difficult to deal with, a burden to society and a hindrance to the cause.

Politics, with all its rules and regulations, kills the natural will of people to behave lovingly. Is our *"civilization"* '*trapped in a ruinous cycle, committed to going from one war to the next, and each more deadly and destructive than the last"*? (1). Do we long for a happy life in a world where moderation and tolerance reign supreme? Or do we welcome a time when we, exultant in the technique of homicide, would rage so hotly over the world that every precious entity would be in danger of being obliterated and lost forever? The common answer to that question: '*we have no choice*', is a poor, ignorant, abhorrent attitude. We have to get informed and contemplate what we want, what we wish for, and react accordingly. The help will be out there, it's up to us to find it!

1. Introduction

Living in the 21ˢᵗ Century is like living on a roller coaster. Nearly everybody is aware of the circus of our society and realizes that the social and financial ship is nearing the hidden reef. The much promised future and adventure of the financial and political bubble is heading for disaster. A disaster that could nearly destroy our future or our existence is eminent. Do we care? Should we be concerned?

Today nearly all nations are in some way in deep financial crisis, nearing bankruptcy. The whole world is so in debt that we can all call ourselves the unfortunate term of living in a 3ʳᵈ world country. The debt of all nations in the world has risen to about 45%, up to $50Trillion. The European Union alone takes $800 Billion credit each year. Greece, Ireland, Portugal, Spain and many others are totally bankrupt, though not publicly stating so. Without raising the tax-rate and taxing the rich significantly and drastically to reduce the budget, these nations will never be able to pay these debts. Maybe they do not even want to. Just figuring the amount of high interest can be quite worthwhile for the lender.

What this means is that we live on the shoulders of our children, our future generations. The sad part is we do not even care anymore; or do we? We are so selfishly conditioned that we often do not realize what we are doing.

Our financial systems, and specifically the stock market, are so much in chaos, and therefore so vulnerable, that it would take only a small spark to ignite a huge bomb. The whole system it seems is nearing a collapse. The consequences can easily be visualized. Could it lead to WW III? I hope not.

The main cause of such a destructive situation is, foremost, the stock market system and its excesses. Over 4 trillion speculative

transactions take place daily in the New York stock exchange alone. Transactions that are initiated mainly by huge computers that deal and react in milliseconds are made. The transactions and deals do not involve real money. They are made without money-backed values; they deal just with numbers, numbers that are deceiving and that give a false sense of security. Years ago there was gold coverage. Switzerland had full coverage of their currency in Gold, and that's why it was a safe haven to harbor one's riches, of every franc and cent. Around 1986 Switzerland was (probably politically) persuaded to sell their gold stocks to accommodate the American monetary funds. Today other countries' banks are required to have only 10% of transactions in money, and not gold- covered funds. If you do not believe this, just look into the way banks are operating. Nearly everything is transacted through numbers on the computer: your salary, your savings account, your mortgage, loan, investments, stocks, and the paying for purchases with credit cards. You pay high interest for numbers that do not even represent money. Go to the bank and ask that your savings are paid out in cash; say a number of $60 to $250,000 or more, and you will not easily find a bank that can pay that cash in a short timeframe in spite of the fact that they deal in the billions and billions of dollars. This are only numbers on their computers, not hard cash.

The financial crisis in the world escalates daily. Just to remind you that Greece, Spain, Portugal, and Ireland of the European Union are already collapsing. Even when the European financial monetary fund gives them a helping hand there will never be a real money exchange. The indebted countries must pay high interest for some unimaginable numbers. Who pays for that interest and debt? Naturally, the citizens of each indebted country must pay through excessive taxation.

Even if you argue that there will be real currency exchanged between lender and borrower in the future, there is not enough

paper money in existence to exchange. Remember the law that only 10% of the total exchange must be covered by money. The simple way to solve the problem is to print money, lots of it. Who is in control of the printing of monetary funds anyway? You assume incorrectly if you name the government. The Financial Might (FM), called the huge banks, are in control. In a collapse of the stock market, you are reminded that the pre World War II crash and the war itself were initiated first with a recession, when that did not solve the problem, a depression and total collapse of the financial and political system followed. War became inevitable. The enemy was created and hunger and unemployment, loss of income, loss of life-savings, and loss of all possessions created a people who were well prepared do whatever was called for. That gave rise to the Nazi Movement. No wonder, people were starving, and robbed of their income and possessions. This is an ideal basis for manipulating the citizenry to do exactly what the power of finance wants. An enemy was created and given: for WW II, people who practiced religion (Jews), and the loss of the 'Sudeten Land' to Germany. That is precisely what the financial power did no matter how you slice it. As said before the FM has no allegiance to religious groups. It was not only the so called bad Germans, the Russians as well as the rest of the world were tapping the money pot (selling weapons, lending money with high interest to nations like GB) as money borrowers. Like the German, the British, the Italian, the French, the Netherland, the Austrian and the American populations are possibly still paying for these loan debts from World War II expenses. How about the American ongoing wars in Iraq, Afghanistan, and other nations? One thing is for certain, the Germans have just paid (2010) down their *World War I* debt and still pay to Israel billions of dollars every year for restitution for WW II. These international payments are draining into certain pots. Whose? You may guess. They make high profits from war, specifically selling weapons,

11

and specially needed war-related items and by high interest loans. Were they not the initiators and directors of the disaster in the first place? No doubt; the stock market is not led by the common man.

Consider the fact that the USA alone has a debt of over 14 trillion dollars (2011) and counting. That's a 14 with 12 zeros. Not counted are the debts of the individual states. Add that up and you will get a sum beyond imagination.

Canada, for instance, pays to the big lenders over $6,000,000 (6 Mil.) interest per month for their federal debt (2009). We do not even want to know how much that, combined with all provincial debts together, amounts to. Each Province is in deficit except maybe Alberta. Just about every state, county, and city in the States, Canada, and Europe, for that matter, knows about it and still dreams of a wonderful prosperous life in the nation. Actually, all nations on this planet operate with deficits and their debts are rising. Do they not realize that they cannot go on like this? Yes, they know that, but what is their solution? The world is literally bankrupt. You don't believe or care about it? Dream on, the awakening will be the more painful. At least you will notice when your tax bill makes you also bankrupt. They will tax you to death; just wait, they have no other choice.

What kind of a role does government play in this disaster? Oh, they lead the citizenry to believe that everything is wonderful, under control and prosperous. Does reality not teach us a different story? Who pays for the enormous debt? Are we capable of doing so? Must our children bear the brand and the burden? What does it mean to them? Who has the decision, the borrower (Government) or the lender (the big financial power)? You know the answer already.

Governments have always used diversion and deception tactics. They have no other way if they want to be re-elected. First, most of these issues are over their heads anyway and second,

they miss the inside scoop. However, people who enjoy the inside knowledge are quiet. Nobody wants to lose a fat income.

This book should provide an eye opener for the dormant giant and raise intelligent and wise citizens to avoid the danger of a totally catastrophic rat race.

The following thoughts, contemplations, critiques, and suggestions should be seen in the light of a directional change for our social and economic vehicle. Are we already too late? The greed must slow down, the system must be changed, and the attitude must become more moderate. Do we want that?

The so called *'enlightened financial and political genius'* will maybe viciously attack these findings and statements. To do so, they have to send out their henchmen and cronies. They will do their dirty work, no doubt. The mass media is a good instrument to convince the vulnerable human of the contrary. Mass media is a strong influence. The sad part is that the henchmen are so manipulated that they do not even realize they are victims and moppets of the system. If they do that's even worse.

What does the real power have in store for us? Does it come finally out of the cocoon or does it stay in a protected castle? More likely, the FM will stay aloof and keep us in the dark about their plans. They have a different purpose and setting of life than we do and we can only hope that they do not send us into a disaster.

In wars, only the common man loses everything: savings, possessions, family, many even life. The rich get richer; the poor are reduced to bare existence. I don't think that wealth means something to the representatives of the Financial Might; they probably have a feeling of responsibility to the world and are convinced that their managing of the world is the only way for the common human. They take the risk and know that every action causes some human sacrifices and victims. That, to them, is apparently unfortunate but unavoidable. Millions of people

must die for the good of the nation? Until now, it has been so. Do we want that to continue?

The reader should never take all that is said and done as the only reality and what's happening as unavoidable. He has to make his own observations, contemplations, and decisions. But the issues are complex. A critical observation is all we need. We have the freedom to think and analyze according to our personalities. Nothing should be forced upon us. Neither should this discourse be taken without critical contemplation. The reader should always be free to accept or to reject any or all of the statements. That's the spirit that should go with everything in life. We are, as humans, unique; nobody is equal in personality, only by law, and therefore should be free to voice his/her opinion.

The statements made in this discourse are found in books mentioned in the bibliography, in newspapers, TV, Internet, interpretations, and observations. If we observe and count the facts visible to the naked eye together, you will realize that something in the nation is wrong. Our freedom is curtailed.

It is the intention of the author to shed some light into the realities of our society, into the political and financial system as well as into the environmental misconceptions. The text represent to some of us a shock, to others a confirmation of what they suspect or mostly already know although not in such details. The reader will be facing realities that could shake him to the core. Maybe he/she will become angry and offended by certain declarations. However, by seriously analyzing the facts, by opening heart and soul and by being truthful to one self it sheds some different views into the statements. *Is it not obvious that telling lies (and the manipulative, deceiving, and conditioning) by the government often enough, especially in print, and the fabrications do outruns the truth, perception and logic?*

For any fact, difficulties or controversy that we encounter in our daily life we have the tendency to avoid, negate, push aside,

ignore, and even attack the most cherished, secretive wishes and hopes in life without realizing it. Thereby we destroy the only value of existence that makes life, beside healing the physical pain and suffering, bearable and livable. We throw our rights and freedoms out of the window of opportunity. What is left is a miserable, deplorable self, were greed, power hunger dominates and the truth, beauty and goodness, the attributes of self is lost. (32).

Sometimes facing realities represents not a walk in the park. Having the courage and strength to do so will bring us out of an undesirable situation. Avoiding on the other side will bring us more self-inflicted misery. A solution to an unsatisfying situation can be difficult at best to solve if the common will is not present to work together to understand and realize that only in a majority solutions can be found and achieved.

The book will and cannot give for every situation an answer or a solution. It would be to complex; the suggestions would be one-sided and can only be elaborated in groups. With a good leader with good and honest intentions the task can be mastered. An acceptable solution will be found that takes the majority of wishes, opinions and goals into account. The following guideline should always dominate the decision process: *A citizen must decide at what point/stage he has to stand firm against the state and the real power (FM) if they try to dictate what the citizen shall accept or think. A reminder that that was exactly the intent of founding fathers of the USA for the constitution.* Robert Bolt said it in the preface:.. *"a society can only have as much idea as we have what we are about, for it has only our brain to think with."* (37).

The reader may claim, and rightly so, that he finds in my text mainly unpleasant facts of our existence. We know that life is not only milk and honey. Life challenges us in every imaginable way. As humans we are as different as our imagination may reach. We realize that we have also common grounds to deal with challenges. There are people out there that know and are able to shape their existence into a beautiful and fulfilling life. Happiness and contentment is their devise. That is exactly what life should be all about.

In our world we have to go beyond our settings and realize what goes on in our world. We human are made of the same "cloth" and we can be brother and sister to each other. We should be a world society with the same rights and freedoms that we can share and cherish. Because if each being stands for him-self will crumble the world of brotherhood into a society without goals, consequently without rights and freedom. Today our world is at the lowest possible stage of society and readily opens to manipulations, conditioning and enslaving. We the world citizens do deserve a better world and we can make it the way we wish for.

In our society there exist a good core of humans with noble goals and goodness. Without them we would be destroyed long ago. They build the base for our wellbeing. They work tirelessly to ameliorate our existence. Without our will and help their efforts will fail to achieve world peace and moderate prosperity. We have to support and strengthen their good work. We have to put aside our shortcomings such as false pride, our stubbornness, and our egotistic strive for power and become a serving human being for a lasting brilliant society where everybody is fair and noble treated. In the end what really counts is the respect and love for everyone.

2. Political Confusion and Intrigues

As citizens of democratic nations, we are able to vote for our so-called representatives in parliament. These are called the national, state, provincial or community elections. Other nations have elections but in many countries the people have no real choice. We know that. But do we know that we, the western world, claim to have a democratic system and a real choice? Do we have such a system or is it only a utopian dream? The system is in place all right, but the execution lags behind our forefathers' intended will. We are affected so much by mass media influence and manipulation that our basic right is distorted. Political parties contribute their parts to the failure with their wasteful budgets. I wonder by whom they are influenced? I know, and you should too; mass media can influence the voter to the point that no chance for the opposing candidate is likely. The method is well established. First, the search for an ideal candidate acceptable to the existing powers is put in place. He/she has to be formed and instructed and has to have the political flair, commonly referred to as "charisma". The most likely candidates come from a stock of already seasoned politicians. Their records are checked carefully.

Not even the raising to power of Hitler was an exception. He was by education not the cleverest man but had the tenacity, conviction and will to do the job. Hitler was born Austrian, not German; some even say that he was an illegitimate son of the Rothschild Dynasty. He was a corporal and served as a messenger in the trenches of the Maginot Line, France, in the German Army during World War I, if my memory serves me correctly. After the war he had the ambition and the will to achieve great accomplishments in his life. With his arrogant and convincing manner of expression he had the skills to manipulate. The

booklet "Mein Kampf", by Hitler, expresses his ideas and will. *Did you know that his book is prohibited in many countries, even in America?* But we haven't touched the details that actually helped him to power. There had to be a great power in the background to make the head strong German Nation accepts a non-native as political Führer. Hitler was even imprisoned as a political rebel, but they freed him and eventually accepted him. Why? It is inconceivable but true that the Germans welcomed a person with such credentials and past history. Without strong propaganda from the underground, this could never have happened. Hitler was chosen to do the dirty work. He was the ideal subject for a hidden agenda, egocentric as he was. Would it be a surprise for you if the guilty were named? You guessed the force behind it correctly.

The time was perfectly orchestrated, that the Germans, due to a managed shortage of food and work and the loss of all their possessions from the depression and collapse of the financial market (here the system worked to perfection) they were prone to do what was called for by the system. The reasons for that move of the financial might can only be guessed. Can it happen again based on today's critical economy? And then they provided a guilty party to the people; the Jews. All misery was made to appear to have been caused by them. The "chosen people" syndrome of the Jews was replaced by the notion of the Arian race. Racism was orchestrated, national pride was stirred up, a prosperous future promised, and it all started with mass media machinery speaking against the Jews.

You may argue that the Jews are the financial might and the power, but when it comes to profit and power, religion is used by the higher (Jew?) echelons only to advance their causes. And the Mighty apparently don't have a religion or an allegiance to anything except money and power. If it serves the cause of the FM sacrifices will be implemented. The guilty party (the Jews,

WW II) had the expected effect, and the reaction of a new Nationalistic Germany was under way. Mass hysteria was now in place and the rest is partially in the history books. Just put an unscrupulous and out-of-control fanatic leader, Hitler, into political power and you see what you get.

You see that kind of thing happen all over the world, and today specifically in the African and Asian Continents, where corruption, manipulation, and mass hysteria is practiced. The citizens, not only the Germans but the citizens from different countries, joined in the euphoria/hysteria in the years between 1930 and 1940. Millions upon Millions of humans had to suffer the consequences, not only the Jews but also the whole world, especially the nations involved in WW II. Genocide of humongous proportions was the result. Only a few in the world where spared. You guessed who. But we don't want to go into the working and excesses of the Nazi movement. There exist much better books to that effect. At the same (WW II) time in Russia raged an even more brutal genocide where over 55 million people suffered and died at the hand of Stalin. The intelligentsia was nearly eradicated. The war with Japan resulted as well in the eradication of a great part of good (est. over Mil.) intelligent human stock in the USA, in Indochina and in Japan.

With the above examples we can demonstrate what can and will happen in the so-called advanced countries, not only in dictatorial states. The influential forces of the representations of interest know the psychological and ethnological instruments of manipulation so well that their success is a given. Knowing how people think and operate is half of the equation. Just look around and you will realize that the drums of a possible war, a good method for spreading fear in the human mind, are going strong. Threat of war is half, and the spreading of fear the other half, of the equation. Iran and North Korea are current prime examples. By the time this is published, Syria, and North Korea might be

more current examples, and Iran maybe a recent one. With luck, they might all be recent, but it's inevitable that some other will have arisen. Only time will tell.

The problem with the world and especially the superpowers is that they blame the other countries for causing conflicts. The Middle East was not really hot on the heels of the Americans. Oil is a necessary commodity for the industrial nations and they needed to have not only the oil but the control of it as well. That's what the US government meant when they mentioned they have to defend their interest in the Middle East. The methods to reach that goal are simple. John Perkins (2) explained in his book the method in clear examples from all over the world. Either the local governments accept the industrial nations' goal and hand over that resource or a revolt is initiated. That creates hatred and so called terrorists begin defending their unclear purpose due to ignorance or created power struggles in their country. There are leaders who want the main money fallout for themselves. A real power struggle ensues. We have total chaos because of that economic resource, hunger. But our government makes us believe that it is Iraq, Afghanistan, Somalia, Libya, Egypt etc. that are the countries to blame and that we must either teach or force upon them a democratic system. Moreover, we are surprised that these people react to the full extent of their means, and wish to gain their own control over their resources and political systems. However, pathetic smoke-screen efforts to help establish democratic systems have failed many times. Only with naked force, therefore, can the nations be subdued. In Iraq (until 2011occupied) and Afghanistan, the game is still ongoing. But that does not bother the mighty industrial nations. They could care less if people are the victims of their action. If the goal is reached the struggle, the atrocities and the pain and "collateral damage" are not their problem. Should we believe that the Americans with their smoke-screen methods cannot

be blamed if these mentioned nations don't want democracy? What form of democracy, anyway, is the American system? Does America have a real democracy?

If you follow the American elections closely, without being influenced by the mass media, you realize that a sort of smoke-screen system is working there as well. American voters are led to believe that they have a choice, for example, for a president; they are given a minimum of two opposing candidates from two different political parties. That is not a real choice. If the candidates are similar in capacity and philosophy to their acceptance, they allow some leeway and in the end, the candidate chosen by the citizens is obliged to the power behind him anyway. If the pre-chosen candidate, for example G.W. Bush, does not appear likely to be successful, his winning becomes orchestrated, engineered. Rumors are that Florida cheated Al Gore out of the presidency. Do such rumors have some validity? Not that Gore would have been a better president, by the way; presumably to the contrary.

Naturally, the parties want their candidate to succeed. In reality and in the end it actually does not matter who wins. In politics there is a truth in the saying, *"the human face/person may change, but the power stays the same"*. The voters are vulnerable to the promises made by the candidates. How ironic in recent history that President Obama, the apparently perfect and carefully screened candidate, promised so convincingly many changes, like ending the war in Iraq. As of this writing, the US has recalled nearly all its military from Iraq, after too many years of occupation, and has left the occupied nation in total disarray and devastation, and politically worse off than before. That country's economy was at its best, the political wrangling was under control and they had order with Sadam Hussein in charge. We in North America cannot understand the mentality of Arabic nations; officially the reason for the invasion was to free the people there

21

from dictatorship, from oppression, and to protect the interest of America. But now they've got it; what an irony. Obama promised to get out of Afghanistan and close Guantanamo Bay, and to create more work places for the people and a better economy, and nothing happened. It is not the governments' responsibility to create more workplaces. The opposite of Obama's promises is true.

A depression is very close at hand – there is currently (2009-2012) in certain regions on the globe a deep recession going on; in Afghanistan the troops are still there, and Guantanamo Bay is still in place. Since Obama's presidency the number of soldiers has even significantly increased in Afghanistan, contradictory to what he promised years ago. The wars are not, by a long shot, over. They send too many young, well trained or even inexperienced American soldiers into war, and send them back home physically or mentally injured for life or in body bags. Is there a disaster similar to that of American involvement in Viet Nam in the making? For the real power the loss of the war was not relevant. The shame was loaded on the shoulders of the people and the soldiers. Many Viet Nam veterans shouldered the blame even when they sacrificed their lives for the war. Just ask their families. They believed in the honesty of their President, and in the cause of fighting for freedom for America. After losing the war in Vietnam the Americans had to realize that the freedom was actually not in question; it was never in danger. The soldiers had to fight a war for other cunning reasons. Words of wisdom for contemplating: *'Those taking to the sword will fall by the sword'*. (3) (15).

How many lives must be slaughtered before citizens realize that they were misused? Through the press we have heard only half of what went on in Vietnam and is going on in Guantanamo, Iraq and Afghanistan. The rest of the internationally forbidden dreadful treatments, to the soldiers on the battle fields, or in

prison camps, or to the victimized civilians, will never come to light. And there is still the 'occupation' of Germany and South Korea. There are at least a hundred thousand soldiers stationed in these countries. Against Iran the war-like drums are sounding loud and clear. In Korea the pot is boiling. Wherever the USA is involved there is trouble brewing. This speaks for the statements of Perkins (2).

WW II is, since 1945, over. But did the USA or the United Nations give Germany a peace treaty? Germany is officially still at war and under war restriction, although under relaxed conditions. The Germans signed an unconditional surrender. America still occupies Germany. That's exactly the control the power wants. Germany developed even under the shackles of the USA into a strong and prosperous nation. They dug themselves out of the totally bombed and economically destroyed homeland to flourish again. That is part of the German strength and pride. Only the German people are capable of such a deed. At least the Russian Nation does not occupy the former East Germany any more. They left to the West Germans, unfortunately, a totally run-down former East Germany. But no matter; the West Germans did, with enormous sacrifice to themselves, restore the devastated East. The people in the former GDR, how ironic that the very name, *'German Democratic Republic'* is a deceiving lie to the people of that former nation, received the newest and the best technology and infrastructure through West Germany. Which land is capable of, and willing to do, that? War-destroyed areas all over the world still stand in exactly the same ruins as during the war, except that nature has tried to ameliorate the appearance a little bit.

President Obama goes on promising and makes people believe with his charm and flair that these promises as mentioned above encountered unforeseen circumstances that hinder the execution of the plans. That's pathetic. As though he had not been informed

beforehand during his election period; that will and cannot change as long as enormous profits are made by the Financial Might and by their industry attitude. It is and will always be lip-service. By observing Pres. Obama, G.W. Bush or former leaders during their speeches, we notice that all is well orchestrated. They learn their speeches by heart or use a teleprompter or other such help. Unfortunately, their speeches are not really their own text. Speeches are made by advisers, administrators and speech writers. They are the representatives (henchmen?) of the real power, if you will. The President has only to be a good actor and convincing speaker. Here he makes his earnings and ratings, the most important achievement for his presidency. Surprisingly, even that cannot prevent disaster. For instance, during a question period in the White House normally the press is limited by the administration in what it can ask. Should there arise another question the president ignores it or if he answers the question, this can be a really embarrassing moment for his advisors. Former President Bush was an expert in answering questions that were not scheduled and his answers were often in contradiction to his prepared given speech. To prevent such occurrences the adviser steps forward to break up the question period, claiming the president has other urgent business. You have probably noted that the president has no choice in all important matters. They make us believe that the president manages their country. If that is really so we should give them the benefit of the doubt that they are trying to prevent us from having to go through even worse disasters. We should give them that. But do they really do it for us?

The worst thing about politics is that it stops being politics; mobile, controversial, cheerful and humorous. It can no longer regulate common issues. It soon falls to the administration. Our political and social issues apparently become too complex for the common human to be able to make free, consensual decisions.

Are the citizenry that ignorant and unable? At least politicians make us believe in this realism. That is not so. The Swiss people prove to the contrary that the people *are capable* and *wise enough* to make the right decision, even when it does not agree with the politician's conviction. Any political system, be it democracy or dictatorship, becomes afflicted with the inflexibility of administration.

Administrators obey other rules and commands. They are really the decision-making executioners. No kidding, the politicians are dependent on administrative advice and execution. Administration has the means, the experts and the personnel; politicians cannot operate without them. It is mostly beyond their scope. Most of the administration, except for a few on the top, is not replaced after each election. Reading the book from former President G.W. Bush (4) gives you a good inside scoop/measure of how the government is running, how a president is operating, to what influences he is prone to listen etc. The worst, however, is that most of the people, due to ignorance or apathy, accept this fact. Many citizens today are unfortunately incapacitated and alienated. Is the chaos perfected and well manipulated? Do the people not know where they are and where this leads?

The leaders with their supposed hidden agenda make us believe that this is the way of glory and will bring an end to all tribulations and worrying. We can, however, not be excused because we each have a brain and should have the natural common sense to refuse such predictions/statements. A big deterrent is that the populous is prone to fanaticism and lynch-mentality. That's an undeniable fact. In our world we encounter them daily. Such behavior is morally unbearable and not acceptable. In the end we cannot really blame the politicians alone; we are as guilty as they are. Consequently, such an environment bears the seeds of fear for our lives, overcharges the mental state, alienates, estranges, and creates aggressiveness, frustration and stress. Just

observe how many people are overstressed from work, family, and politics and daily atrocities and occurrences that influence them. A high percentage of the people become lost and helpless, especially our youth. Drugs and alcohol become the golden rule, the savior. This is, however, a false hope and such reactions damage our sanity. This results in weakness and mental illness in the citizenry, especially in our youth, and causes difficulty in dealing with them. To mention the health costs would exceed the scope of this discourse. Those who seek refuge in drugs or alcohol become a burden and hindrance to society and it does not solve stress and helplessness. They revolt and use force to vent their frustrations which is exactly the wrong way. Using force has never succeeded in demonstrations of the young citizens. Our young generation senses the wrong-doing and secretiveness of our 'representatives' on the G-8 or G-20 meetings, but cannot really penetrate the workings and can't understand the system. They demonstrate for good intensions against the meetings and their secrecy. No matter what they do; no attention to the concerns of the youth is given. They are totally ignored, as are we all. The peaceful and legal demonstrations end in disaster and violence which, by the way, is well orchestrated from behind the scene through the henchmen and cronies, 'hiring' hooligan to do their work and the rest of society goes along.

The demonstrators are judged and branded, marked as terrorists and they will always be the losers. Are the politicians and the president responsible for sending in the troops and ordering a force that cannot be withstood? Is it not horrible to see how our politicians *have to protect themselves* against their citizens/youth for their political actions? In case there could be demonstrators and even before the demonstration begins, and to protect their delegates (G8, G20 etc.), the host country has to guarantee the guests' safety, and the host government has to mobilize and hermetically close off the area with military troops.

People are not allowed to fly private planes in and around a radius of over 150 miles or be close to the meeting area. Something is wrong in this picture. Why are they so afraid for their lives? What are they doing that affords a military/police protection? We could give here clear answers but leave it up to the individual to answer.

Instead of being open and accountable political leaders they shroud themselves in secrecy. That's why. We never get to know what really transpires in the meetings. The citizen has absolutely nothing to say to all these financial and political agendas and decisions. Sure, they issue a communiqué that says nothing at all. The real deals are shrouded in secrecy. We probably would not understand them anyway. Is it not the citizens who should decide their future? They are sending the citizenry into a corner. In a corner where there seems no way out except by voting the politicians out of office. But that will usually not happen. Let time grow over the problem and it disappears. It is the young people that are the wrong-doers, not the politicians, right? An open transparent government is mandatory if the citizen is to have the final say. But, for example, in America the people do not have the final word; they have absolutely no possibility of speaking out except maybe through a referendum. A referendum is very expensive and without the support of industry, finance or the political parties it is practically impossible to get it under way. The government can and has many times ignored the results of a referendum (Canada); they don't have to accept the demands of the people. Also, referenda are often carefully worded so as to confuse or misdirect the participants. A nice democratic system we have here. Compared to the direct democracy of Switzerland this is a total farce of democracy.

Nothing is open for the public. Everything is done behind closed doors. And what is openly shown is orchestrated and shrouded by smoke-screen. Does the citizen not have the right to

know what really goes on? Analyzing the official's communiqué says it clearly: everything is only a farce for the people. What went on inside stays inside and stays a mystery. We elected the politician or delegate to represent our interests. But do they really do that? Even the representatives in diplomatic service use arrogance in language and bad behavior. Wiki Leaks (5) brought to light, for the broad public to see, the behind-the-back attitudes of Politicians and Diplomats, or Representatives. They even showed their real attitude towards foreign leaders, mind you, behind their backs. No doubt that's reality. Certainly they cannot like all opponents and foreign government leaders. But our leaders learned diplomacy and respect for the other. Should we be ashamed for our elected people? Should that not have to stop and the utmost respect be extended to everybody, and especially also to the foreign politicians and diplomats and not making derogative remarks behind their backs? It's everybody they discredit, just not themselves. We will see how this develops. The right to publicly show what really goes on steps on their toes, and we should not be surprised when the owner of Wiki Leaks, Julian Assange, and his men are forced to stop and/or they will be jailed. As for the Internet, does the US government put a total ban/blockage on the site of Wiki Leaks?* (2011) (5). Is that called freedom of expression, freedom of the Press, freedom of speaking and thinking? Wiki Leaks did not even express their opinion. They just published real papers that tell us what goes on behind the "iron curtains". How far will the situation deteriorate until somebody stops that secretive behavior of our politicians and diplomats? And by the way, do we think that other nations, with their secret services (e.g. China), did not already know the attitude of the Americans against them? *

* Note: This happens already: banking blockade in 2012, see also Annotation.

The opponent is not sleeping; nothing is hidden from them either. The good part of these Wiki Leak exposures is that we can see how our representatives behave; this is unacceptable and deplorable behavior. That cannot be diplomacy and is totally inexcusable and specifically un-American. We could hear voices on American TV stations that called for killing Julian Assange as traitor, terrorist and spy. That is really dangerous and scary. If Americans (like Jesse Ventura) or foreign people cannot express their views and opinions about what they find, and believe is their duty to publish, our democratic way of life is really in danger of collapsing. In the American Constitution there is stipulated guaranteed freedom of speech and expression for the citizen. Do we really want to abandon that?

The politicians are, as we should know by now, forced to do the dirty work of the real power. However, admitting that results in a defeat they cannot afford. Too much is at stake for them.

They are even convinced that they make all these decisions in favor of the citizen. In their opinion, the people are not capable of understanding the implications of all the complicated issues. Even for them these implications and issues seem to be too complicated, incomprehensible and inconceivable. What chaos is lurking over our heads?

Switzerland's direct democracy clearly demonstrates that the citizens are capable of making the right decisions, even when they have decided against their politicians' opinions and convictions. It is the will of the populous and that is always respected. Not even all the Swiss appreciate what political advantage they have within a Direct Democracy. Are there underground forces at work to destroy that system? In a so called 'democratic system' like USA's or Canada's, the people don't really have a say. Sure, they can vote a representative into the legislature every four or five years (the communistic nations had, and have, that system too) but do they get effective representation? You can answer that question.

"The historian of the future, looking back on the past half century, will be struck by the tyranny of academic and pseudo-academic ideas over common sense. In area after area of contemporary life – child rearing, education, sexual relations, crime, even foreign affairs – educated and well-meaning people have tried to impose their "truths" upon the real world." (6) We are now in the 21st. century and nothing has changed other than that we have entered into a worse predicament. *"We have turned our responsibility over to so-called experts, politicians, only to realize that the result is total confusion".* Kristol expressed correctly that we have permitted 'sophisticated' theories to prevail over common sense.

> *"One can expand almost indefinitely the catalogue of errors where expert theory has been allowed to dominate a clearly contrary reality"…. We deinstitutionalize the mentally ill because it is supposed to be good for their psychological health, and we are then shocked that our streets are populated with homeless, helpless people. We permit our philosophers and educators to assure us that there really is no necessary connection between religion and ethics, only to discover that we then need "ethicists" to teach our students morality – and then to discover the ethicists can teach them about moral beliefs in general, but not the difference between right and wrong."* (6).

Here we can find the real challenge for our society. We train our kids already in kinder garden to become more and more non-thinkers and followers. Don't believe that does not happen to your kids, it does. Individuality is sacrificed "for the good of society"; this is the *buzzword*. In reality the kids are educated to become robots of obedience of the establishment. The sad part is that we do not even realize it, as clear as it may be. Just observe how they communicate with each other or how isolated they behave.

We know that humans are by design far ahead of all other life forms with their endowed consciousness, intelligence, and ability to make sensible decisions. We should actually be far better off. But are we? We have a free will to choose to do what we can do in our best interest. We can do so many things with our intelligent brains. We are also endowed with ambition that can lead us to great heights. Ambition is part of our growing and results in progress. Should we neglect the goals set for the advancement of a healthy society? Going backwards, however, is not really a smart move. It hinders progress. Without progress we go backwards and who wants to become a low savage beast, like the soldiers and civilians alike during a war, anyway? We should use our brains, our minds, and our knowledge of ethics to advance in a future for a better quality of life. This demands nothing more or less than brotherly love, as trivial as this may sound. Hate is a bad adviser. The fruits of evil are always pain and despair. Love has to start in individual homes to be able to bear fruits in the community, society, nation and world. (32).

Friedrich Schiller says in his papers that as long as the human is *plagued with greed and materialistic strife* he will never find *beauty and happiness.* In 'Freedom', he says that we are created as free beings even if we were born in chains. We shouldn't be afraid to break those chains to be free. In a second work, 'Virtue', he states that we should exercise it every day with the innocence of a child in order to reach Godlike understanding. In the last work, 'The Will', he says that the will lives. Even if we falter we can still strive for highest understanding. The will does not come from outside us; it rather comes from our inner selves and bears witness that humans will never be robbed from the three words: 'Freedom, Virtue and Will', when they believe in them (8).

There will probably always be some good and some evil in mankind. That is part of human abilities. Seldom have we felt free of negative feelings. But mostly negativity is not natural; it is

mainly taught by upbringing and influence of the environment. Animals don't know the meaning of hate or negative feelings. They live according to what nature intended for them, instinct. Mankind, however, has negative attitudes and sadistic behavior. Only people are capable of causing physical and mental pain and suffering to animals and other humans. Only humans deliberately employ atrocities and enjoy killing. These are all learned behaviors and not given by nature. Give to some people the possibility (uniform, function) to do such things and they will do them with full enjoyment. Why? We have the burden of free will and we misuse it to the fullest instead of using our brains for the good. Lack of self-esteem and self-confidence are part of the equation. Further, the perpetrators have mainly not to bear the consequences. Animals kill for sustenance and survival; we kill for many reasons, even for pleasure, except when it is done for sustenance. Both animals and humans feel the pain and agony. Who is the beast anyway? We are on top of the food chain and have to demonstrate that we are what we really should be, humans.

With our will, understanding and learning we can turn negative into positive thoughts. Will there always be a certain number of bad men and women that can only be evil? Unfortunately, yes, but we can reduce the number every day. We can eradicate wars, fights and discrimination. Our environment and how we raise our offspring marks humans for life. We have the tendency to use negative words in our daily lives dealing with both adults and children. We should avoid words like *can't, **don't**, no* and so on. We know that, and still fall into that mistake. Instead, use words in an encouraging sentence, especially with children. Where there is a will there is a way. We are human and are entitled to make mistakes. Repeating them all the time is not really encouraging or intelligent.

Listening to the news all over the world gives us a little picture of what goes on around us. All over the globe there are wars, political killings, genocides, political imprisonments and other atrocities. Is the human being already deteriorated to the lowest possible level that allows continuing it indefinitely like that? Can we stop that insanity? Who is behind, driving that system? Reading the 'Confession of an Economical Hitman' (9) we come to understand the causes and effects, which are: imperialistic greed combined with vulnerability of the citizen. No actual choice is given to the international leaders. Some don't even care as long as their pockets are well filled with bribes. If they follow the offers from the greedy, apparently the Imperialists, and ignore the deceiving methods used, then they do their part for the imperialists. The Imperialists (FM) promise to improve the economical and infrastructural needs of foreign nations by building roads, industries, houses, schools etc. and this seems to the leaders and people of the world a noble cause. But if the promises are made only to gain access for the Imperialists, and control of the nations' resources, land or militarily strategic locations, do they become a lie? That's the real cause behind that economic help. The president or dictator of any nation that agrees to co-operate with the Imperialists receives handsome payouts in his own pockets. Scrutiny of secret Swiss bank accounts could shed some light on that. However, and rightly so, the Swiss are not bending to the demands of foreign countries to abandon the bank confidentiality law. The politicians in Switzerland have no real say on banking matters anyway. It is the citizen who has to decide through a national vote, and not the government.

In Chapter 3. *'Financial Chaos'* we will discuss the case of resource-rich nations and their power struggle problem. The infrastructural amelioration done by Imperial aid programs are only cosmetic. They look good but if the nation can't use the infrastructure due to lack of knowledge or technology, the

citizens cannot take advantage thereof. Nor can they afford to buy the needed machines and run the installations. This is usually only a waste of investment. But that's a small price they are prepared to pay for the peaceful exploration of the national natural resources in exchange for humongous returns from oil, diamonds, etc. It would be like giving to a newborn child a real race car. Nice, but useless to the child. This foreign help happens all behind closed doors with the local politicians', president's or dictator's agreement. It seems the better solution compared to civil unrest or war that would otherwise have to be initiated. For instance in Somalia, Libya (their dictator, Kaddafi, is now gone and replaced by an interim government) and Egypt, (their leader and president Mubarak ousted and replaced by a military junta/stratocracy), different leaders struggle for the sole right to deal with the imperialists. Nothing has really changed. The faces are different but the system is still the same. These three are only the obvious and visible ones and should only be viewed as an example. Many of the African Nations are, as of this writing, in turmoil due to the same kind of power struggle at the tops of their nations. Why? The Imperialists and our politicians make us and others believe that it is a question of liberating the people from dictatorship. The real reason could be, however, that some foreign leaders might have been not very cooperative with the imperialists and so they plant the seeds of an idea in the people that they need to free themselves from their dictator.

Regardless of who gets the spoils in the end, the loser will always be the citizen. In cases in which the struggles result in a different despotism that's just great to the Imperialists. As long as they get what they demand, the president, dictator or the politicians are left alone. If the original leaders, however, refuse to cooperate, the method of initiating a revolt is tabled and used. That's an easy task. A defeat of the regime is certain. Suggest anything that has to do with corruption in their government, supply

them, secretly, with weapons and money and they will rebel, even though that government could have been acting exclusively in the interests of the people, and against the imperialists. After defeat of the non-cooperative existing system, with a new co-operative leader or a new dictator, the exploitation can continue. If you have doubt about that, then just observe what happens on the African Continent. Unexplainable wars are raging; there are, besides tribal differences, fights over who receives the spoils of a deal with the imperial might. This all happens on the shoulders of ignorant, docile citizens, and is caused by trouble makers and profiteers. Those who suffer most are the elderly, women and children. Can it get more pathetic?

Is it not always potential gains or enormous profits that draw the greedy like bees to honey? As mentioned before the majority of citizens get the short end of the stick. They receive new streets, schools and infrastructure alright, but they have neither the means to maintain and sustain the new installations provided by the imperialists nor the knowledge to use them wisely. The investment of the imperialists is only a fraction of their profit. And the sad part is that the whole world sees only the good deeds of the imperialists. If some are aware of what goes on, they are quiet. The real story will never be reported to the general public through the mass media. Why? Who cares? Nobody, unfortunately, does anything without having the better deal in the end. That's a fact of the greedy materialists.

Some help-organizations have similar difficulties. They raise huge amounts of donation money from the common helpful citizen and only roughly 10 to 15 % reaches the needy, if that. Why? Somebody has to manufacture and supply the food, the warm clothing or whatever is needed. Thereby the entrepreneur collects enormous profits from the deals. Then the goods have to be delivered, usually in countries suffering continuing wars. Both sides of the fighting entities are stealing or confiscating the

goods from help-organization convoys for their use. The needy go empty-handed. These are, however, the negative aspects. The positive aspects have to be seen and appreciated. To people from earthquake destroyed areas, for instance, the citizens of the world went almost beyond their means to help all over the globe. Volunteers are sacrificing their holidays, even workplace income, to go to help the needy. There exists a human strain of altruism in the citizen, no doubt. That's the spirit of a society that can call them human. But everything also has its negative aspects. Some managers of help-organizations receive enormous salaries and perks from suppliers for their work. They take away money needed for the already deprived. That's not only unfortunate but nearly morally criminal.

Our politicians promise to donate and help the needy with generous amounts of money or goods. That happens occasionally. The past has proven, however, that this is mainly lip service and they do look good in the eyes of the people of the world. If their financial assistance or goods do actually materialize, the delivery companies make enormous profits as well. The deliveries of goods do not always find their way into hands of the needy but end up in the possession of local oppressors. The supply companies do not forfeit their profit to help the cause. They need their profit to prove to the stockholders that they are good managers. But, there are always exceptions to the rule. Luckily, we have a high number of good, solid organizations. We should be proud of them. We should never forget that we have a challenge and responsibility for the less fortunate children in the world to solve the following:

- Adequate nutrition, so children get enough to eat
- Water and sanitation, a basic right we take for granted
- Healthcare, so children don't die from preventable diseases
- Education, so children learn important lessons for their future

- Family income so parents can support their children
- Peace, love, respect, and happiness.

The total world military budgets and associated economic side effects are going into the hundreds of trillions of dollars. Surprisingly, the USA uses nearly half of it over the years for their budget alone. As of 2011 the USA was over 14 trillion dollars in debt and rising. But they want us to believe that everything is fine and the big world powers are on the path of freedom. So why do they still spend such high amounts for war preparations, if there is peace between the super powers? The government's spending is over ¾ of the gross national product expenditure for war preparations. That means in reality that we depend on war production for, apparently, no danger/threat from foreign powers. Is that not sad? The populous has to pay the bills.

It doesn't matter in which time frame we are living; it is always the same destructive method of managing our affairs. As long as the false impression that we live a good life exists, we will not change. As soon as the citizen realizes that he is stressed, unhappy, devastated, he looks for a reason. The reason and cause of a guilty party will be supplied and a war is apparently the sole solution. Only in a self-inflicted and ravaging war (in misery) will the citizens eventually realize that they have been misused or deceived. But will it then be too late for regretting their participation in the wrong doing?

Some people still remember the oath that our fathers made after the WW II to never, ever join in another war again. Have the rest of us already forgotten? Or are we already ignoring that promise? As long as we humans tolerate such manipulation and management of the citizens and of their tax dollars, nothing will change. Do we actually need the military and war budget kept so high to keep our economy going? It seems that way. We have to change this destructive cycle, become less greedy and more moderate. Our lives have to be steered in another more sensible

and worthwhile direction. The gap between rich and poor has to be closed. Excessive gouging of materialistic goods and money has to stop. Utopia?

For the leading powers, it is necessary to eliminate that individual sense of personal dignity and value in people. They are 'hazards' to the imperialists' agenda. But men and women of dignity and value will never become slaves of their leaders.

The same system is used by other Governments as well. To solve the created, apparently 'unsolvable', (really?) problems in their nations they threaten other nations and blame their opponents of causing their own economic messes. Thus only in such depressed situations,

> 'the people forget their factionalism, their local antagonisms, and their political differences, their suspicions of each other, their religious hostilities, and band together as one unit. Leaders know that, and that is why so many of them whip up wars during periods of national crisis, or when people become discontented and angry. The leaders stigmatize the enemy with every vice they can think of, every evil and human depravity. They stimulate their people's natural fear of all other man, or nations. Attacking another nation, then, acts as a sort of catharsis, temporarily, on men's fear of their immediate neighbors. This is the explanation of all wars, all racial and religious hatreds, all massacres, and all attempts at genocide.' (10).

Is it comprehensible and true that we have to deal with a power that goes far beyond our politicians and that is an unlimited power? Is it a power, mainly a financial power, of the so called faceless men and women that have accomplished, by their control of governments and money, the management of all-important affairs? Are their decisions based on their own dynamics and

values? Could their control be absolute? Have our Governments become puppets and slaves of these forces? Do Politicians have to do their bidding? Without going into the details and workings of this system, we can deduce that: *'He who has the means has also the power'*, or *'he who has the gold makes the golden rules'*. Do not believe that this could not exist; it does. They have the means and the power to make the decisions. Their actions are beyond our control. Why do governments make, against their beliefs and wills, decisions that are obviously detrimental to everybody? Are they not decisions that speak against human rights and freedoms? A clever President or government representative must make what is obviously a lie believable to the populous without hesitation. He has no choice. Only then is he a good leader for the real power. His existence is in the balance if he does not comply with its orders. The power has means and possibilities through the media, which it owns and can manipulate as well, to send a representative or a delegate into oblivion, even death. This is not a joke, it is just a fact. Apparently Presidents Lincoln, Kennedy, Reagan and Clinton, for example, had to experience that. History has proven it over and over again all over the globe. Why do presidents of domestic and foreign states or even leaders of the United Nations die of unknown causes or have unexplained sudden accidents, or die in an assassination? They had to be eliminated because they were a threat to the cause. For the common man this is hard to swallow. But, the real power will not accept dissidents.

We, the people, once trusted in governments. We believed that governments did not lie, cheat and deceive. But did they? Is it their free decision to do so? Have Governments, and parliaments, become a farce? Is your representative in fact there to represent you or is he there to do the bidding of the real power, the financial power? This can certainly not be true for all elected representatives. There are in existence representatives who are for the people, but they are seldom visible. The party

whip controls all their actions. A representative of the people who would vote against the dictates of the party would be called a dissident and the party whip would oust him from office. That happens regularly. That's called democratic politics.

How come lobbyists, the instruments of the real power, are cruising the halls of parliament? They even sit beside your 'representatives' in parliament as advisors. Parties depend on the donations of the economical/financial powers. If the party did not follow their guidelines, they would withdraw financial support. This goes also for the mass media. Without the support of a strong advertisement clientele they would have no chance to exist. What choice does a political party have without financial support? The party members' dues are far too little to be able to support the party. Having financial support gives them the possibility to strengthen the party and make some contribution to their goals. This is not a utopian fantasy; this was openly declared in a TV show in Switzerland in 2011, by several parties. It happens all over the world. We could go on and expose more of the working of this system. However, this is not the place to enlighten humankind of these realities. There exist much better papers/books explaining the working of that system. Do we have solutions for such realities? Supposedly we could teach people to fear and hate slavery more than they fear freedom and responsibility. If mankind does not come of age, humankind is doomed and will die. We will die a terrible mental death of desperation and oblivion. Mankind will destroy itself. What will remain is only a robot.

Does this doomsday prediction have a possible salvation? Can we find a way to enlightenment and freedom, a life worth living for? Is the doomsday prediction real; will it happened to us? The reality is that religion or any idea of human moral value is out of the schools, out of public places, and everything which has a

Christian or other denominational or religious connotation has to be changed and accepted as 'politically correct'.

Many nations, with their politicians' sanction, have adopted the anti-faith destructive way. They support the movement that everything that has to do with religion and beliefs has no place in daily lives. But they are not, on the other hand, really consistent? Opportunists always behave like that. They still uphold the clauses in their constitution in which belief in a Supreme Being is solidly anchored. They convince the people that they are for religion. It all depends, however, on their trickery and when and where it will serve them well. Expressions like: *"God save our country, the King, the Queen, the People"*; *"In God we trust"* are such manipulative sayings. Our forefathers knew why they introduced God into the constitution. Without such guidelines the country would have fallen much earlier into chaos. Today what our forefathers feared most is happening. The result is the decay of social behavior. Brotherly love for each other is not demanded anymore and has decayed into each for himself, and money becomes the 'Supreme' to cherish. A society that loses its moorings is doomed to fail.

Another deep-reaching part of our being is the question: what is justice? Is it that everyone possesses the same rights and freedoms, that each individual is treated equally? Would that not be nice? Reality teaches us a different story. Every day we encounter reports of nations that treat their citizens with injustice. Rights and freedoms are not respected. People all over the world are imprisoned just because they had the courage to openly disagree with the government. Even elected politicians experience the same fate. But if we want to think that can only happen in third world countries, reality keeps us from that illusion. If only past presidents would speak out and tell us the facts. But they are afraid for their lives. And they should be. Why risk losing everything? People would not even believe if they were told the

truth. In the first place, it would be difficult and frightening to face an opportunity of openly telling the facts. Secondly, the mass media would not even send the message through the channels. How sad.

If citizens get the chance to openly criticize the power, they are directly and openly ridiculed, destroyed, and declared an enemy of the system, even being called terrorists and traitors. And the listener believes the politicians and the media. They never lie. Or do they? Why risk being openly attacked and destroyed and for what? Wiki-leaks is a prime example. First Hillary Clinton declares that the internet should and must have absolute freedom of expression and no government interference can be allowed. A half year later, after Wiki Leaks published on the internet examples of irregularities in the diplomatic and political core, she announced that the internet should be under the absolute control of the Government.(In 2012 it became a fact). Do we know now if that is the opinion of Ms. Clinton, or from whom it comes? Again, a prime example of what the individual representative has to say. Even a former presidents' wife, first lady and now a Foreign Minister, is influenced. Does it not remind you of the war reporters on Iraq and Afghanistan or, for that matter, Vietnam? Reporters were only allowed to show and report what the government approved. They claim the reason for the censoring is the safety of the military operation and the soldiers. But the truth can never be reported. During the war against Japan the US dropped 2 atomic bombs, one on Hiroshima and one on Nagasaki. This was and is one of the worst tragedies and atrocities, besides the massacre camps during WWII, against humanity perpetrated, mainly, on the innocent elderly, women and children. How low can a government go? The excuse was that this saved a few American soldiers. That may be so, but the war was at its end. Japan had nothing left to fight with and was on its

knees. Their fighting was only sporadic at best. No other nation has ever used its nuclear arsenal to gain a selfish advantage.

Afterwards, it is easy to criticize the guilty, you would say. You may argue that only the timing of bombing Hiroshima and Nagasaki was off. A little earlier in the fighting and not aimed against civilians the measure of employing an atomic bomb would, however, not be justified either. The Japanese raid on Pearl Harbor was aimed at the US Navy, but killed civilians as well. Was it, from the States, mainly retaliation to that effect? Or was it desperation or another cause like injured pride or, injured personal pride for the president? Or was it well orchestrated? We will never really know. What would have changed? Nothing, really nothing, justifies killing. Misusing such devastating power is beneath human intelligence. Wars are unjustified, brutal, unforgiving and insane. *Each human killed is one too many.* War is the result of our cold, heartless, negative attitude, a lack of respect, and a lack of compassion for the citizens of the world. Only the human being, a species that claims to have a functioning brain and morals, can do such a horrible thing.

Why build A-Bombs if there is no possibility of dropping them on real cities, right? Scientists would say that Japan was the enemy of the US, and therefore a good subject for an experiment. Only a few hundred thousand citizens, mostly women, children and the elderly would be affected. No real Japanese troupes were stationed in these cities. The politicians and army leaders who made that horrible, unforgiving decision to drop the bombs should be judged at the independent international tribunal. At the time, and up until today, no one has had the courage to bring the matter to the Tribunal because such action would have had repercussions and who would oppose the mighty USA? How deplorable. The perpetrators are mostly deceased and the question becomes futile.

Can it be possible that families and mothers can allow their husbands and children to go to war and fight for a cause that is a deceptive manipulation? Do they know that they will never have any gains, only losses? This can only be explained by assuming that they have been manipulated to believe in fighting for "freedom"; that they have become blinded. The lie that we must go to war to protect our freedom has never ever really materialized. Our freedom in North America was never really threatened by Vietnam, Iraq, or Afghanistan nor has it been in cases where there has been other military intervention. WWII was, however, a real threat to England and Europe and especially to religious people (Jews) by means of racial discrimination, called Arian syndrome. This worked into the hands of the imperialists (FM, Untouchables) and the Jews were only the people to be sacrificed. Japan, on the other hand, had to pay for their aggressiveness for Pearl Harbor against the US. Was this also well manipulated and orchestrated?

President Roosevelt and parliament decided only after the tragedy of Pearl Harbor to enter World War II conflict against Japan and Germany apparently mainly against their intensions (really?). The reasons of engagement of the United States in WWII are explained in Lynne Olson's book. (11).

Humans are the sole animals that are capable of inflicting misery, pain and suffering while consciously knowing the horror of their actions. Did the citizenry ever gain freedom from a war? How can you lose something if you either don't have it or nobody is seeking to take it away from you?

"Human is the only animal willing and able to do bad for evil's sake, knowing fully that his doing is horrible: he destroys by greed, bullies by hatred, crushes with contempt, humiliates with pride, tortures and kills with religious convictions, exterminates as he assumes the right to be the Almighty, does the same to innumerable

animals, not because of need of sustenance but by voracity, that neither the Giraffe nor the Saint Bernard, nor the Orangutan will ever be able to do". *(12).

Atrocities committed by people against people, or any creature, are unforgivable. It is inconceivable that humans commit them even with pleasure, as in sadism, and for their own enjoyment. Not even out of hate or revenge can anything of that nature be acceptable. All creatures feel the pain the same way as any person would. Hate and revenge are shameful ways to behave. This has to stop; neither humans nor animals have to experience such atrocities.

The so-called 'cold war' after WW II was masterly orchestrated by the governments from both sides (USA and Soviet Union), and the people believed their propaganda. Profits obtained in the manufacture of war equipment, fighting tools and installations, are the real reasons for a war or for the cold war. The 'bad' Russians played the same game.

Another problem is that the more a foreign nation tries to interfere in other nations' business and dictate the way to run any other country, the more real terrorists -not nations- will show up at its doorstep. A perfect example is the Near East. The oil resources are a challenge that must be conquered by the imperialists. This has happened under the charade of providing these nations with democracy. Afghanistan and Iraq are nations that currently feel the power of the Americans. The USA acted to 'help' them with the brutal force of a mighty nation. No wonder the people used the only means they knew, terrorism. Against American strength no other method can be employed. Direct confrontation is just not in the cards. Reality proved that terrorism is a weapon of great effect. All the cautionary measures taken at airports since 9/11, and the laws introduced by then Vice President Cheney (patriot act, national security act, homeland

* "Faire le mal pour le mal"; (Causing pain for pain's sake).

security act), illustrate the effectiveness of the terrorist attack that preceded them.

Other changes include making it possible that the government or the police can break into your house anytime without a warrant and take you without reason into custody and keep you there indefinitely. The prison facility at Guantanamo Bay is a prime example of this. Even proven innocence will not free you. Is it not like the communistic Soviet Union Regime all over again? In the end, who is really the perpetrator of evil? These interferences in the workings of other nations become self-inflicted actions and will never pay off for the American citizen. The government does not even care. The end result is that it obtains the power to restrain and control its own people. The USA has penalized its own citizens with invasive and devastating measures, so that the people, in effect, are prisoners in their own country. The fighting with the 'defenders' will only escalate and who really suffers is not the politicians or the real power; it is us, the people. A war, a fight, never solved any problems. Being the winner of a fight does not give you the right to claim that your opponent was wrong or to take away his freedom and possessions. Doing so results in you becoming your enemies' purpose for war or terrorism. There are always two sides to a picture. It all depends on the view and perspective, on ethics, morals and the interpretation of the law. As we know lawmakers can convincingly claim that they have the real truth. But what is the truth and which one is the right one? Ethnic background, religious beliefs, social and justified human morals, is important to the pillars of truth. Does a real truth exist on earth? Not likely. At least, as long as we have human beings with only selfish goals in mind, greed and materialistic striving, there will never be an honest single truth. Only based on ethics, fairness, and love, and with respect for all citizens on our planet can we succeed in settling for a universal definition of an acceptable truth. We will probably never find absolute truth; only

the Creator of our cosmos knows the unshakable and omnipotent truth. We have to strive for a perfected truth that everybody can live with. (32).

The pain and suffering in the world goes on without us moving a finger. Do we accept these shameful deeds, or are we prepared to do something about them? Amnesty International (AI) could be a good place to get involved, to make that institution more effective in dictatorships and other nations that do not respect internationally declared human rights. Did AI lose sight of their mandate due to their ignorance and manipulations of the power? Are they now more a smoke screen of the powerful? There are still so many innocent people, after many years, which endure incarceration and torture, and are even sentenced to death. If we considered ourselves in that situation we would really do something. Even in Guantanamo Bay there are prisoners of the US that have no rights, have not been proven guilty and still are in a horrible place, and, against international laws, have received no jurisdictional trial. Don't kid yourselves; the US government could do this to you, the so-called free American. Give just the hint of apparent wrong doing, not even a proven one, just your neighbor's hint to the authorities and you could land somewhere incarcerated. Jesse Venture in his televised conspiracy theories showed how this is done. America has undeniable organization in place that spies randomly on American citizens (neighborhood watch). Being jailed because you disagree with your government makes you already an enemy of the state. Don't let the government take hold of you with unsubstantiated accusations. This is a dictatorship method and has to be eliminated before it is too late. Make certain that 'Cheney law' will be cancelled.

We could go on endlessly about the mayhem, deception and conniving behavior of the governments in the world. The above examples should, however, suffice for the time being. The world has clever authors who can bring more light based on proven facts into

the picture. It is the reader's choice to believe in the content of this discourse. Due to lack of inside participation, all statements have to be taken with a grain of salt. Are the politics and management of our society, our nations really that bad? Can we ever trust our nation and people? You may be the judge of that.

3. Financial Chaos

Over forty-three billion speculative transactions take place daily in the New York stock exchange alone; over 4 trillion worldwide, transactions that are initiated mainly by huge computers that deal and react in nearly milliseconds. These transactions are not made with real money; all this is without money coverage, dealing only in numbers, numbers that are deceiving and can give a false sense of security. Years ago, Switzerland had full coverage of their money (Swiss Franc) in gold and that's why it became a safe haven for harboring money. Today other countries have only 10% of their transactions in secured, that is, backed by gold, money. If you do not believe this, just look into the way banks are operating. Nearly all transactions are done through numbers on the computer; your salary, savings account, mortgage, loan, investment, stocks, and your credit card transactions. You pay high interest for numbers that are not even money. Go to the bank and ask that your deposit be paid out in cash; say a number between $80,000 and $150,000 and you will not easily find a bank that can pay real money in spite of the fact that they deal in the billions and billions of dollars. They are not even willing to do that. The same happens with a mortgage to build a house. You will never receive your money in cash to pay the contractors. If the need arises, and there is a shortage of the 10% of real money they claim to have, the big Banks have the discretionary power to print additional money. We have been led to believe that it is the government that has this power, but in actuality it is the banks.

Banks and the financial powers also may artificially raise or drop monetary value at their whim. They want us to make us believe that there is no inside trading of stocks. They are totally right. We have in effect, no inside scoop of the transactions. That's why we are the only real losers in the stock market. It is

inconceivable that a person can make over $50 Billion and more in a lifetime, starting out with only a few thousand dollars, without having something to begin with. Just luck does not really do the trick. There has to be a way to get that lucky or do possess big/ fast and expensive computers that do the work instantly.

With a good understanding of the stock market, and a firm belief that we have found the way the stock market works, we can make some profits, but not into the billions. Sure, occasionally there are small investors that make a gain but the rule is that you have to lose so that others, the big investors, can make their billions. Why does the 'normal' investor always get the short end of the stick? He is manipulated into believing that this is the way to riches. Our greed and gamblers' disease makes us do the stupidest things. A great number of investors have to lose many of their assets in order to make some others really rich. If the majority of the common investors would quit investing just for a while, the stock market would really be in trouble. But the joy and hope of gambling, combined with greed, makes the idea of possible success only an imaginary fiction.

People will never change as long as mammon is their imaginary savior. Go around in the country and observe the casinos. You will be surprised how many people who do not have the cash to play and possibly lose their livelihoods are to be found there. A significant number of elderly are among them and play with their 'meager' pensions. But they have the impertinence to complain constantly that they do not receive enough pension benefits from the state to survive. A contradictory statement you may assert, but here the sociologist would have a word or two to say. Gambling is and will be a disease as long as we are not abandoning greed. To be fair, though, remember that it is certainly not the majority of the elderly who are caught in this trap.

The reality is, however, that we do have an undeniably high number of pensioners or retirees that have not enough income

from state pensions to live on. They live in real poverty. The circumstances did not allow for them to put some spare change in a savings account during their working days. Their circumstances are due to participation in wars; (willingly out of patriotism or forced by age on a social group) or lack of education, knowledge and income; or less favorable economic times during their working lives. They are the unfortunate, the victims. Elderly people need more medical care due to their aging bodies and Medicare is sparsely provided. They cannot afford the medication prescribed nor the Healthcare insurance and they have to sacrifice sustenance or living comfort to meet these costs. Elderly people have to endure the most illnesses and age related problems. However, the health benefit system in numerous countries incl. USA is minimal at best or not affordable for the elderly. Do they really deserve that? Did they not contribute all their lives to the pension system as well as they could? Luckily, for them there exist several help organizations that do their best to reduce the suffering. What does the government do? Oh, they promise to help and call a commission to study the problem. Do these promises ever materialize in real assistance? The fact is we leave many of our elderly, living amidst our society of affluence, still unaided.

Then there are our youth that cannot find, after High school graduation, a place to learn a trade or can't afford to go to university. The only place for them is our streets. We do not even discriminate specifically between social groups. The social gap between rich and poor is already wide. However, society is quick to blame these unfortunate youth as asocial, useless, lazy, and bad. Who blames them? Definitely the poorer part of society doesn't. We claim our North American nations, (US, Canada) to have the most advanced system, to be the richest nations. That is outright lip service. Being in high debt as they are tells another story. If we would just open our eyes, we would be ashamed of how we treat our elderly or young citizens. We have too many

children, no matter the reason, suffering of malnutrition and lack of mental care. In such rich countries like North America that can and should never be allowed by our officials.

However, famine in children's lives is rampant and we do not even care, or do we? Luckily, we have private organizations in place to do the work that is entrusted to the government but sits idle. Are we so self-indulgent and egotistical that we can't see the injustice, or maybe even care, as long as we are not the victims? We claim to have no time, that we struggle for our own lives, that each is for himself. Are we going away from our humanitarian way of living together? Are we so egotistical that no matter what happens to certain citizens, it will be unimportant? Should the wheel of destiny once turn around for these people, would we be the first to cry foul? Would we ever hear the end of that cry? Where, has the so-famous American pioneer spirit gone? Did it fall by the wayside?

Going back to the financial market, we find it difficult to understand that we need the stock market. Do we really need that institution? Do we believe that there are people out there who have made a fortune without an honest day's work? Who does their work? Huge sophisticated computers are programmed specifically to take advantage of the market fluctuations of the market in nearly milliseconds. The average investor has not a chance. He is mostly the loser. We could say that's his prerogative and you are right. Why does he invest hard-earned money in a losing cause? You are right, not everyone loses all the time; but most of the time. If someone makes a fortune others have to lose. With such a sophisticated computer it is not likely that the owners are the unfortunate ones. How many times could we hear the common citizen claiming that he invests only his spare change? Gambling is an addiction and the stock market counts on it. Without the small investors, the majority, the stock market would not be as lucrative to the big investors. They would have

to gamble amongst themselves. With these giant computers no prosperous business can be managed and no manufacturing be done. It does not really state the actual business success either. The owners of these giant computers are often driven by the addictions of greed and apathy. Nevertheless, governments that intervened would lose a large amount of tax revenue, and money is the common denominator in all our society's decisions.

The government needs revenue to satisfy all the demands of society. We the people demand the impossible from our government but we are not prepared to bear the consequence of the resultant tax burden. The only question remaining is: does the state use our tax contributions wisely or prudently to provide us with the necessities? What are the necessities of our land? Are they not the infrastructure, the schooling, the healthcare, the culture, the scientific research and welfare? And the government must be frugal with its expenditures. If we go on as we are today, we will be taxed to death. We have to reduce our demands and ask ourselves what we can do on our own. The government is not the instrument for solving all our wishes and problems. We the people have to become more conscious of what is important and reduce our demands drastically. As you now know, the US is several trillion in debt. If we accept current wasteful military expenditures, and if our demands are not moderated, we will be taxed to death. From whom do governments borrow, obtain the credit, if not mainly from the big banks and foreign nations? And the loan interests are so high that governments can barely pay them with their tax revenues. The rich banks become even richer. That is how they obtain absolute control over the governments. Is it the borrower or the lender that has the power? Certainly, it is not the citizen or the government. We are paying for the greed and power-hunger of the big financiers.

To be fair, we are not innocent in all this business. We demand more and more from the state and our representatives don't want

to lose their positions. Being a representative means a lot to them. Why? This goes mainly back to human shortcomings and our need to feel loved, admired, and respected. These are week beliefs, needs, but they are still the main driving force behind. Or does someone go into politics just to represent our problems and wishes? Maybe they start as innocent novices but they have to learn the ropes fast or they are quickly thrown out of the party and legislation. Why do really good men and women not go into politics? They understand the way politics works and do not want to have any part of it. Is that called being wise?

In North America the collected revenue from taxpayers, fees, gambling revenue and such are disappearing in the general revenue account, also called "bottomless pit". To have a precise control over the finances the Government has to *earmark* all revenues. Without that, we the people, even our representatives have no knowledge and control over it. The party in power represents a budget that is shrouded in secrecies. That must change. If the private sector of industry and commerce would deal with their financial affairs like the government they could not exist. They can only spend what they collect. That's the way a government has to operate as well.

4. The Entrepreneurial Dilemma

In the workplace, employees occasionally have a tendency to judge their companies wrongly. They notice that the owner makes money and they assume that he should share the spoils. That's easier said than done. The companies must make allowance for future investments and for less fortunate times. They also are expected to protect the employees from work shortage and pay loss in recessions or depressed times. We call that the short, middle, and long term stipulated measures. A serious company considers that. Mostly the owner of the company does not even thinking in terms of his retirement; rather, he has the well-being of the company and employees in mind. That is paramount to him. However, the employees' leaders, the unions, see it differently. They convince their members to go on strike and to demand increased salaries. At least that is one reason for a strike. In reality if the owner agrees to pay the employees more, this has significant implications. Because of the higher salaries, the company has to raise product prices. This has a follow-up in other companies and the result is that the cost of living standard also goes up. In the end the employees have a higher number in their salary but inflation and the extra income tax they must pay make the raise a loss. They are probably worse off than before. We know that inflation is dependent on several factors. Salary plays an important role, besides the factors of supply and demand. Just by checking the inflation rate and salary increases, you can see that they usually go hand in hand. Taxes however, can take more away from the increased income due to classifying the new income in a higher tax bracket. Money numbers increases on paper but the value decreases. Today, being a millionaire has not the same magic anymore. We already have too many billionaires and this also contributes to the devaluation of money. Do we really want

to become millionaires/billionaires to be able to buy a loaf of bread? If we continue to deflate monetary value, we could really achieve that. Just to remind you that the Deutsche 'Reichsmark' prior WW II went exactly that route. Did we forget that the Germans lost all their savings due to these manipulations? Do we want that too? Do not think it cannot happen to us, it can and if we continue to waste our resources and ask for more and more it will happen. The financial power has no other choice than to set our behavior in a regulated direction. People in high power are also only living humans and humans apparently make many mistakes. Probably they judge their decisions as not wrong. If they see the need and no other alternatives then that will be their decision with all its consequences. War is such a possibility and can be initiated easily. They have the means to do it. We play into their hands with our ignorance and vulnerability.

5. Lifestyle Choices and their Consequences

After WW II our economy, our lifestyle and our demands have increased manifold to the point of over abundance. Our hunger for more became insatiable and the waste became enormous. We have everything and this has made us complacent and lazy but still greedy. Nothing is good enough; nothing is important enough to interest us in what goes on in the world. The main thing is a full stomach and a thick purse. The only thing that matters is to be better off than our neighbor, to have more and better things to show off. As long as we are speeding up our downfall toward feeling sorry for ourselves, nothing will have real value anymore. We become materialistic slaves with no goals of value. Today we are still not prepared to live a life of common sense and moderate expectations. We have an insatiable hunger for materialistic plenty, are spoiled, and at the same time we indulge our young people, supplying them with meaningless gadgets.

Can we imagine a world without all these toys and possessions? Is our young generation happier than the elderly folks that had to do without all these electronics? We should listen more often to Jeff Foxworthy, his redneck stories and his satire.

Observing how our youth communicate with each other today, we observe that direct interpersonal communication suffers. They are talking to each other only through electronic devices, even when they are only a few paces apart. The electronic industry has found a lucrative niche and through suggestive advertising has reached admirable levels of profit. Science and technology have progressed so quickly that humans can barely keep up. Did the apparently necessary become the undesirable, a waste of time and

money? Have we produced a mountain of waste due to the rapid changes of the electronic devices?

A few years ago the car industry had as many car models together as each manufacturer today has by itself. The mountains of unusable cars in the grave yards reinforce the argument that we are a wasteful society. Where does that end? Must our children's' children suffer for our stupidity? Probably, we don't care anymore. We want to live a life full of self-gratification. We talk about our wrong ways but all is mostly lip-service. We drive the wasteful vehicle into the ground. We drive also our wasteful cars needlessly, consuming huge amounts of fuel, and then as they begin to look a little used, we replace them pointlessly with newer models. Maybe we understand that how the financial powers work drives our insanity. Right now, we cry wolf, but play the part of sheep. We are the makers of our own destiny. It is up to us to understand the necessity of moderating our lifestyle, of making our societies more reasonable, and more affordable. In the past we were not able to achieve this way of life.

That doesn't mean we have to return to the 'good old times'. They're gone and they are mostly outlived and were not all that great either. Worthwhile and positive progress is always welcome. Not everything in the past was bad. We just have to look back to our roots, come to our senses, and practice reasonability. The habit of absolute wastefulness has to become a thing of the past. We don't all need multiple cars. If we do not reduce our wants, the oil industry will do it for us. Gas prices will climb to astronomical heights. Crying for more income will not do the trick. Inflation and taxes keep pace or surpass the rising salaries. And it is good to remember that people spend beyond their means as demonstrated below:

"A new report suggests the average family debt in Canada has now hit the $100,000 mark, says Vanier Institute" in 2011. (13):

In addition, says the Vanier Institute of the Family, the debt-to-income ratio measuring household debt against income, is a record 150 per cent.

'This means that for every $1,000 in after-tax income, Canadian families owe $1,500'.

The Institute says in 1990, average family debt stood at $56,800, with a personal debt-to-income ratio of 93 per cent.

Other data compiled by the Institute shows the number of households behind in mortgage payments by three or more months climbed to 17,400 in the fall of 2010, up nearly 50 per cent since the recession began. (13).

The average debt per household in the US could even be higher than that reported for Canada. The slowdown in North America (recession) of the economy and the loss of employment makes it really hard for the average worker to survive. People will lose everything, including their houses and all their beloved gadgets. Does that not make us think twice before we purchase some unnecessary items, just for the sake of keeping up with our neighbour or friends and coworkers?

For VISA, Master Card and other credit cards the average per-personal debt amounts in North America to $ 43,000.00 with up to 28.8 % / per annum interest for the outstanding amount. Imagine just the interest of $ 12,384.00 per annum (p.a.), or $ 1,032.00/month. No wonder they make aggressive advertisements to have us as their customer.This is gouging, robbery. Does this not speak for a stop to insanity? Destroy all this high interest plastic cards. You will be much better off.

6. Life's Tragedy

6.1 In General

Living in the 21st century we can see the danger that our developed world's financial, personal and worldwide behavior could easily lead to a total collapse of global social and economic systems. The signs are visible all over. The stock markets of developed countries are threatening a melt-down; lifestyles have developed insatiable appetites for wants rather than needs. Our society has gone out of bounds and is totally confused. Our sense of values is distorted and misguided. Even with all our toys and gadgets, we are dissatisfied. Emptiness is deeply felt. The suicide rate is at an alarming height. Numbers of lost people on the streets are rising and drug and alcohol abuse is rampant. Laws don't cure this disease. These are signs of decadence and the downfall of society. As Rome decayed socially and then dissolved due to decadence, so could we. The decadence eventually led to the weakening of the Roman Empire and made it vulnerable to attack from the north, which was successful and resulted in the total downfall. We are on the way to self-destruction. The poor become poorer and rich acquire more riches. The gap is widening. No end is in sight. We continue to indulge in mediocrity and a life aimed at acquisition.

Lifestyles in developed nations as they are have to come to a slow-down or we will indubitably end in disaster. Financial collapses have proven in the past that war becomes inevitable to alleviate and solve such problems. And the wars are well orchestrated and manipulated. The consequences are well known. Millions upon millions of citizens lose their lives. Innocent humans lose everything; not to forget the loss of a great percentage of

irreplaceable good human stock. A third world war will without doubt eradicate more valuable human stock while destroying or further diminishing the earth's vital resources.

The sensible way to solve the threat is to become more involved in finding solutions. One of these solutions is personal transition from the wants to the needs in our lives. Searching for the better satisfiers, which are compassion, honesty and harmonious living, lifts the moral spirit to as yet unreached heights. Gone are the false ideas of greedy materialistic goals, replaced by sensible and moderate demands of society on each other. If we can reach that, the world will become a better and a more beautiful place to live. It is in our hands to create our destiny.

*"This world is a comedy to those that think, a tragedy to those that feel".(14)**

* Note: A similar expression is found in the Shakespeare papers.

6.2 Women and Children in our Societies

a) Women's plight

Atrocities committed against women around the world, in history and even today, are inhuman. Some religious congregations or sects still promote discrimination, even rape, against women. There are still cultures in which women are kept in slavery, and in which killing them is sanctioned. What causes people to behave in such a manner, to enact such unbelievably merciless conduct? Can it be that these persons feel *inferior* and are attempting to justify their own perceived shortcomings? *This has to stop!* Men and women of emancipated societies should join forces and introduce lasting changes to protect women, to establish firmly the knowledge that women are not inferior as some societies would have their members believe. Both genders have unique characteristics, but the characteristics of basic humanity are shared equally between genders. There will always be the personality gulf between men and women. '....Only socially will men and women compete on equal terms. In earlier times it was man's duty to secure the animal food, women's business to provide the vegetable edibles. Therefore, when man entered the pastoral era of his existence, woman's dignity fell greatly. She must still toil to produce the vegetable necessities of life, whereas the man need only go to his herds to provide an abundance of animal food. Woman's work was derived from the selective presence of the child; women naturally love babies more than men do. Thus woman became the routine worker, while man became the hunter and fighter, engaging in accentuated periods of work and rest. Times has given social equality and the co-ordinated functioning of men and women in the home, school, and politics, with specialized service of women in industry and

government. Each sex has its own distinctive sphere of existence, together with its own rights within that sphere '. (15)*

b) Children's dilemma

Two other deplorable concerns in our current world are child abuse and child slavery. Sweatshops using child labor are still functioning. Using children to work in reputable companies such as fast-food chains is also unacceptable. It is a modern use of child labor no matter how you slice it. We blame overseas companies but we basically do the same with our children, although under better working conditions. Some companies have, however, age restriction. What is wrong with our attitude toward sending children to work? Would they not be better off doing sports based on their preference under adult supervision? Aren't outdoor activities more beneficial to kids than working in sometimes unhealthy conditions? Unfortunately children haven't learned to read good books. This would enrich their life. Even when children want to go to work in fast-food companies or other enterprises they remove themselves from the process of growing up as children. The time comes early enough for the adolescent to enter the work force and fend for himself.

But on the other hand, youth in our privileged society are becoming increasingly disconnected. At least, when they are contributing to the families' well-being, they gain the sense of being needed, of being positive members of their immediate community. The whole idea of 'childhood' (in the working class) as a time of carefree play and learning is a result of the industrial revolution. Until then, childhood ended when the child was able to assist in meeting the needs of the family. The institution of factories resulted in the use of children as inexpensive workers. Public outrage eventually made itself heard, and the recognition

* excerpts from the (15) UB, Pg.936

of the rights of the child ensued. So childhood as we understand it is a fairly recent phenomenon.

Not everybody agrees with either argument. Our discussions, as with all our concerns, should search for solutions that take the well-being of every individual around the world into the equation. That is what we must strive for.

7. The Human Factors

We humans are basically complicated creatures. By nature we differ only slightly from the rest of nature's animals. We differ only with our brain capacity and free will to make choices. But, standing at the top of the chain means responsible and responsive behavior.

By nature the body of any creature, big or small, is a miracle of creation. Even though our scientists have reached a high level of understanding of the working of body systems, they are at a loss to explain other aspects of our mysterious mechanism.

'Many seemingly mysterious adjustments of living organisms are purely chemical, wholly physical. At any moment of time, in the blood stream of any human being there exists the possibility of upward of 15,000,000 chemical reactions between the hormone output of a dozen ductless glands'. (15) *

In addition to the physical, electrical and chemical workings of a human body there exist other mysteries; our thinking, our minds, our feelings, our expressions, our judgment and reactions, just to name a few. We may say that the human being is a mystery in itself. Unpredictable reactions, irresponsible behaviors, exaggerated expressions of despair and sadness, and emotionally uncontrollable behavior are only a few of the less pleasant aspects of the human.

We could call them our shortcomings. There also exists a lovable element in humans defined as love, trust, compassion, altruism, empathy, faith, hope, enthusiasm, happiness, joy, and such that makes our lives much easier. We are endowed with seven adjutant mind-spirits: "Intuition, understanding, courage, knowledge, counsel, worship, and wisdom". (15).**

* UB, P.737 - §6
** UB,P.401 - §6

The animal lacks these mind attributes and lives mainly as nature intend for them. They do not analyze or have wisdom nor do they worship.

What are we doing with it?

Nevertheless, history shows that we humans have a tendency to dwell on negative more than on positive attributes. Even when we know that they don't satisfy, we still engage in these follies of negativism. Thereby we penalize ourselves to the point of moral and physical self-destruction. Have we reached that stage yet?

Humans also have the tendency to hang on to certain behavioral patterns that make our lives unhappy. Why? Is sharing our positive attributes with our fellow humans not a better way? Changes are hard to accept. Even harder are changing patterns of behavior and lifestyle. Whatever we do we should do it for the good of society. To receive trust and love you must give it in the first place. Another downfall of our behavior is to blame everybody else for our shortcomings. By becoming responsible adults, we contribute to the wellbeing of society and make the lives of others enjoyable. Why waste a lot of time and effort on negative things if positive action brings responsible prosperity and happiness? Apparently, it is always easier to blame others than to bear consequences for oneself. This is only an excuse and we have to admit that it is not the smartest way to act in society. The weak indulge in complaints and resolutions, the strong act and bear the consequences.

We encounter so many environmental challenges. We have a natural tendency to react. But sometimes we are not prepared to accept the consequences of our actions. To name an example: we waste an enormous amount of electricity, as already mentioned above, ask for more, but are not prepared to allow the building of more power plants. We have two choices: either we use less electricity or we allow additional power plant construction. It is

nearly impossible to find a solution that will satisfy everybody. That is alarming.

Our habits of using pristine water (potable water) for irrigation (lawns), pleasure, drinking, washing also cars and such, have brought us nearly to the end of reserves and expansion possibilities. Solar cell and windmill installations are unsightly and not yet that efficient. Nuclear power plants present a potential danger for a nuclear catastrophe. Over several decades there were Three Mile Island in the US, and Chernobyl in Russia and recently in Japan, at Fukuoko; nuclear disasters that are strong in our minds. We are sitting on a time bomb. It is lucky that nothing more has happened to so many nuclear plants in the world. Further, now begins the disposal of the nuclear waste from the power plants. Nobody wants these waste products. They continue dangerous for maybe thousands of years. Just don't let us think where the plant companies deposit all these waste materials.

A perfect example we have here: the principle of demand and supply of energy. It is we, the consumer, who expect to be able to waste more electrical energy. That's exactly what we are talking about here. It is not the plant that bears the responsibility alone. It is we who should become reasonable and moderate in using the resource. Without additional demand there is neither reason nor economical justification for building further power plants. Reduction in consumer demand can potentially save a lot of grief and lives down the road. More to that in Part 2.

Unfortunately we sometimes express our reckless and thoughtless attitude that as long as it is not in our backyard or vicinity we don't care. That's again exactly what we are talking about. The world is full of activities that work on the same principal. The wasters demand more but will not bear the consequences of their demands. In all our activities we contribute to that system of foolishness. But nobody is prepared to tell the citizens that fact, especially not the politicians. They want us to

work into the hands of industry and power. It is a devil's cycle of argument. Building unnecessary plants creates jobs, and that's the soother the politicians give to the people. Job creation guarantees their re-election. And job creation gives more of us more money to spend on more acquisitions.

8. Hind sight

We are living in a fast, confused, and insecure time full of mysteries and realities. The world is turning too fast and its citizens fall out of balance. A necessary balance that could prevent disasters for mankind has to be implemented by the powerful. Politicians, financiers, and people in general behave dangerously. Their behavior is the result of more than one factor but the main factors in causing this chaos are human greed, apathy, irrationality, fatalism, fetishism; a lack of guidelines, faulty orientation, and all sorts of inadequacies, as well as the lack of personal characteristics such as altruism, faith and brotherly love for mankind.

The world is a dangerous place. A wrong move could trigger an orchestrated catastrophe in the financial society. Combine that with the insatiable wants of the population and we have a time bomb on our hands. And that leads to a strong possibility of a World War III. We cannot even think of such a disastrous incident and its consequences. With all the nuclear, chemical and biological bombs in storage and the world-wide buildup of military arsenals an unimaginable devastation to human kind, animals, land and climate could be in the making. It is questionable if the world after such a war would be inhabitable. And we can trust that people are able and willing to initiate that catastrophe. If you believe that can't happen, just wait until you get the chance to experience it. But then it will be too late. If you behave like arrogant young soldiers that believe only the enemy will pay the ultimate price of combat, that's foolish. We know better than that. The body bags coming from the battlefields are too many already.

Mothers who have a real love for their offspring, relatives and partner should use all their power to prevent their husbands, brothers and sisters, their young men and women from going

to war. But they probably know nothing better and believe that they must send them to war, even under a false pretext. Their lack of experience and belief in the words of political leaders without considering the real motive should not excuse them. It is our duty to show them the real causes and make them aware of government goals. They should have learned by now that in the Korea, Vietnam, and the Iraq, and the Afghanistan Wars, the sacrifices were not made for the freedom of the USA. It was and will never be in question. America is safe. However, is it not inconceivable that mothers can send their husbands or sons and daughters to war/death? Do they love the manipulators more than their loved ones? We have to change the way we live, behave and think. That's the only way to prevent a further disaster.

These are not dooms-day predictions. We have it in our hands to prevent a disaster. Never should it be thought that only the other party has to comply; everybody is involved and bears the responsibility. That's the way of a responsible, sensitive society. We have no other choice but to work together and not each for himself or against each other. Did not Caesar say: *'Divide and conquer (and enjoy the spoils)?* That's exactly what the method employed will be in order to control the masses. We must make sacrifices if we hope to prevent world-wide disaster from becoming reality.

Do sacrifices make us stronger, better, and through them do we become positive contributors to society? Sacrifices for war definitely do not; they make us weaker, pathetic.

'The weak indulges in declaration, but the strong act. Life is but a day's work; do it well. When the weak and dissolute mortals are supposed to be under the influence of devils and demons, they are merely being dominated by their own inherent and debased tendencies, being led away by their own natural propensities. (15)*

* UB, P.1094 - §7.

'The weak and the inferior have always contended for equal rights; they have always insisted that the state compel the strong and superior to supply their wants and otherwise make good those deficiencies which all too often are the natural result of their own indifference and indolence'. (15)*

However, we cannot unfairly allow the exploitation of the weak, unlearned, and less fortunate of humans by their stronger, keener, and more intelligent fellows. We must respect everybody and give them a chance and help them to become strong. We are together in that task of achieve those goals. We can and will do it. Nobody wants to be a loser and to be useless. Life is too short for that and distributes no satisfaction.

Opra Winfrey (16) elaborated the thought of the goals of a fulfilling the highest expression of ourselves by making sense of, and making the most of, our lives. She goes on beautifully:

"If you watch the news and the images it bombards us with – politicians running amok, despair, all-around craziness – you might think there's nothing you can do to make this world better.

I know that's not true. The world is a reflection of our collective consciousness. When a concerted mass of us start thinking differently, we will start to see change.

It begins with your own awakening, your own desire for a life that's not just lived on the surface but is rich and deep and high and wide. For sure, that's how I want to live. So I'm going to keep learning until I take my last breath." (16).

There are wise and good people out there, listen to them but contemplate, judge fairly but verify. Could people like Jesse

* UB, P.794 - §11.

Ventura or Oprah Winfrey be one of a group of leaders that has the courage, be candid and lead the citizenry correctly for a better, fairer, and enjoyable future? These possible leaders have to answer that.

9. Reality, Perceptions, and Interpretations

A demonstration which occurred as recently as October of 2011, against the rich establishment (Corporate greed equals total financial power, plutocracy) has really had no lasting effect. Even when demonstrations are justified, legal and have moral value they do not effectively change the current power of the rich system. As mentioned already, such demonstrations only awaken the already manipulated citizenry to oppose what causes an unpleasant situation, the demonstration itself. We can predict what will happen with any demonstration. Demonstrators will be crushed and sent into oblivion. The efforts of the demonstrating few will be in vain. Nothing will be accomplished because what remains in memory is the ugly end through the intervention of police and the follow-up. That's really sad but a reality. Demonstrators need to be led to a different strategy. Without proper leaders with authority, knowledge of the implications and ways to overcome the difficulties of our established rigid system, demonstrations will always be doomed.

An advice you should take seriously:
'Do not fight against the mighty; why fall into their hands?'
(15)*

What we have to do besides making the general population aware of the fact that the rich cheat and steal from the citizenry, is help them realize that people have the power to make changes if they hold as one unit together and concentrate on promoting the necessary legal steps. Here lies the problem: we the people are not capable of building a united front. The main reason for

* UB, Pg. 710-87§8.

this failure is that we are too manipulated and too conditioned (brainwashed). We cannot create a united front without the necessary convincing leaders. As I mentioned several times before, our complacency, fear, and manipulation by the real power of the rich (Plutocracy) hinders achieving a unified populace that is capable of defeating this power. The rich know how to make the citizenry happy and complacent. If this generally successful strategy doesn't work they use the method of fear of losses (job, income, sustenance) that can be prevented only by maintaining the current state of affairs. People become thereby 'content' and 'happy', even in misery. Their attitude is defeat and hopelessness and they do not face reality. They do not realize that in unity they have the strength to confront the challenge of defeating manipulation and conditioning.

Only our youth who are not yet cowardly, who are not weak and have an opinion, have the courage to oppose the oppression, the manipulation and the disrespectful gouging of money or possessions. It is well known that the rich have no allegiance to anybody and have no moral conscience. Unfortunately, the youth take the wrong approach toward dealing with these challenges and use the method of demonstration that will, as mentioned before, inevitably fail.

We have our so-called elected representatives in legislature. Unfortunately, they are not the real power, and most of us know that. But we do have the political instrument to demand from our representatives what we the people want. Should they not comply with our demands, it's up to us to make them aware that the citizenry that elected them can also recall. At election time, we have to set clear conditional demands to the candidates and make them aware of the consequences of misrepresentation like recall or resignation by default as a fact of law. The Internet is a powerful instrument for persuading the politicians to do the will of the people; use it.

If politicians have no other choice than to do effectively the will of the citizenry the powerful rich will no longer have their henchmen to manipulate, do the dirty work and enforce their will. Do not understand that this means equal distribution of wealth; that is a communistic/ socialistic goal that has proven in the past not to work; think of it more along the lines of closing the gap between rich and poor, bridging the ravine between the rich (the 10% of the population who own 90% of the wealth of this world) and the hard-working population.

The question is only how can we make it work? This is not as easy as it may sound. Let us see how we could solve that challenge. The net profit of banks, entrepreneurs, and developers must be partially dedicated to less price gouging, better salaries and fewer price increases. The cost of living must be reduced, made more affordable commensurate with the income of the working people. The people who own company shares must stop demanding higher and higher dividends. That behavior is exactly that of the rich. Greed is a disease and a bad adviser. We play as a result into the hands of the rich.

We may argue against all these recommendations and say that the more we possess the less we depend on the rich. But that is a weak and deceptive argument. We can never beat the rich at their game; they have control of the monetary funds. Moreover, even if they allowed us to gain wealth it would be very fragile and we could lose everything over night and mostly by our own fault. Greed has everything to do with it. A majority of us are prone to acquiring power and gain over others, which is by nature a survival mechanism. However, our greed goes far beyond survival. It is insatiable and boundless.

We have to realize that fewer and fewer American people are needed for labor; everything is sent abroad to places like China, where labor is cheaper. More and more US workers are out of work and suffer. People are not needed anymore. (17). Robert

Reich, former Minister of Labor under the Clinton administration initiated and demanded in his book (34) that products and goods should be manufactured (outsourcing) where the best price is available. We know the result of that.

This only touches the surface of all the challenges and difficulties to face in turning the ship of destiny around. We have to meet many conditions and challenges to achieve a *strong and lasting* effect on our financial and social life. An endless discussion could ensue in regard to the benefits of one political or social system such as capitalism, socialism, communism, and democracy over the other. Each has its good and lesser points. The past has clearly demonstrated that communism and socialism and, to a degree, democracy and capitalism have failed because in these systems the *human factor*, greed, is hidden but present. In the first two systems, incentive is missing. People become 'zombies' and opportunists; they rely too heavily on the state to bear the cost of living. Without incentives (reward or recognition) to work, productivity and income for the system become impossible. Work ethics decay to the point of complacency and hopelessness. In other words, the system fails in which no gain for efforts would results. Similarly, equal pay for everyone lacks the necessary challenge and penalizes effort. Why study years for a degree as physician, engineer, lawyer, or such if everybody will get the same income? That defeats in a way the purpose. Nevertheless, history has shown that clever politicians and opportunists were secretly and handsomely rewarded in practically all these systems.

Even when we do not like the capital system, it could be the successful alternative system if moderation and common sense prevailed. On this planet, socialism and communism are too similar, lacking incentives and personal rewards. The premise is that everybody must be equal. But because nobody is equal in perception, feelings, understanding, and expression, we cannot

be equal. Each person is unique, diverse, exclusive, and original in nature as well as in personality.

By law and fundamental legal rights, there should be equality. But unfortunately, in democracies and capitalist systems some are treated differently than others. For example, the rich have the means to influence the law through the use of clever and expensive lawyers. The common citizen, without the strength of unity and strong leaders, does not have these means of changing the system. Nobody should be able to defeat the established good and common- sense laws by means of trickery, force, bribery or other ways, neither rich nor poor. The laws must be for the *necessary protection and prosperity, fairness and wellbeing of the people.* Existing laws fail miserably on these accounts. A friend of mine said:

"The socialism would work in heaven perfectly but there we do not need it anymore".

Norman Mailer wrote long ago: *"The function of socialism is to raise suffering to a higher level".* (18). Very well sad.

"Republics decay into democracies, and democracies into dictatorship. That fact is immutable. When there is equality - and democracies always bring equality - the people become faceless, they lose power and initiative, they lose pride and independence, and they lose their splendor. Republics are masculine, and so they beget the sciences and the arts; they are prideful, heroic, and virile."

"Our society slides into a confused democracy, and only materialism, greed, the lust for power, and expediency, - feminine traits - is their goal. 'Masculinity in nations and men is demonstrated by law, idealism, justice and poesy, femininity by materialism, dependency on others, gross emotionalism, and absence of genius. Masculinity seeks what is right; femininity seeks what is immediately

satisfying….. Masculinity is vision; femininity ridicules vision. A masculine nation produces philosophers, and has respect for the individual; a feminine nation has an insensate desire to control and dominate. Masculinity is aristocratic; femininity has no aristocracy, and is happy only if it finds about a multitude of voices echoing its own tiny sentiments and desires and fears and follies. Rome has become feminine Priscus. And feminine nations and *feminine men** inevitably die or are destroyed by masculine people". (10).

Taylor Caldwell made here a strong statement and could cause an outcry of the feminists. Her interpretation of "Feminism "is misleading and has to be explained for the reader to understand the meaning of the expression 'Feminism'. The word has to be defined and understood not as *gender specific attribute*, neither male nor female specific, rather a behavioral way of conducting politics and business. Why she chose that expression is unknown.

One reason could be that Feminism has the tendency to judge, perceive, express in a manner that is emotional, softness, eager to please everyone, overwhelming, not rational, realistic and tends to lead to overshoot the target. Fact is that since feminism is in place of masculine, (such as in Greek and Roman Empire) the powers of the states deteriorated due to the introducing of too many laws that only cause exact the opposite of the intent. The empires of Greece and Rome did deteriorate into chaos and did fall victim to their own default. The enemy had easy pickings. Our political system goes the same route of falling socially apart. The common sense is lost and mediocrity is present. Observing how politics has changed since feminists (men or women) entered the arena, we should seriously question, what happened to common sense and

* italic by the Authors

to the balance of law and its necessity. Nevertheless, it is up to the reader to judge and decide the merits of her statements.

Will our nations decline and decay when 'feminism' wins dominance and no door of law, business, or politics are closed to them, or does the dominance of feminism merely indicate that the nation is decaying? Will it happen to us as well? You make your own decision but do not kid yourself. Our industrial nations (mainly North America and Europe, and lately the rest of the world) are in decline and morally lost, that's an immutable fact.

10. Ignorance and Apathy, Naivety and Complacency

The Financial Might, I call them "FM or THEY", sometimes also called Untouchables, Imperialists, Mighty, will go after our chosen leaders. THEY will destroy the leaders who are well intentioned, and for the people, unless we stand behind and protect them 200%. THEY find enough henchmen in the mass media, and those people who are weak or have no creed, opportunists, politicians, criminals, at their disposal. THEY use these people do their dirty work and in that way are fully protected from prosecution and justice as long as they follow the rules and dictates of existing law. Why do we not see this unfair, backstabbing, brutal system? Still we trust and believe in the good of our nation, our representatives, and even the Financial Might. How ignorant, even stupid, can we get? Unfortunately, there are always enough opportunists to do the dirty work for the Mighty. Do we have a chance against the FM? Do I have to remind you again of how the Nazi Movement operated? The citizenry knew that it was a wrong, inhuman, outrageous and brutal organization but still fanatically and enthusiastically supported and followed the regime. Even going to war was well arranged and the soldiers went willingly and fanatically into battle and death for the "cause". The methods are quite simple but effective: first take work and income away from the people, then create a food shortage and blame somebody else for it. Nurture dissatisfaction and hunger in any nation and its desperate citizens will do anything suggested by the regime to ameliorate their situation of misery.

Only ignorant people could believe that a war (such as WW II) would solve their misery. History proves the contrary. We know that humans can be manipulated and conditioned by

desperation, fear, hate, and hopelessness to follow illegitimate orders (illegitimate according to the fundamental human rights and freedoms act) and to believe in the necessity of brutal actions. We lose our common-sense and humanity and commit atrocities without scruple. We become the instruments of the Mighty. Our thoughts are diverted away from the real issue and this is the goal of the FM, satisfaction of their hunger for control and endless power. When all is said and done, when the war is declared over, the FM and the poor population remain just as they were before. Nothing will have changed, other than that the rich became richer, and the poor who survived, poorer. "THEY" were able to sell their weapons and the citizenry paid for them. The German population can tell a long and unpleasant story about that. Nevertheless, they do not. Why? Many are ashamed, some have died, and who would listen anyway? Life goes on and the history of suffering becomes only a figment of imagination to the new generation. Interestingly today, we face the danger of misery because we do not, or we will not, believe the warnings that are visible all over the globe. We deserve no better if we do not listen and respond. We are so naïve and ignorant that no matter what proof is presented we do not change our mindset. Wake up!

Even in the misery of depression, war, and suppression, the citizen seems to choose to live in a trance, a dream, and to wish not to be awakened. Apparently, it is easier and less stressful to live in a false and imaginary world than it is to face reality. Facing reality requires courage and strength. Making the necessary changes is hard, especially if it could mean loss of face. We are cowards and do not want to be bothered. Facing the brutal reality that causes unknown sacrifices would be too much. But are the sacrifices really unknown?

We know that the citizens are not capable of doing anything against an unpleasant or miserable situation without leaders. For

example, demonstrating against the gap between rich and poor, the lavish life style of the rich and the hunger and misery of the poor cannot result in change. Leadership is needed to unite the populace in order to make lasting changes for the betterment of the people and the nation.

The main reason is that the citizenry is too easily manipulated and conditioned (brainwashed). The human being is a complex entity. To be able to solve all difficulties and challenges without the *understanding* and knowledge of the issues involved is a difficult, even insurmountable challenge. To rephrase it: unless the citizenry open their eyes, hearts, brains, listen to the arguments and throw over-board all manipulative conditioning, and preconceived notions, successful change for betterment is impossible. We can't continue to believe falsehoods fed to us by manipulative leaders. We must stop trusting current leaders, fanatically defending what we hate the most, *the loss of our individual rights and freedoms*; that is what we have lost, as paradoxical as it may sound. We hate the misery of: inflation without salary or pension increase, loss of jobs, homes and incomes, break-ups of families due to the strain and stress. We do not want to fight the reality but choose instead to whine and at the same time accept defeat. Necessary changes cannot happen this way.

Fear is the strongest factor in keeping the citizenry in line. Nevertheless, without *courage* nothing could have changed in the past or will in the future. We will always have opportunists and freeloaders who willingly sell out their souls, families, and friends. These are the people who complain constantly yet allow themselves to be manipulated because they do not want to see reality, a reality that is often brutal and difficult to face. We could ask the question, which is more difficult: facing reality or accepting reality? Which is worse and harder to accept? The human being is, as we know, a complex entity. No one is equal in

perception, understanding, knowledge, interpretation, feelings, and emotions.

We must face reality together. We have to realize that going on as we have in the past and are doing now will not be in our best interests. Losing ground everyday in respect to our rights and freedoms is dangerous. The consequence is that we will suffocate and become very apathetic. This is exactly what the FM and the government want us to be. The populace as an indecisive mass, afraid of everything, willing to do for the powers everything they wish, is easy to manipulate and to govern.

If this is what we want to be, we deserve nothing better and must bear the consequences. We do not have the right to complain. We must live only in accordance with the dictates of the FM. The notion of being free, having civil rights and the ability to participate in the forming of our future is lost.

The movie: "Soylent Green" (19) with Charlton Heston comes to mind, in which people sank to a state of indifference, apathy, and ignorance and lost their will. The gap between rich and poor widened even further. We need instead to ask ourselves: do we, the common citizen, want to become mentally lifeless creatures for whom life has no meaning or value, having nothing to live for, nothing to look forward to? I don't think that we are fallen so deep down. Maybe there are some exceptions. Naturally, I could be wrong. Nevertheless, I think that such a miserable life would be not worth living. I think we would be better off dead.

We have an innate natural will to survive and we should therefore invest considerable effort toward improving life. I am convinced that everybody has that wish in one way or another. Our efforts must be directed toward an obligation to make our world worth living for.

We do not need a life with unnecessary hardship, wars, famine, pain, and suffering. We do not need to be worthless or to inflict atrocities on others. We need to exercise the will and tenacity

to face reality and to take the necessary steps to ameliorate our predicament today. *If we, the people, for once hold together, we will succeed.* We have the power of the population behind us that is not afraid or influenced by the FM and its endless manipulating of the citizenry into believing that the way of the FM is the only right one. THEY would have to give in to the voice of a united population. Politicians, police, military leaders, lawyers, and pedagogues would have no choice but to do the will of the citizens. THEY would have to help lead the ship to calmer waters, to guarantee that a more balanced financial system be in place and the distribution of wealth and power is counter-balanced amongst the people. There would still be rich persons, that is unavoidable, but they would be less wealthy and less powerful.

What we are talking about here is the insane stock market and financial gouging. The stock market is in reality a clever strategy of the rich to steal enormous sums from the vulnerable masses, the people, and the honored but vulnerable elderly. In the stock market, no real work or product is accomplished. It has strayed far from its original purpose, to help the commercial and industrial economy. The stock market has taken a separate path from its purpose. Its sole purpose today is to be able to gouge as much as possible from weak and unwise investors, weak people who still believe it is possible to make a ton of money in the stock market. Except for a few lucky ones who make some money, most small investors lose. They are like the dreamers who play at casinos or participate in lotteries. Greed is a strong motivator. Usually the common person has no chance against the sophisticated computers of the FM. To me, it looks like the beaten ones come back for more beating. Moreover, in accepting this situation we are helping perpetuate the whole mess. When will we understand that we are being used, and abused through our own fault, in order to enrich the already beyond imagination rich, FM?

We observe how highly CEO's, managers, actors, athletes, lawyers and even physicians and the like are paid for their services. They receive remuneration beyond reason beyond justification. Compared with salaries paid to the hard working population, with a good education mind you, they are paid 100 to 200 times more; up to 6 to 12 Million or more (that's $6,000,000 to $12,000,000.00) compared with the average workers' paycheck of $ 45,000.00. Some CEO's receive even $ 45 Mil. to 65 Million/a. This cannot be justified. Nobody, really nobody, provides a service great enough to deserve these salaries and bonuses. However, what are we doing? We support such outrageous paychecks by attending sports events, watching movies, watching sport events on TV, consuming health and abusing beautification products, happily burdened by advertising, buying items laden with expensive advertising. We pay for all that expensive advertising; it is offset to the consumer. What would happen if we denied them our participation? One thing is certain: they would have to reduce the ridiculous and outrageous salaries and perk demands. Why are we paying unnecessary amounts on top of already over-priced items on the market? Are we capable of using our united will to build a front against such gouging?

The power is with the people; we can make a difference. Peaceful legally approved demonstrations that this had no effect on the issue. Rather, they usually became ugly. Hooligans were sent in. Who send them? You may ask. You may guess why; to destroy the peaceful demonstration. The government then stamped these demonstrations as anti-social, not peaceful, made them appear to be anti-government, even terrorist in purpose. With the mass media at their disposal, the public was influenced against the peaceful demonstrators. The police, even the army if necessary, was sent in and the legal demonstrations were destroyed by force. The results are well known: nothing changed and the movement was destroyed.

The method employed always seems to be the same, be it in our own country or against other nations. A terrorist action is created. Who does that? A case in point is the 9/11 destruction of the Twin towers. That provided a reason to create the Patriot Act, On Jan 7, 2011 (Bush/Cheney). President Obama signed the 2011 Defence Authorization Bill, which is unconstitutional by international law and takes away all human rights and freedoms. As already explained, the democratic system allows neither the citizenry nor the parliament to decide. Both were ignored. In a communistic system this was known and practiced. But in a so-called democratic system this is a complete discrimination. How could a government enact such unconstitutional laws? Does it not clearly say that the citizenry are considered so mentally and psychological manipulated, conditioned and laden with fear that they would not dare to oppose them? Many authors suggest that the twin tower catastrophes were well orchestrated by government agencies. Others deny this. At the very least it is suspicious that the towers scene was enacted at a time in which the government was preparing to introduce restrictive measures for the citizenry. It offered a situation where another entity could be used to solve their problem of influencing the voters. It proved to be perfect timing. The population even believed, and many still believe, that the Patriot Act is established in a right cause. Emotions following the Twin towers destruction were high, and for some they remain so high, that the population has lost all sense of reason, of personal power. As mentioned before, that is exactly the strategy for sending young men and women to war. It is practically impossible to argue with such conditioned people. This proves that the method of the system works. To have total power over them, government needs a citizenry that is afraid, oblivious, non-thinking and very obedient.

This is the ultimate goal of a power hoping to lead a nation.. However, several political and dictatorial systems have tried

without success. In time, it may take generations, as they mature humans will not accept such manipulation any longer. They will take the wheel in their own hands. We can only hope that will be sooner than later.

The notion that the wealth in a nation, and in the world, should be equally distributed amongst the people is also an illusion. Why? We know that the populace is not equal in their ambition and will to succeed. Some are clever and some have tenacity. It is clear: only hard work in an economically moderate society bears fruit. Laziness, apathy, and ignorance deserve no easy lifestyle. Each must put in a day's work to be entitled to food and shelter.

The capital system works under certain conditions such as a moderate profit and gain system well. The incentive system is paramount. Work effort should be honored. "The more you work the luckier you get" is a proverb to reckon with. However, there is a fine line between moderate and excessive earning. What does that mean? What is too much profit, too much wealth in your pocket? Those are simple questions but with a difficult answer. Where is the limit of income for a successful entrepreneur, for a CEO or manager? How much income should be allowable or desirable? Should there be tax systems in place that would prevent that? There can only be one answer: Without the will to acquire a moderate life philosophy, to give excessive income back into the economy for the benefit and employment of everybody and to accommodate a decent income for all, the system will not change. That does not mean that the higher functionaries have to accept pay equal to that of the average worker. The incentive system has to work for their enrichment. But it must be within moderation for the system to function for an ideal economical system.

Today regulations and laws favor the rich. We, the working people, and especially the middle class, are the majority who must bear the tax and social burden. We do not have the means

to commission top lawyers and accountants to avoid paying taxes. Some rich people say that *'everybody that pays taxes is stupid'*. They are correct. Approximately 10 % of the population owns 90% of the wealth but pay little or no taxes. These are not made-up numbers. If the FM were to contribute to the tax burden, they would also make sure that the waste of tax money stopped. Today they have no interest or inclination to reduce their gains from the government. The government is an ideal source of income for the FM. They do not stop at milking our cow dry but they rip the government off shamelessly as well. Again, the US President declared recently with the same "election conviction" that he would charge the FM with higher taxes, which is a theme he has sounded many times over in his re-election bid.

Another example how a President, Obama is not the first and will not be the last if we allow such promises to stand, deceives the public. He knows that he cannot keep that promise, because he has not the free will to do so. Nothing will change. Why should the working common citizen with his moderate income pay up to 87% taxes when the FM pays no taxes at all? The reader can give that answer, it is too obvious.

A good tax system should receive from everybody the necessary financial contributions. It should not allow that the rich are exempt. Until now, who made the tax rules? Who decides what and how taxes will be collected? Definitely not the people. The tax rules are forced upon the common people without either their input or acceptance. Therefore, they are forced down their throats. A rough estimate of the percentage (%) of total taxes collected from the working people by the federal, states and communal government; direct, indirect and compounded taxes, all the separate fees for government services, property taxes, school taxes, food and beverage taxes etc. that should actually have been included already in the basic taxes, amounts to 83 to 87 % (author's conjecture) of the earnings. I can remember from

history in school that in the past 10% taxes brought the citizenry to revolt. That is not a figment of imagination; it is a simple fact. The government proudly announces each year at the end of July that we are tax free from this date on. They avoid mentioning that this is only from direct taxes; all the other hidden taxes are, not included. Besides, we, the vulnerable and trusting citizens, believe the government. A government doesn't lie and does not deceive, right? If only that could be true. Just look into the past to see how we were betrayed and misinformed. If we still trust and believe in our government, we are beyond help. The expression, "We, the governments do that for the benefit and the good of the people" is a catch phrase that still works in some groups of citizens. Why do government representatives not openly declare in clear and understandable terms the reality? They would probably not be re-elected or they would be ousted from office. Adding to our difficulties, governmental mismanagement of common funds is irresponsible and downright criminal. How can we expect to trust the government if they escalate our national deficit to over $14 trillion? Furthermore, from whom do they borrow this money? Mainly from the FM banks at an outrageous interest rate of over 18% up to 28.8%, such as those charged by VISA, Master card etc. We will never be capable, and especially not in the current economic downturn (2011/2012) called a recession that could even become a depression, of paying off that debt. The interest alone will swallow all our tax contributions. That is scary. However, our government goes on sinking further into debt. The FM use war as a means for gaining wealth. THEY, and their lobbyists, convince governmental representatives that new, more powerful weapons are necessary for our safety. This spending has helped to bring our economy to the brink of collapse. Yet, our governments continue to wrack up debt. We the people allow this to happen. We have, as a fact, the power but we tend to forget

that. We remain inactive and give away our rights and freedoms. In reality who is to blame?

We, the citizens have to demand that clear regulations, not lawyers' mumbo jumbo which not even the lawyers understand, are implemented. All revenues have to be earmarked and not disappear into a treasury of unknown purpose, usage, and venture. We currently have no means of knowing where our tax contributions are allocated. Apparently, not even our representatives in parliament have a clue. What that means is that the administrators make the decisions. The representatives are unable to read and understand the technical and legal papers in order to come to a justifiable solution as requested by citizens. And as things stand now, even if they were able to do all this there remains the parties' doctrine against which they cannot vote. We know what happens to delegates who vote against party politics. They are ousted and sent into oblivion. What good can they do there?

The costs of living: food, taxes, gasoline, etc. are rising in spite of the recession. The citizenry loses jobs and income, and suffers hunger without hope. Our older generation still remembers the depression times before WWII. How many families went hungry; even starved to death? In China during the culture revolution, 30 Million citizens died alone from hunger. What did the government do? They did nothing to help.

After knowing what really goes on behind the publics' back, do we still continue to admire and fanatically support and idolize rich people, actors, stars, CEO's, and politicians, because they have money, power and drive to keep them? Reality proves that their lifestyle is not worthy of admiration. That is not the lifestyle that they themselves really love. Mostly it is unrealistic and acting is a great part of it. There are undoubtedly a few exceptions whose fame does not influence their normal lives. Certainly, we have to leave the people something to dream of, certain ideals to

hope for. We have people who are admirable for their goodness and grandeur. Mother Theresa and Doctors without borders and others fit into this category. We should admire only people who have the courage to do their calling even in adversities and danger.

Life is tough and dishes out many challenges. Not only the less fortunate sometimes suffer in life; it hits the rich people as well, perhaps even harder. No money in the world can prevent aging, sickness, physical and mental pain. Nature is impartial and has no respect of wealth; it treats humans indifferently. We are born into this world with an unequal chance of survival; some will encounter more challenges than others. Nature does not differentiate between the rich and the less fortunate. Suffering caused by nature is by chance and only if we challenge and take high risks it is our doing. However, social and politically man-made difficulties are avoidable and unnecessary. We can only blame ourselves. The difficulties dealing with such issues are influenced by multiple causes, individual difficulties of understanding, perception, and reactions. The task of channeling all these parameters under a united endeavor is delicate. However, it is a fact that we can influence the outcome to our liking. If we do not act, the consequential lack of change can only be our fault. We can influence the future and our destiny as we see fit. Only together, we can reach the acceptable result of our envisioned goals. Compromises have to be reached due to human individuality. But common ground can always be found if we accept individual understanding and opinion. We can find a lasting but, if necessary, flexible solution. This is not an illusion. It depends mainly on the acceptance of different opinions and individuality, respect, and love for each thinking person.

A known example of how people can change destiny comes from the mainly rigorous regime of communism in China. The industrial might wanted to force upon the citizenry, mainly farmers

in the region of the Leaping Tiger Gorge, 68 water power plants along the two main rivers Mekong and Yangtze. That would have destroyed the livelihood of the farmers. The government and the power industry misled and manipulated the susceptible folks to believe that the projects would bring them prosperity and wealth. Luckily, some determined and knowledgeable, environmental groups and leaders did the research and informed the farmers of the realities. They proved to these people that in other cases the people were similarly misused and must now live in inhuman poverty and famine. I would like to refer to the TV transmission: "Nature of Things" (4). The transmission shows how the citizenry can change their destiny in their favor. The amazing part is that in such a controlled and regulated political, dictatorial system a united front of citizens can change the way the government rules. With good leaders and the united support of the farmers, they won over the government to change and make the issued permits to the electric power industry void. What a success!

If we think we are too inept to make changes for our future, we cannot expect that we will preserve our freedom and peace. We have lost so much. We have to turn the wheel around to prevent a greater loss of our freedoms. We have to bear the responsibility for a better social and political system in the future world. We cannot accept that we destroy not only our future but also and the future of our offspring. Why do we have children in the first place if we deny them, by our ignorance and apathy, a good, livable future without war, pain, atrocity, and suffering. In nature, no animal neglects his or her offspring, as we are well under way to do so. It is an inherited, natural instinct as well as our conscious awareness of our moral and ethical feelings to care for our children. In any society, there are people with confused minds who exhibit limitless love for animals, more than for people. They may even hate humans. However, we humans are at the top of the scale of the animal kingdom with our endowed free will

and cannot make animals our equals. As nature intended, animals and plants are provided as part of our survival and sustenance. Without them as part of nature, we humans would not be able to survive. That is an immutable fact.

An animal does not deal, as we humans, with challenges such as making moral decisions, and do not have the free will to make sensible conclusions, justifiable goals, and emotionally controlled choices. They live a life mainly controlled by nature's law. They obey unconditionally the alpha male leader, be it in their species or human. Humans react and behave according to their feelings, perception, understanding, and morals. These factors present to humans a constant challenge. Compassion, fairness, love, and emotions will always be present. The human being is a complex entity to deal with; a fountain full of surprises.

Our world harbors many cultures, ethics, ethnicities, religions, creeds, mores, and morals. Dealing with everybody equally is impossible. The human psyche cannot be molded into an equal form. The individuality and uniqueness of personality hinders conformity and sameness. Nobody is equal; we differ in many characteristics and perceptions. So, what governments and their departments like the CIA do is mind-manipulation and the use of threats of fear, deprivation, and mental and physical force; mind manipulation via science misuse, and have shown some success to justify their means. The human will was thereby destroyed, the human beings' faculties failed. The subjects became 'vegetables'; incapable of acting independently or of judging, understanding or deciding. They were lost to society forever. How can these men do that without scruple? Such actions are devious and inhuman.

Never forget that this happens daily all around the world and does not halt at our western borders. What really happens in Guantanamo Bay is beyond our knowledge. Media reports leak through that give evidence of illegal interrogations. Nevertheless, the Obama administration puts a lid on the news. Reports that

innocent citizens are incarcerated and maltreated is exactly what we the people detest the most. How can the American political power sanction such inhuman actions? Still we have many citizens who believe the government does a good service, fair, square and human. Think again. We realize how well the manipulation and conditioning is working. That is scary. We know and use as excuse 'in politics the faces will change the politic itself not'. Politicians come and go, die or are replaced. We know also that they can do a lot of damage during their term. Nevertheless, we must prevent replication of the power-manipulations. Only a united citizenry can change politics to align with their goals and envisages. We have, especially in our youth, citizens who disapprove of, or do not accept everything dictated by the authorities.

Here are some comments of US citizens in respect to Government dictatorship 2011: (even older people are beginning to realize what is going on; they have also lost their belief in the government): (7)

(In reference to a woman arrested for boarding a plane with an image of a gun on the side of her purse.)

- *A government big enough to give you everything that you want, is big enough to take away everything that you have —Thomas Jefferson*
- *Someday, Americans are simply going to have to take their country back....*
- *This country has lost all common sense. This is a threat somehow? What was she going to do, brandish the image on the side of the purse and take control of the plane? How did we get so stupid as a country?*
- *STAND UP, PEOPLE ... It's only going to get worse and worse if you don't!!! Glad I'm old and won't be here so many more years. I am ASHAMED of what my country is turning into, right I just felt the ground shake pretty hard, oh wait it must of been our founding fathers turning*

over in their graves disgusted of how they left the country and where it is now... I bet if they came back for just one day they would not recognize the place... when they left it, everyone had freedom,...before my very eyes!!!!

Other comments:

- *"Post 9/11 America! The war in Iraq! The coolly calibrated manipulation of the credulous American public, by an administration bent upon stoking paranoid patriotism! Avidly reading the New York Times, the new York review of books, the New Yorker and the Harper's, like so many of our Princeton friends and colleagues Ray Oates (husband of Joyce Carol Oates, Author), is one of those choked with indignation, alarm, a despiser of the war crimes of the Bush administration as of its cunning, hypocrisy, and cynicism; its skills at manipulation the large percentage of the population that seems immune to logic as a common sense, and history". Page 14. (31)*
- *The consequences of oppression, suppression, and wars should be known to everyoneWhole generations, good and intelligent human stock and the knowledge that they carry, will be lost............. Do we really want pain, misery, oppression, suppression, atrocities, hunger, poverty, destruction, and loss of millions of lives? At the level of the "States-Government" the system becomes even more controlled. However, the control is not visible to the public and the force behind it is not willing to show their hidden agenda. (20)*

11. Possible Solutions

In respect to all above-mentioned critiques, observations, and contemplations, we must pause and reflect on such strongly worded statements. Do these things really happen in our free society, in North America? With certainty, it does in many nations of the world. The signs are clearly marked and written all over. By realizing that the existing system could lead us into an apocalyptic state of society, we have to take the challenge to deal with the issues. Solutions are only found by analyzing, brainstorming, assessing, proposing possible solutions, and acting accordingly. We will be surprised at how clear the situation is when we realize what is wrong in our society and how it has to change, and then act accordingly.

We have to find better solutions, change the existing inadequate system into a system that is more free and respectful of the individual and society. We need a system that gives back to the citizenry the right to decide through a *direct democracy*, that is, free elections without the influence, manipulation and conditioning of the Financial Powers through the mass media. A precondition is that we have to get out of our conditioned mindset rather than accepting everything from the authorities and failing to scrutinize their actions. Further, we have to convey mistrust of the existing laws that curtail the rights and freedoms of the individual, society and nation. Except for the constitution, the existing laws in the US, for example, are so complicated that not even the lawyers or the politicians who created them understand the implications and the burden to the citizenry. The current tax system is a primary example. Is it not a fact that such laws keep lawyers indefinitely, and lucratively, busy? Charles Scheideman, (35) in his book, *"Policing the Fringe" says:*

"The conflict in their (the Lawyers*) position is that the system in its present state of dysfunction is so lucrative to them that they must fight to keep it as it is."

It is obvious who creates the pertinent laws. Daily we can observe how lawyers are involved and how they fill their pockets. Into the same categories go the contracts for different studies like environmental studies, feasibility studies, inquiries, etc. After spending millions upon millions of dollars, such studies have one common denominator: They are lengthy, complicated and solve nothing. Rather, they call for additional studies if they need a delay of the political process. They can interfere in any process without our awareness. This process acts behind closed doors. Only the Insiders are involved and they keep it secret. An open government is necessary if we want to be able to participate. The representative may say that the people would or could not understand the issue or are ignorant and fallible. Does that mean that he believes citizens are stupid?

A clear and decisive answer would bring a solution to the table. There has to be in all endeavors the perspective that the issue will not seem so important after a few years. A problem that seems very important at the time proves to be insignificant down the road. We should not make laws that prove later on to be inflexible and detrimental to our goals. Existing laws are rigid, not adaptable to time or needs, and yet are never replaced or removed. We are complacent and complain only via anonymous channels like the Internet. Why? People are afraid to state their opinions openly. The citizens young and old, fear repercussions from state and police. I do not have to make you aware that the police force can and does spy on us through such media as the internet, telephone, and observation of our attendance at political or social gatherings. The information gleaned can be used to

* Authors remark

make us appear to be potential terrorists. According to Jessie Ventura (30) on TV "Conspiracy Theory", it goes even further; the government has put in place a network of a neighborhood spy system. Your neighbor becomes your secret spy and any irregularity is reported to the government agency. Each report, insignificant though it may be, gives bonus points to that spy through a benefit system that protects them from government reprimand. That is the worst behavior the citizen can demonstrate towards a society.

The Nazis had, and the communistic nations have, this system perfectly in place. Even the kids were involved in the Nazi system. They spied without realizing what they did or what the consequences were, and through the conditioning of a nation and its citizens, they delivered their parents (in their case, the adult Jews) to the authorities. We despise such acts, but do not realize that in the US there exists exactly the same spy system. This was confirmed by an official in charge of the system, in an interview with Jessie Ventura (30) on TV in 2011. With that system, the government plants fear in the citizenry. Through fear, they have total control of the citizen with the result that the citizen will do whatever the government demands. This is not a figment of my imagination. Other authors, and even a US State's Governor, expressed such findings and showed such realities on TV. Did not the UDSSR and the east block plant that fear into their citizens, resulting in total and absolute control? Fear is, as we know, a self-inflicted mental poison and the biggest enemy of humanity. It is the best instrument for implementing whatever goals the government has. Using fear, the government does not even need to be concerned with possible objections or opposition from the populous.

Having the courage to show openly what goes on behind the "US' iron curtain" proves the strong conviction of citizens that we have to recognize the seriousness of these facts and act

accordingly. North America makes us believe that under the pretext of a free and democratic political system that we are free. Did not the German Democratic Republic pretend to be democratic and free? How deceiving and pathetic. Such a lie works perfectly into the hands of the real powers.

The FM has, as we know no allegiance, neither to God, nor to humans nor to any moral values. They "love" only money and the power that comes with it. Can they effectively manipulate, even dictate, all actions in the nation? Do they respect the rights of freedoms of the citizenry? Are they living their lives barren of sentiment and compassion for the people? Could we even call them callous? Are they driven only by their conviction that everything they do, good or bad, is in the interests of the nation, the people, and the world? Do they do so with such conviction that it is imperative that they stop at nothing? If a war would fit their goals, seems necessary, and might bring great financial advantages and increase their power, would they have no scruple to implement such measures?

People are apparently held to be expendable, as we realize daily from war raging all over the globe. If we follow the leading of the warmongers, we can blame only ourselves. As a fact, we are so gullible and easily persuaded that we do things without proper consideration of moral issues or of the consequences. We are easily influenced. We can become fanatic, and can be led to commit atrocities, even with pleasure (lynch mentality). Give to people, no matter what nation, race, dogma, ethics, or religion, a sense of self-worth and importance. Then place them in a position of power, provided with a uniform, or set them in a prestigious committee, and they will do whatever is called for without hesitation. Or give them a reason, or the impression that they can do whatever they please with their friends, coworkers, neighbors, parents, siblings and they turn against them immediately. They become unscrupulous and commit atrocities. We do not have to

go far to prove that point. The Nazi/Hitler system proved that fact, the Vietcong and the Red Khmer in Cambodia as well. Therefore, it is no wonder that the FM could suggest all these behaviors and actions without scruple. Such gullible ordinary people lose their common sense of reality, and the basic rules and morality of society are lost with it. It is nearly impossible for a conscientious citizen to understand how people become such inhuman beasts. Wars, and militant rebellions which destroy human self-esteem and undermine the self-confidence of the group, are a prime example of such behavior and actions.

The FM could claim that they did not commit the dirty work; it is the people who should protect themselves against such behavior. The FM could stay aloof and only profit from our pathetic doings. We can only blame ourselves. The argument that we have no choice and have to go to war is a poor excuse; it could even be called self-deception. It assumes we are all an unthinking people who find faults in others and blame others for our own shortcomings. Certainly skillful manipulation and conditioning of the people plays a decisive role here.

If people would begin to think and analyze what really is behind their fears, they would not be so prone to manipulation. Uniting and standing firmly behind real leaders who have genuinely good intentions is the second step. We humans will always need leaders. Without leaders, we are like a herd of sheep without the Shepherd. To be successful we must protect and support benevolent leaders. Standing firm behind them gives us the supremacy to act according to the constitution. The rule, however, stands: *Trust..... but verify, be vigilant*, only then can you make a wise decision.

We know the rules, mores, morals, and ethics of our society that support human rights and freedoms, but we seem to have lost our grasp of the rights and freedoms themselves. The insanity is that interest groups, without seriously considering the

consequences of their actions, ask for legislation introducing laws that in effect curtail the rights and freedoms they want protected in the first place. The legislators can introduce a law, if it suites their purpose of more control over the citizenry, without the consent of the majority of the electorate. If difficulties arise, they have the means and the power to divert public attention.

A case in point is the disaster of the twin towers in N.Y. with the resulting patriot act and homeland security act proclaimed without the consent of parliament or the people. This act actually curtails and penalizes only the US citizen. As a matter of fact, the government knows and has on file all possible names of terrorist groups or individuals. The general public of the US are neither criminals nor terrorists and therefore *not on the list yet*. Under the pretense of homeland security and protection against terrorism, (the majority of the people actually believe such a governmental lie) they created that act. With that law the real terrorists can rest on their laurels; their goal is reached. They have caused a nation to act in terror against its own people. The real reason for such a law is to be able to have absolute control over the citizenry. Are we at a stage of communistic control and government terrorism? Here comes to mind what purpose the founding fathers had in mind with the 2nd Amendment of the Constitution. They had the wise prophesy that in the future there exists a great possibility that the citizenry has to stand, even by force, against a corrupt government. Are we already there? I hope not. *"Si vis pacem, para bellum ": "If you wish for peace, be prepared for war"*. (23).

Certain people will argue the point, even with threats to the author's life as in the case of Julian Assange, that some statements are a threat to the security of the people and the nation, and work into the hands of the terrorists. How pathetic is that? To be fair to the public, we have to ponder the question: why do we have terrorist threats against the US? Who gave cause to be hated so much that they spare no life to protect their own country against

the US? In his book: *"Confession of an economical Hitman"* (2) the author elaborates the facts that the Government, FM, the oil and natural resource industry, plunder foreign countries. What would the US do if that were to happen to them? That is no problem: the US is too powerful to allow foreign powers to take control of the economy, the nation, or its resources. Are the citizens afraid of the truth? Do they react in a conformist manner? Do they behave according to the ostrich syndrome? I am concerned that the citizenry has lost the sense of freedom and rights and lives in a totally controlled and manipulated environmental and existential vacuum. If this is what the people really want then the survival of the nation is in peril. However, I strongly believe that there are enough citizens who do not approve of the present situation. Nevertheless, they are at a loss when it comes to solutions and action. Pertinent leaders must emerge with clear goals and plans to execute and lead the nation to a better future.

Is it mindful, desirable, to know too much about what is going on behind the closed doors, called 'the iron curtain of the powers' and what is brewed in these secrete halls? Should we not rather be ignorant and live our lives as well as we can, adapting to changes and restrictions as they arise? Ignoring the working of these political, economical, and social manipulations could prove detrimental. Should we really be inactive and compliant? Is this what we really want? Will it give us, and especially our offspring, the expected and hoped for prosperous future? Will life still be livable after the goals of the powers are reached, goals of total control and dictatorship?

History gives us some indications that many political systems have tried and failed. Why? Because the citizen recognized wrong doings and acted accordingly. Nevertheless, "try repeatedly until you succeed", that is the powers' motto. It does not matter if human lives are destroyed, right? That is, in view of the aimed goal, unavoidable, and people are expendable anyway, right?

Observing people going their way, working and living a decent and quasi happy life, minding their own business, you will be surprised that such occurrences happen. The US has an enormous land area and in sparsely populated areas, the control is not needed and not noticeable. People in such areas are not targeted, and have not first priority, to be a controlled population; they will be integrated into the system later on without difficulties. The police force is sparsely spread in such areas and people do not spy/snitch on each other as occurs in the bigger agglomerations. There are a few areas, such as the rural areas, where the people can be innocent and unaware of the scenes in big cities and urban areas. The contentment of these country peoples gives, however, a false impression nationally. The target is mainly the big cities with millions of people who can and must be manipulated, conditioned and controlled.

Luckily, there exist in our political world different mentalities, ethics, costumes, religions, creeds, and races that are so different that it is practically impossible to find a common consent. That is the beauty of this world. The lack of such diversity would make the world monotone and leave us without challenges. We need challenges, this is the only way we can progress and grow. Without them we would stand still, even regress. How come that the FM power want us to be robots? In the end, there would be nothing for them to do, and no challenges left. Did they think about that? *Soylent Green* all over?

Nobody wants that destruction of humans. Why not come to our senses and work out our challenges together? We have common challenges, which should be for everyone to have a moderate, a satisfactory life, filled with common sense. Do we have to have misery and hardship and cause each other miserable lives? Worldwide we can and will succeed if we put our senses together and use our brains and work out a solution that is flexible and adapted to the needs of different groups and societies. Utopia?

Without expending an effort to prove that, it is possible that it will not happen. If it doesn't, we will have lost an extraordinary chance to ameliorate our living together ourselves as well as our future generations.

12. Epilog to: Part 1

This book is written with full awareness that the mass media could viciously attack its statements. As with everything in life, we need to deal with two sides of a coin. One side is the positive, constructively critical side (watchdog), the other only negative, and destructive (henchmen). The author leaves it up to the reader to make his own decisions and to give answers to all the questions containing in this book.

The mass media try to destroy and discredit authors like Avram Noam Chomsky, (33), Wiki Leaks, (5), David Ike, Jesse Ventura (30) and others, and even ridicule the authors openly. And we as ignorant as we are, we join them in instead of thinking about what they are telling us. We should realize that the media machinery works to influence our ignorant opinions.

Noam Chomsky, in his well known speaker tours, lectured against the establishment in regards to the manipulative powers in America. In his opinion they are the hidden force behind the curtains. After his lecture at the University of Victoria, B.C. many years ago the students discussed amongst themselves what Chomsky had insinuated against these powers. They came to the conclusion that if Chomsky's lectures were correct, the establishment would shut him down. They proved exactly what Chomsky expressed: the establishment knows what he is teaching and advocating. They (FM) are so secure in themselves that they see no need to interfere with what he is saying and so they do not care.

They assumed as well, not without foundation, that the citizens and students would not believe Chomsky. His ideas seemed too unrealistic to be true. But here they err. More and more citizens stand behind such people as Chomsky, David Ike

and Julien Assange, among them also Governor Jesse Ventura and others.

People still believe, after realizing and accepting that a greater power exists, that it has only good intensions for society. They do not grasp that they have been manipulated by a deceiving mechanism. But the media helps the deception and loves to attack everything that does not fit into their mindset, although they usually exercise the *"smoke screen tactic."*

A recent transmission on CBC, Canada, "The National" with Peter Mansbridge, CBCTER of December 14th 2011, 11:30 pm MST, interviews Canadian reporters of CBC Canada acting during the past and present wars in the world. During the interviews the reporters elaborated on their impressions of the restrictions and censuring of the media and what they were allowed to report to the public. They questioned the reasons and the validity of the wars; they knew that the reasons given were false. But they were not allowed, or were afraid to report, what actually transpired. All their work was censored. They feared to be fired if they would report uncensored messages. They realized that the powers behind them were much stronger than their desire to report the truth. An American reporter was instantly fired because he showed uncensored factual information on American TV. The TV station was, due to pressures of time, unable to screen the Video beforehand.

In hindsight, Canadian reporters are also disillusioned in their work. Many are retired now and away from reporting the realities from the war zones. The scheme still goes on all over the globe and we receive reports from the field that remind us of the Movie: "Good morning Vietnam" with actor Robert Williams.

That's exactly what goes on this planet, in our nations. People have to wake-up and smell the roses. So many bad things are going on around us and are committed by us to other innocent citizens. Can we change the way we deal with our environment and citizens?

People will say, *"Please leave us alone with your negative and apparitional predictions; we don't want to hear about it"*. It seems that these people are victims of manipulation and have already accepted a sort of slavery and defeat. They are not readily prepared to change, to improve the environment and to live with a citizenry that requires peace, love and harmony around the globe. Church leaders try to make you become peace-loving, fair, trusting human beings. By avoiding reality and submerging ourselves in a fictional world many of us think that we can avoid responsibility. We should fear slavery more than freedom and we will change. Is it not our and our children's futures that we are neglecting?

Those who say that nothing can be done against the current powers might be correct. The situation remains as long as we accept defeat. And with our inaction it can only get worse. Investing in a future of moderate and sensible lifestyle will without doubt improve our existence. Refusing to work into the hands of greed and becoming vigilant against overindulgence or gratuitous materialistic action will not make our frugal lifestyle less comfortable. The opposite becomes reality. Less stress, less unhappiness, greater health, greater zest for life, will result. Anxiety will be replaced by happiness, love and admiration, trust, compassion, empathy. We will have a life worth living for. Materialistic superfluous things that never could really satisfy will be replaced by inner peace and tolerance.

We have to start at the root of all evil: become aware of what goes on in our lives, who and what actually controls them, what is wrong with our lifestyles. We must take the courage to change and bear the consequences. No doubt it is not an easy task. Nobody claims that life is easy; it is quite the contrary. But in dealing with all tribulations we become stronger and what counts the most is being the loved human we always hope to be. Gone are the false dreams of riches and being somebody, which never

materialized anyway. In their place is the real you, the person who is content. Accumulating material things or realizing the ambition of being rich and famous is more a burden and does not set you free.

There is no need of going to the other extreme and trying to become a moneyless person owning nothing and living in poverty. That's not the right way either. What we should aim for is having fewer unnecessary items for living, being frugal with our demands and becoming more aware of what our needs and wants really are.

Investing in a stock market is not really a wise choice, but can be beneficial if one remembers to retain money sufficient for daily needs and for emergencies. We have to set clear priorities and establish what we really need and what we are prepared to spare. Under such self-control and restrictions should be all avoidable duplications and unnecessary items like cars and luxury items that we can easily live without. Just imagine how much less stress, fewer overtime hours, fewer blockages and frustrations on the way to and from work, less sickness due to overworking of the body and more time to recuperate your tired body and soul. Think of the moments you will have available to spend quality time with family and friends. We know that's really what we want in life. So why not work for it?

An unhappy workplace should be a reason to look for a better place no matter what the losses might be. It is much healthier to change jobs and become happy than to remain ailing and miserable. The hospitals are filled with self-inflicted (stress related) illnesses. The health costs are skyrocketing.

Don't believe everything our so- called union leaders say. They have their hidden agenda as well and in the end they are not really looking out for you. They want to keep their well-paid jobs and show that they are doing something. But many times it would be better if they were more sensitive to individual situations

than eager to introduce strikes that help neither the employers nor the employees. There should be between company owner and employee a synergy and not an adversarial attitude. We are in the business together and not against each other. The fair owner provides jobs for us and we provide a service. We accepted conditions like salary, hours, and work conditions at the time of hiring. Circumstances for the owner or at the workplace, such as the economy or availability of supplies can change and a fair owner will make adjustments accordingly. Not all company owners are thieves; many pursue the market and workforce fairly. Certainly there exist less desirable owners but it is our choice to change workplaces. We should change our work place as soon as we have found a promising job. That doesn't mean that it has to be the same profession or work. Statistics show that in a human life-time we change our profession or work five to six times. We must get out of the rut if it makes us sick. We should free ourselves from such burdens. We are entitled to that self-worth.

Also, we have to get more involved in the affairs of the nation's politics. Giving a 'blank check' to our 'representatives' to make decisions without our consent is a thing of the past. We must vigilantly observe our politicians and get involved in the decision making. The politicians don't like that a bit but that's the way it has to be. We have to be our own destiny makers and not leave it up to politicians alone. If every representative were influenced truly, were bonded, by those who elected him, the influence of the professional lobbyist would fade into insignificance. Look at the system of Switzerland, with direct democracy where all important decisions of parliament must be approved or defeated by the citizenry. That's the way we gain our freedom back. Otherwise 'the power' has the say and the citizen is left out in the cold to bear the consequences. If we are required to pay for an action such as war, or conflict between nations, we must have the final word. That requires many changes in the set-up of existing

political structures but it is the only way we can regain political influence. Don't believe in promises by politicians and leaders that never materialize. We are at the turning point of our destiny. We have the choice to turn the wheel of the future in a direction that makes us a better, more worthwhile nations and world to live in. We just have to do it together! In the mass of the population is power. Start organizing at the grass roots and build from there to become a strong, fair nation. That's not an easy task. We will encounter many hurdles and obstacles but with persistence we can and will succeed.

Humans have to grow-up and become responsible citizens with only the wellbeing of humans in mind. We have to get rid of unrealistic dreams, set our feet down and change our rotten behavior. Those are really hard words but in thinking about it we realize that that's exactly what we have come to. Only changing our attitudes and goals in life can we be successful in initiating our livable future. Self-esteem and self-confidence are an integral part of our wellbeing. We can only achieve them by trusting each other, giving and receiving love and setting our standards of living at a sensible level. No materialistic striving will ever be able to do that. In the meantime, our craving to be loved and respected might be subdued but is never lost. We can easily dig it out and use it to become valuable citizens again. With regained self-respect and affirmation from our fellows we have the will and tenacity to attack the task needed and to reach the goals of a better and more reasonable environment. Begin in small groups and let it grow worldwide. It does not only benefit us; it benefits everybody with human feelings. By giving and receiving love and respect we strengthen our will for a better life, improve our environment and become happier persons. Together we can move mountains of difficulties and succeed in our worthwhile endeavor.

There will always be a number of negative and evil elements around us. But love can conquer hate and evil. If evil is the enemy's main goal he is at a loss when he encounters love. His sting will have lost its strength.

We have a promise from our Supreme Being: *"Freedom /Peace I leave with you and my freedom/peace will always be with you".* (15) (3).

We have to become entirely free from superstitions. And we should free ourselves from religious prejudices; never practising intolerance. We should have nothing in our hearts resembling social antagonism. That's our basis of function. Life can and will be beautiful again without stress, hate and animosity.

Love is the principal force to endure and succeed!

Some authors claim that companies such as Goldman &.Sachs or AIG are the actual FM and the real power, the financial, economical, and political manipulators. Sure, they do that but they are only the working instrument (henchmen) of the effective power, the FM. Who are these FMs? Could it be that these FMs are the Rothschild, or even the direct descendents of the Phoenicians? Are they the FM and Untouchable and unknown to us? Is this farfetched? Think again.

Should we not aim for a world government that is totally controlled by the citizenry? In general, we developed from the tribal stage to the appearance of strong rulers and kings, a product of progressive evolution. The unconditional monarchs were eventually succeeded by many different orders of governments – abortive republics, communal states, and dictators came and went in endless profusion. The subsequent transition from monarchy to representative form of government was gradually. Today however, we diluted and distorted that system to the point that the citizens are excluded from the decision-making. A world government has to be governed by actual representatives that have to bear direct consequences for their doing. The danger of a democracy will always be that we glorify mediocrity.

Basic rules that work in a united world nation need the following steps to the evolution of a practical and efficient form of representative government:

- *'Freedom of the person.* Slavery, serfdom, and all forms of human bondage must disappear.

 If one man craves freedom--liberty--he must remember that all other men long for the same freedom. Groups of such liberty-loving citizen cannot live together in peace without becoming subservient to such laws, rules, and regulations as will grant each person the same degree of freedom while at the same time safeguarding an equal degree of freedom for all of his fellow mortals. If one man is to be absolutely free, then another must become an absolute slave. And the relative nature of freedom is true socially, economically, and politically. Freedom is the gift of civilization made possible by the enforcement of LAW.

- *'Freedom of the mind.* Unless a free people are educated--taught to think intelligently and plan wisely--freedom usually does more harm than good.

- *'The reign of law.* Liberty can be enjoyed only when the will and whims of human rulers are replaced by legislative enactments in accordance with accepted fundamental law.

- *'Freedom of speech.* Representative government is unthinkable without freedom of all forms of expression for human aspirations and opinions.

- *'The right of petition.* Representative government assumes the right of citizens to be heard. The privilege of petition is inherent in free citizenship.

- *'The right to rule.* It is not enough to be heard; the power of petition must progress to the actual management of the government.

- *'Control of public servants.* No civil government will be serviceable and effective unless the citizenry possess and use wise techniques of guiding and controlling officeholders and public servants.
- *'Intelligent and trained representation.* The survival of democracy is dependent on successful representative government; and that is conditioned upon the practice of electing to public offices only those individuals who are technically trained, intellectually competent, socially loyal, and morally fit. Only by such provisions can government of the people, by the people, and for the people be preserved.

'The ideals of statehood must be attained by evolution, by the slow growth of civic consciousness, the recognition of the obligation and privilege of social service. At first men assume the burdens of government as a duty, following the end of the administration of political spoils men, but later on they seek such ministry as a privilege, as the greatest honor. The status of any level of civilization is faithfully portrayed by the caliber of its citizens who volunteer to accept the responsibilities of statehood. These are the prerequisites of progressive government and the earmarks of ideal statehood.

'No society has progressed very far when it permits idleness or tolerates poverty. But poverty and dependence can never be eliminated if the defective and degenerated stocks are freely supported and permitted to reproduce without restraint.

'A moral society should aim to preserve the self-respect of its citizenry and afford every normal individual adequate opportunity for self-realization. Such a plan of social achievement would yield a cultural society of the highest order. Social evolution should be encouraged by

governmental supervision which exercises a minimum of regulative control. That state is best which co-ordinates most while governing least.

'Human society is confronted with two problems: attainment of the maturity of the individual and attainment of the maturity of the race. The mature human being soon begins to look upon all other mortals with feelings of tenderness and with emotions of tolerance. Mature men view immature folks with the love and consideration that parents bear their children.

A world government has to:
- The abolition of all forms of slavery and human bondage.
- The ability of the citizenry to control the levying of taxes.
- The establishment of universal education--learning extended from the cradle to the grave.
- The ending of war--international adjudication of national and racial differences by continental courts of nations presided over by a supreme planetary tribunal automatically recruited from the periodically retiring heads of the continental courts. The continental courts are authoritative; the world court is advisory--moral.

'These are the prerequisites of progressive government and the earmarks of ideal statehood. *Earth is far from the realization of these exalted ideals, but the civilized races have made a beginning--mankind is on the march toward higher evolutionary destinies.*' * (15).

As a note to ponder: If you do not believe in the above findings that history repeats itself and what the government can and does do to the people, study the life of Geronimo and the Indian

* excerpts and interpretations of the Urantia Book: "Development of the state"

Nations. Greed for possession (Land and natural resources) made the European Immigrants and the Americans steal, kill and send the Natives of America into a miserable and degrading existence. Do the rich people today robe us as well bear but with only much more subtle methods?

"Relax and be serine, life is too short to be miserable".

13. Afterthoughts

We are living in a fast, confused and insecure time full of apparent mysteries and perplexing realities. The world is turning too fast and its citizens have fallen out of balance. A balance that avoids disaster for mankind has to be implemented by the powerful. Politicians, financiers and ordinary people are behaving dangerously. Many factors contribute to this situation. The main ones are greed, apathy, irrationality, fatalism, even fetishism. There are a lack of guidelines, a sense of disorientation, many human inadequacies, and a loss of real altruism, faith and brotherly love for mankind.

The world is a dangerous place. A wrong move could trigger a catastrophe in financial and political circles. Combined with the insatiable wants of the population, this creates a time bomb. It leads to the real possibility of a world war. Such a disastrous incident and its consequences are unthinkable. With all the nuclear bombs in storage and the vast military arsenals of many nations, unimaginable devastation to human kind, animals, land and climate would be the result. It is questionable if the world after such a war would be inhabitable. And we can trust that people are able and willing to initiate that catastrophe.

If you believe a third world war can't happen, just wait. Don't count on your 'confidence'. If you wait for proof, you will be too late. If you behave like the arrogant young soldiers who believe only the enemy will pay the ultimate price of combat you will learn a hard lesson. We know better. The body bags coming from the battlefields of Iraq, Afghanistan and other places in the world are too many.

Mothers or fathers who have a real love for their offspring should use all their power to prevent young men and women from going to war. They don't know better, and believe in a false

cause. Their lack of experience should not excuse them. It is our duty to give them the real cause, and that is that we the people are out of control and we have to be restrained. We must change the way we live, behave and think. That's the only way to prevent a further disaster.

The insanity of the stock market must be slowed down and set to new levels of moderation.

These are not dooms-day predictions or irrational demands. We have it in our power to prevent a disaster. And it should not be others who must comply; everybody is involved and bears responsibility. That's the way of a responsible, sensible society. We have no choice but to work together rather than each for himself. We must make sacrifices if we want a reality of moderation for all. Remember that sacrifices make you stronger, better, a positive contributor to society.

"The weak indulge in declaration, but the strong act. Life is but a day's work, do it well. When the weak and dissolute mortals are supposed to be under the influence of devils and demons, they are merely being dominated by their own inherent and debased tendencies, being led away by their own natural propensities.' (15)*

"The weak and the inferiors have always contended for equal rights; they have always insisted that the state compel the strong and superior to supply their wants and otherwise make good those deficiencies which all too often are the natural result of their own indifference and indolence. (15)**

We cannot allow the unfair exploitation of the weak, unlearned, and less fortunate of humans by their strong, keen, and more intelligent fellows. We must respect all and give everybody opportunity and assistance to become strong. We are together

* UB, P.1094 - §7.
** UB, P.794 - §11.

responsible for building our future, ensuring our existence and promoting personal wellbeing. Only together can we achieve these goals. We can and will do it. Nobody wants to be a loser or useless. Life is too short for that and gives no satisfaction.

> 'As you grow older in years and more experienced in the affairs of home, society and the world, are you becoming more tactful in dealing with troublesome mortals and more tolerant in living with stubborn associates? Tact is the fulcrum of social leverage, and tolerance is the earmark of a great soul. If you possess these rare and charming gifts, as the days pass you will become more alert and expert in your worthy efforts to avoid all unnecessary social misunderstandings. Such wise souls are able to avoid much of the trouble which is certain to be the portion of all who suffer from lack of emotional adjustment, those who refuse to grow up, and those who refuse to grow old gracefully'. (15)*

We must not accept the destruction of not only our own future but also and specifically the future of our offspring. Why have children in the first place, if we deny them, by our ignorance and apathy, not a good, livable future without war, pain, atrocities, and suffering? In nature, no animal would neglect its offspring, in the way that we are well under way to do. It is an inherited natural instinct, as well as our conscious awareness of our moral and ethical feelings, that leads us to care for our children. In any society, we will find people with confused minds who exhibit limitless love for animals, more than for people. Some may even profess to hate humans. However, we humans are at the top of the scale of the animal kingdom with our endowed free will and cannot make animals our equals or betters. As nature intended, animals and plants are part of our survival and sustenance. In

* UB, P.1740 - §5

turn, they behave in the same survival mode: eating and being eaten. Without them as part of nature, we humans would not be able to survive. That is an immutable fact. An animal does not deal, as we do, with such challenges as having to make moral decisions, and of having the free will to draw sensible conclusions, formulate justifiable goals, and make emotionally controlled choices. They live a life mainly controlled by nature's law. Many obey unconditionally the alpha male or female leader, in their own species or, in place thereof, they will accept a human as pack leader. Humans react and behave according to sensitivities, perceptions, understandings, and morals. These factors present to humans a constant challenge.

If we think that we are too inept to make changes for our future, we cannot expect that we can preserve our freedom and peace in the world. We have lost so much and we have to turn the wheel around to prevent a greater loss of our freedoms. We have to bear the responsibility for a better future social and political system in the world. The method to be employed should, however, not be one of forcing a system upon others to implement new ways of conducting a nation, lifestyle or political system. Force will serve no legal purpose and will lead only to failure as it has in Iraq, Afghanistan, and Vietnam. We have to understand that the real reason the US went into Iraq and Afghanistan was to gain control of the natural resources, mainly the oil, and other resources like selenium. At the same time, the industry for military products made big profits, kept their business going, and kept the workplace for the American worker alive. I doubt that the official reason was to liberate the oppressed citizen and bring them democracy, or to defend us against terrorism. Sounds good but has no validity because neither Iraq nor Afghanistan was a threat to the USA and the question remains whether these nations want democracy in the first place. Did the American

idea work; did they achieve freedom for the people? Do we have another Vietnam at hand?

By the way, no nation should impose help on another nation, resolving their political problems and invading the country with brutal force, if no help is requested in the first place; an official declaration was that the Americans had to protect their interests. Which interests? Sending our young soldiers into war under false pretense is inconceivable.

We must not accept the destruction of not only our own future but also and specifically the future of our offspring. Why have children in the first place, if we deny them, by our ignorance and apathy, not a good, livable future without war, pain, atrocities, and suffering? In nature, no animal would neglect its offspring, in the way that we are well under way to do. It is an inherited natural instinct, as well as our conscious awareness of our moral and ethical feelings, that leads us to care for our children. In any society, we will find people with confused minds who exhibit limitless love for animals, more than for people. Some may even profess to hate humans. However, we humans are at the top of the scale of the animal kingdom with our endowed free will and cannot make animals our equals or betters. As nature intended, animals and plants are part of our survival and sustenance. In turn, they behave in the same survival mode: eating and being eaten. Without them as part of nature, we humans would not be able to survive. That is an immutable fact. An animal does not deal, as we do, with such challenges as having to make moral decisions, and of having the free will to draw sensible conclusions, formulate justifiable goals, and make emotionally controlled choices. They live a life mainly controlled by nature's law. Many obey unconditionally the alpha male or female leader, in their own species or, in place thereof, they will accept a human as pack leader. Humans react and behave according to sensitivities, perceptions, understandings, and morals. These factors present

to humans a constant challenge. Compassion, fairness, love, and emotions will always be present. The human being is a complex entity to deal with; a fountain full of surprises.

Our world harbors many cultures, ethics and ethnicities, religions, creeds, mores, and morals. Dealing with everybody equally is impossible. The human psyche cannot be molded into an equal form. The individuality and uniqueness of each personality prevents conformity and sameness. Nobody is equal; we differ in many characteristics and perceptions. What did the government and their departments and, for example, Amnesty International do against mind manipulation and the use of threat, fear, deprivation, and mental and physical force or mind manipulation via misuse of the successful research of science by the CIA, KGB, and Gestapo? What did they do to prevent or stop it? The human will was destroyed by such methods. The human faculties of the individual ceased to exist. The person became a 'vegetable', incapable of doing anything of his own volition, unable to judge, understand or make decisions. Are such victims not lost to society forever? How can the henchmen practise such atrocities without scruple? Such actions are devious and inhuman.

Never forget that this happens daily all around the world and makes no halt at our western borders. What really happens in Guantanamo Bay is beyond our knowledge. Media reports leak through that give evidence of illegal interrogations even through torture. Nevertheless, the Obama administration puts a lid on the news. Reports that innocent citizens are incarcerated and maltreated is exactly what we the people fear and detest the most. If it is the truth then how can the American political power condone such inhuman actions? Still, we have many citizens that believe the government does a good service, fair and square, human. Think again. We realize how well the manipulation and conditioning is working. That is scary. We know and use it as excuse, 'that in politics the faces will change the politic itself

not'. Politicians come and go, die, or are replaced. Furthermore, we know that they can do a lot of economical and social damage during their terms.

Some will argue that this cannot happen in the USA. But the same argument was promoted about the NAZI Movement in Germany, but history proved that it can and will become reality in any nation at any time.

Nevertheless, we have to prevent replication of the power manipulations. Only a united citizenry can influence politics toward their goals and envisages. We have, especially in our youth, citizens who disapprove or do not accept everything dictated by the authorities.

Together we have to face reality. We have to realize that going on as we have been will not serve our best interest. Losing ground in respect to our rights and freedoms is dangerous. The eventual effect is that the citizen will suffocate and become apathetic. This is exactly what the FM and the government it runs wants us to be, an undecided mass of citizens, afraid of everything, easy to manipulate and govern, willing to do whatever the power in place demands.

If this is what we want to be, we deserve nothing better and we must bear the consequences. We forfeit the right to complain. We must live only in accordance to the dictates of the FM. The notion of being free, of having civil rights and having the ability to choose our future will be lost.

The method employed always seems to be the same, be it in our own country or against other nations. A terrorist action is created. Who does that? A case in point is the 9/11 destruction of the Twin towers. That provided a reason to create the Patriot Act, On Jan 7, 2011 (Bush/Cheney). President Obama signed the 2011 Defence Authorization Bill, which is unconstitutional by international law and takes away all human rights and freedoms. As already explained, the democratic system allows neither the

citizenry nor the parliament to decide. Both were ignored. In a communistic system this was known and practiced. But in a so-called democratic system this is a complete disaster. How could a government enact such (purulent) extraordinary laws? Does it not clearly say that the citizenry are considered so mentally and psychological manipulated, conditioned and laden with fear that they would not dare to oppose them? Many authors suggest that the twin tower catastrophes were well orchestrated by government agencies. Others deny this. At the very least it is suspicious that the towers scene was enacted at a time in which the government was preparing to introduce restrictive measures for the citizenry. It offered a situation where another entity could be used to solve their problem of influencing the voters. It proved to be perfect timing. The population even believed, and many still believe, that the Patriot Act is established in a right cause. Emotions following the Twin towers destruction were high, and for some they remain so high, that the population has lost all sense of reason, of personal power. As mentioned before, that is exactly the strategy for sending young men and women to war. It is practically impossible to argue with such conditioned people. This proves that the method of the system works. To have total power over them, government needs a citizenry that is afraid, oblivious, non-thinking and very obedient.

This is the ultimate goal of a power hoping to lead a nation. However, several political and dictatorial systems have tried without success. In time, it may take generations, as they mature humans will not accept such manipulation any longer. They will take the wheel in their own hands. We can only hope that will be sooner than later.

14. Quotes and Quotable

a) Reverend J. Parker Jameson said in 1975: *"It knocked out of me the idea that America was the center of the world. I learned that the globe is a much bigger place and that there is a whole world of hurt out there that needs to be taken care of. We need to work together to deal with it."* * (11).

b) *Soylent Green* is a 1973 American science fiction film directed by Richard Fleischer. Starring Charlton Heston, the film overlays the police procedural with science fiction genres as it depicts the investigation into the murder of a wealthy businessman in a dystopian future suffering from pollution, overpopulation, depleted resources, poverty, dying oceans, and a hot climate due to the greenhouse effect. Much of the population survives on processed food rations, including "soylent green".

The film, which is loosely based upon the 1966 science fiction novel *Make Room! Make Room!*, by Harry Harrison, won the Nebula Award for Best Dramatic Presentation and the Saturn Award for Best Science Fiction Film in 1973.

In a 1973 film presentation, New York City in the year 2022 is depicted as having a population of over 40 million. Most food, to feed the concentrated masses of people, must be manufactured in local factories. The dinner choices produced by the Soylent Company are between Soylent Blue, Soylent Yellow, or Soylent Green. When William Simonson, an executive in the Soylent Company, is found murdered, police detective Thorn is sent in to investigate the case. As he delves deeper into his

* (11) from "Citizen of London": Lynne Olson, P.391

investigation, he uncovers a dark secret-- the heinous truth behind the real ingredients of Soylent Green.*

c) NEW YORK (CNNMoney) (21) – "President Obama traveled to the heart of Republican Kansas on a recent Tuesday, where he presented Americans with a choice: a "fair shot" with him, or a return to "you're on your own economics."

Obama firmly embraced the rhetoric of income inequality, and laid out a plan to rebuild the middle class.

"This is a make or break moment for the middle class, and all those who are fighting to get into the middle class,» Obama said. «At stake is whether this will be a country where working people can earn enough to raise a family, build a modest savings, own a home, and secure their retirement."

Problem is, his plan was pretty short on details.

The much ballyhooed speech was delivered in Osawatomie, the same town where Teddy Roosevelt made his case for "New Nationalism" -- a plan for broad social and economic reform -- more than 100 years ago.

All the pomp and circumstance was sure to invite comparisons between Roosevelt, the man who promised Americans "a square deal," and Obama.

That's no accident. Roosevelt's speech "really set the course for the 20th century," White House Press Secretary Jay Carney said on that Tuesday.

No pressure.

For the occasion, Obama hit on major campaign themes and evoked the language of income inequality

* (20) From Wikipedia, the free encyclopedia ,2012.

that has become the hallmark of the Occupy Wall Street movement.

One big idea: Fairness.

Obama used the word "fair" or "fairness" a total of 15 times in advocating for an America where everyone gets an equal opportunity.

"I'm here to reaffirm my deep conviction that we are greater together than we are on our own," Obama said. "I believe that this country succeeds when everyone gets a fair shot, when everyone does their fair share, and when everyone plays by the same rules."

How does that happen? Well, according to Obama, by following his policy prescriptions, and avoiding those of the opposition.

Republicans have, he said, refused to raise taxes on the rich. Republicans have blocked his nominee for head of the new consumer watchdog agency. And they have advocated for weak regulation and oversight.(21)

"Swing state economies complicate 2012 picture."

"We simply cannot return to this brand of (you're-on-your-own) economics if we're serious about rebuilding the middle class in this country," Obama said.

Obama said America needs to invest in education, and develop a commitment to science, research and high-tech manufacturing that will help win the "race to the top."

The president spoke broadly of the need for banks to help homeowners refinance mortgages, and give the unemployed more time to look for work without losing their homes. And he mentioned that long-term reform of the tax code is needed, a conviction shared by many Republicans.

That stands in sharp contrast to Roosevelt.(22)

"When I say that I am for the square deal," Roosevelt said in 1910. "I mean not merely that I stand for fair play under the present rules of the game, but that I stand for having those rules changed so as to work for a more substantial equality of opportunity and of reward for equally good service."

For Roosevelt, those reforms took the form of an eight-hour workday, a minimum wage for women, a wider social safety-net and a progressive tax system.

Meanwhile Obama, who has been constrained by a recalcitrant Congress, was reduced to advocating for one specific policy proposal -- an extension of the payroll tax holiday -- that would merely extend current policy.

What the president didn't offer is a series of specific reforms that would make America more equitable.

"In case you haven't heard, President Obama wants the wealthiest to pay more in taxes.

Noting the rise in income inequality in recent years and the need to reform the U.S. tax system, the president on Tuesday said that some of the wealthiest in

America pay far less in federal taxes as a percentage of their income than many lower down the income scale.

"A quarter of all millionaires now pay lower tax rates than millions of middle-class households. Some billionaires have a tax rate as low as 1%," Obama said in a speech in Kansas.

Here are some of the facts behind the claim: In 2006 roughly 25% of those with adjusted gross incomes over $1 million paid a smaller portion of their income in federal taxes -- income, payroll and corporate -- than 10% of those with AGIs (Annual General Income) below $100,000, according to a recent study from the Congressional

Research Service. As for the president's assertion that some billionaires have a tax rate as low as 1%, Roberton Williams, a senior fellow at the Tax Policy Center, said that it's definitely possible but hard to verify.

Buffett rule could hit 25% of the very rich

Billionaires are still rare enough that we cannot get data for them without running afoul of privacy rules," he said.

But for a lot of reasons, Chris Bergin, president and publisher of Tax Analysts, said, "It is certainly not implausible."

Last year, 4,000 households with incomes over a million dollars owed no federal income tax whatsoever, according to Tax Policy Center estimates.

What's more, of the top 400 federal tax returns with the highest adjusted gross incomes in 2008, 30 had an effective tax rate of less than 10%, noted Mark Luscombe, the principal federal tax analyst at CCH.

A big reason is that a large percentage of wealthy Americans' income comes from investments, which are often taxed at lower rates than ordinary wages and salaries.

What's more, some perfectly legal tax code provisions allow taxpayers to reduce their investment tax bills even further.

Of course, the wealthy aren't the only ones who enjoy what Obama refers to as "loopholes and shelters." Anyone who deducts their mortgage interest, saves money for retirement, realizes a capital gain or loss, or gets health insurance from their employer is enjoying a tax break.

The difference is that the rich use a broader array of tax-preferred investments, such as partnerships. Or they may invest in dividend-paying foreign stocks and can claim

a foreign tax credit for the tax withheld from them by the foreign government.

Typically, too, the wealthiest are more likely to be retired or self-employed and are in a position to make big charitable contributions -- all of which come with distinct tax advantages.

And the wealthy can afford to be more risk-averse and park a lot of money in bonds, often tax-free.

To Obama, the fact that the wealthy can so whittle down their tax burden is "the height of unfairness."

Fairness in the tax code is a real issue, but there is no absolute answer to the question "what's fair?" And that's one reason why reforming the tax code will be a tough fight.

Earlier this fall, Obama proposed what he dubbed the Buffett Rule, named after billionaire investor Warren Buffett, who has urged Congress to tax the rich more.

The Buffett Rule is intended as a guiding principle for tax reform to ensure that millionaires pay a higher percentage of their income in federal taxes than those who make less. That may not be as easy to implement as it sounds. *(22)

d) *Si vis pacem, para bellum* is a *Latin* adage translated as, "If you wish for peace, prepare for war" (usually interpreted as meaning *peace through strength*—a strong society being less likely to be attacked by enemies). The adage is from 4th or 5th century Latin author Publius Flavius Vegetius Renatus's tract <u>De Re </u>Militari,book 3.

A Relief located at the entrance of the Cultural Center of the Armies (former Serviceman's Casino) of Madrid

* (21) By Charles Riley @CNNMoney December 7, 2011: 10:49 AM ET.

(Spain), at 13 Gran Vía (a downtown avenue), showing the Latin phrase "Si vis pacem, para bellum".*

Another scam:

Despite Access to Information requests for the data, the Bank of Canada refuses to release it, the CCPA report states:

"Canadian banks got $114B from governments"

Canada's biggest banks accepted tens of billions in government funds during the recession, according to a report released today by the Canadian Centre for Policy Alternatives.

This is a typical scam of the FM to steal from the government and the taxpayers. If you follow the televised: Conspiracy Theory from Jesse Ventra on OLM you realize that the banks manufactured the crisis and profited enormously, no losses could be satisfactorily proven as CCPA senior economist David Macdonald declared.

"That definitely was not the case here: not one bank in Canada was in danger of going bankrupt or required the government to buy an equity stake under taxpayer-funded bailouts"; David Macdonald

This confirms what Jesse Ventura always claimed. (30).

Surprisingly the banks did in their arrogance publicly declare that they made in the first quarter of the year a net profit of over $ 4 Billion and have not to reimburse the government loan. Why should they? Did not the banks (FM) lend to the government the bail-out? Remember the government has no money only a deficit of billions of dollars. Perplexing and confusing to the public?

* From Wikipedia, the free encyclopedia, 2012

The real sufferer in a recession or depression, however, is the common citizen but here our government did not bailout the real losses of job, house an livelihood of the citizen with billions of dollars.

Note: Is the recession not still in progress and it could end in a depression? The indicators are there. I would like to remind that after World War I the signs were exactly the same.

e) *Alex Pattakos to:*
True Freedom:

"We are by nature creatures of habit. Searching for a life that is both predictable and within our comfort zone, we rely on routine and, for the most part, learned thinking patterns. In effect, we create pathways in our minds in much the same way that the path is beaten through a grass field from repeated use. And because these patterns are automatic, we may believe these habitual ways of thinking and behaving to beyond our control. Life, it seems, just happens to us. Not only do we rationalize our responses to life but we also fall prey to forces that limit our potential as human beings. By viewing ourselves as relatively powerless and driven by our instincts, the possibility that we create, or at least cocreate, our own reality becomes difficult to grasp. Instead, we lock our selves inside our own mental prisons. We lose sight of our own natural potential and that of others. (36).

f) Deepak Chopra
"We erect and build a prison, and the tragedy is that we cannot even see the walls of this prison" (37).

g) **Bankruptcy among Canadian seniors rising at alarming rate.**
By Liam Lahey | Insight – *Fri, 6 Jul, 2012 12:47 PM EDT*

"(Seniors' debt) is at a record level … what it's the highest for is the rate of growth."

Canadians over the age of 65 now have the highest insolvency and bankruptcy rates for their age group and seniors are 17 times more likely to become insolvent in 2010 than they were 20 years ago, according to the Vanier Institute's 13th annual "Current State of Canadian Family Finances: 2011—2012 Report."

Note by author: Does the government care? Are old people expendable and should they die as soon as possible so that the healthcare system doesn't has to pay for their high bills anymore? Every one of us will sooner or later be old and be in need of support in one way or another.

You may argue: why did they not safe money in good times for the harder times? What good times? WW II, recession, galloping inflation? Your savings, if you were able to put some dollars aside, are dwindling so fast that you will have nothing of your hard earned savings left anymore.

Retirees are getting caught off guard with unanticipated medical costs and rising food prices, said Spinks, and are finding they don't have enough money saved to make it through.

h) Retirees forced back into workplace*

Retirees are getting caught off guard with unanticipated medical costs and rising food prices, said Spinks, and are finding they don't have enough money saved to make it through.

Bad idea: first they would take away the workplace of younger employee, second they would be lucky to find a job. Why? Seniors are usually too expensive due to their experience.

* *CBC – Wed, 4 Jul, 2012 10:33 AM EDT*
 Aus Bild-Zeitung, Deutschland

i) **USA: Millionen Handydaten gehen an Behörden**
Washington – US-Mobilfunkbetreiber müssen millionenfach Daten, SMS-Nachrichten und Aufenthaltsorte von Mobiltelefon-Besitzern an Ermittler rausrücken. 2011 seien die Firmen insgesamt rund 1,3 Millionen Mal entsprechenden Anforderungen nachgekommen, berichtet die „New York Times". Diese bislang unbekannte Gesamtzahl gehe aus einer Antwort von Unternehmen wie AT&T, Sprint oder T-Online USA auf eine Anfrage des Kongresses hervor. Die Datenherausgabe habe in den vergangenen Jahren deutlich zugenommen. Viele Aufforderungen zur Übermittlung von Namen, Nummern und anderer Privatdaten müssten ohne gerichtliche Verfügung befolgt werden, da die Behörden sie als Notfall deklarieren.

Translation:

USA: millions of cell phone data have to be submitted to the Government
Washington: US- mobile server had to submit millions of data, SMS- messages and locations of mobile cell phone users to the inquisition of the government.
In 2011 the phone servers followed the authorities demand for over **1.3 million** cases according to the "New York Times". The before unknown total number of cases are from the answers received of AT&T, Sprint, T-Online USA upon request of the Congress. The revealed data submitted have significantly increased in the last years. Many demands for revealing names, all kinds of data, numbers, and private information had to be submitted without court order because the government declared all cases as an emergency.*

* Translation by the author

j) Recently (July, 2012) in the News on TV the American Government announced the sale and delivering of American weapons to the Russian Government. But they make us believe that the Russians are our adversary. Which is now the truth, friend or foe?

Reality

- *"Inherited capacity cannot be exceeded, we are born with it; acting foolishly is an act of pride and self-inflicted irresponsibility".*

But:

- *"Friendship is a flame that burns in our hearts forever".*

A Touch of Wisdom

Life is only a short voyage on this planet.
Social harmony brings freedom and
Peace within each human being.
Trust God that you can do his will
and be where you are meant to be.
Forget not the infinite love and
possibilities that are born of faith
and given freely to each of us.
Use those gifts of love that you have
received and pass this on to everyone.
Be content knowing you are a child of God.
Let His presence into your heart and soul
and allow it to grow and become free.
It is there for each and every one of us,
Take it gracefully and be content.*

* Author unknown

Bibliography to Part 1

(1) Mitchell Zuckoff; Lost in Shangri-La.
 ISBN: 978-0-06-198834-9 (Hardcover)
 ISBN: 978-0-06-209358-5
 (International Edition)HarperCollins Publishers,N.Y.

(2) John Perkins: Confessions of an Economic Hitman
 en.wikipedia.org/wiki/Confessions_of_an
 _Economic_Hitman_

(3) The Bible; P2664; #47/52.

(4) Craig Unger: "The Fall of the House of Bush"
 1. Conventional wisdom has it that the Iraq war, the
 Middle East crisis, and the war on terror are all
 products of a clash of ...
 ISBN # 13:978-0-8075-4

 2. "House of Bush, House of Saud"; The Secret
 Relationship between the World's Two Most Powerful
 Dynasties is a 2004 book by Craig Unger that explores
 the relationship ...
 ISBN N# 10:0-7432-875-X,
 Library of Congress Control Number: 20004287.

(5) Julian Assange, WikiLeaks: www.wikileaks.org

(6) Irving Kristol: The Wall Street Journal, January 17.p.64.

(7) The Wall Street Journal, January 17.

(8) Friedrich Schiller in:'Die Worte des Wahns': „The words
 of delusion" and Die Worte des Glaubens: "The words of
 faith".

(9) John Perkins; The Hidden History of the American Empire; www.johnperkins.org ; ISBN No.: 978-0-452-28708-2

(10) Taylor Caldwell, Pg. 425, Dear and glorious Physician

(11) Lynn Olson :"Citizen of London"; Pg. 144; Pg.191 www.lynneolson.com

(12) Janette Kirchmeier, Aigle, CH, Migros Magazine No. 50, December 13,2010. « Fair le mal pour le mal »

(13) **THE CANADIAN PRESS** Vanier Institute, 2011

(14) Horace Walpole, in a letter to Anne, Countess of Upper Dossory,1776.

(15) Urantia Book* ; ISBN 0-521-86479-8; the book is 40,92,95,101 available in many Languages 103,139,143,147,148

(16) The Oprah Magazine, Breakthroughs!, October 2011, Vol. 12, Nr. 10: "What I Know for Sure"; www.Opra.com

(17) Robert Reich: "The Work of Nations, Preparing Ourselves For 21st Century Capitalism".

(18) Norman Mailer

(19) *"Soylent Green"*, From Wikipedia, *2011.*

(20) From Wikipedia.com 2011

(21) By Charles Riley @CNNMone.com- December 7, 2011: 10:49 AM ET

* Urantia Foundation in Chicago; URANTIA BOOK; urantiabook.org

(22) By Jeanne Sahadi | CNNMoney.com – Wed, Dec 7, 2011 1:05 PM EST

(23) Si vis pacem, para bellum :From Wikipedia, the free Encyclopedia; see also under: *14. Quote and Quotable*

(24) "Nature of Things": CBCMO from 1ˢᵗ of December 2011, 6:00-7:00pm (PT) by David Suzuki and CBCMO from 1ˢᵗ of December 2011, 6:00-7:00pm (PT) by David Suzuki.

(25) A border crossing incidence. December, 2011. From Yahoo.ca;

(26) From Yahoo internet press release 2012.

(27) Ibid.

(28) From the Internet 2011: compact TV: "Wer regiert uns?"; (Who is governing us?").

Original Text: "Diejenigen die entscheiden sind nicht gewählt und Diejenigen die gewählt werden haben nichts zu entscheiden". Zu dieser Aussage kommt der Ministerpräsident von Bayern und CSU-Vorsitzenden Horst Seehofer. *Sind unsere gewählten Volksvertreter nur die Marionetten von „Schattenmännern"?**

(29) Deepak Chopra, *Unconditional Life: "Discovering the Power to Fulfill Your Dreams"(New York: Bantam Books, 1991).*

(30) Jesse Ventura, The Conspiracy Theory, OLN June 11,2011and : 2012 Apocalypse 2/6 Video
1. Pindz's video about Jesse Ventura Conspiracy Theory

*　From the Internet 2011: compact.TV: Wer regiert uns? (Who governs us?)

2012 Apocalypse documentary on Disclose.tv
www.disclose.tv/action/viewvideo/37137/J__Ventura_
Conspiracy...

2. Wall street conspiracy; Institutional corruption that
 brought the economy to its knees. Greed is the game;
 OLN April 27/2012. 10 to 11 pm MST. The power of
 Goldman&Sachs and AIG revealed.

(31) Joyce Carol Oates, author: "A widow's story", A memoir;
 Page 14. Harper Collins Publishers; N.Y.
 ISBN 978-0-06-201553-2

(32) Simon Peter Bargetzi: In Search of "Truth, Beauty and
 Goodness"; AuthorHouse™ Publishing;
 ISBN: 978-1-4634-3380-2(sc) and
 ISBN: 978-1-4634-3379-6 (ebk)

(33) Noam Chomsky: "The Prosperous Few and the Restless
 Many" 1993; Pg. 67.

(34) Michael Lind: "The Next American Nation"; Pg. 312.

(35) Charles Scheideman: "Policing the Fringe";
 ISBN: 1-4251-6573-4; Harbour Publishing
 www.harbourpublishing.com/title/PolicingtheFringe.

(36) Alex Pattakos: "Prisoners of our Thoughts"; Page 3, 2010,
 ISBN 978-1-60509-524-0, Berrett-Koehler Publishers,
 Inc.

(37) Deepak Chopra, Unconditional Life:"Discovering the
 Power To Fulfill Your Dreams", New York Bantam Books,
 1991.

(38) Robert Bolt, "A man for all seasons"; page xi: preface. Heinemann Educational books LTD, London; SBN 435 22100 0; 1968.

(39) Christfried Coler: Ullstein Weltgeschichte; Daten, Stichwörter, Bilder, 1740 bis 1913; Band IV

Books you should read

(1) *"In Search of Truth, Beauty and Goodness" by:*
 Simon P. Bargetzi, Authorhouse Publishers
 ISBN: 978-1-46334-3380-2 (sc)
 ISBN: 978-1-4634-3379-6 (ebk)

 Book Sales Operations
 AuthorHouse
 1663 Liberty Drive
 Bloomington, IN 47403
 United States
 812-339-6000 x5023

(2) *"The Fall of the House of Bush" by :*Craig Unger
 1. Conventional wisdom has it that the Iraq war, the
 Middle East crisis, and the war on terror are all
 products of a clash of ...
 ISBN # 13:978-0-8075-4

 2. House of Bush, House of Saud"; The Secret
 Relationship between the World's Two Most Powerful
 Dynasties is a 2004; book by Craig Unger that
 explores the relationship ...
 ISBN N# 10:0-7432-875-X,
 Library of Congress Control Number: 20004287.

(3) *"The Prosperous Few and the Restless Many"*: 1993, by
 Noam Chomsky

(4) *"The Next American Nation"* by: Michael Lind

(5) *"The Work of Nations: Preparing Ourselves for 21stCentury*
 Capitalism" by: Robert Reich

Part 2:

The Environment

Realities, Interpretations, Hypocrisy and Protection

Like Ironwood we have to become:
'Weather resistant and strong to be able to survive;
intertwined and like our life, hardened by time
and environment, but hard to be molded.

by
James Burk

0. Table of Contents: Part 2

1. Introduction

We are living in world full of mystery, challenges and possibilities. Understanding the universe is a gigantic challenge for the scientist and almost insurmountable for the rest of mankind. With all our technology we cannot grasp even a fraction of the whole. The immeasurable cosmos will probably stay forever out of reach for us. How mind-boggling are the distances between each solar system, involving millions of light-years. If our technology could one day enable us to reach the speed of light it would still be impossible to travel, via manned spacecraft, from one system to another in a single lifetime. We would like to be able to go beyond our immediate sphere, but we are probably destined to stay for one lifetime in one solar system. If there were a possibility of humans reaching another solar system, it wouldn't be the same individuals who began the trip. Whole lifetimes would be spent in transit. With telescopes, robots and other technical innovations we will be able one day to discover many unknown cosmic realities. Sending satellites equipped with strong telescopes into space revealed clearly to us the immensity of the cosmos. It seems, to our understanding, that the cosmos has no beginning and no end. But I am convinced that the universe is an all-encompassing unit with an expanding outer sphere (universe expansion in time and space). Our scientists have already discovered other universe systems of gigantic dimensions and they will continue in the future to discover wonders that remain for now unexplainable phenomena.

What significance does our planet earth have in the vastness of the cosmos? We are barely visible on the universal, or cosmic, scale if at all. We are a tiny point in the Milky Way. What does that mean for us?

Our planet plays a diminutive role in the balance of our own solar system. In relation to the cosmos, the earth probably has no particular importance at all. But many humans believe Earth to be the *Centrum* of the universe. Without knowledge of what's out there, we can indulge in such self-aggrandizement.

The sun provides us with not only light, heat and magnetic balance, but also with the energy of existence. She is the life giver for our planet. Without the sun life would be nonexistent; the earth a dead planet. Everything goes in cycles and renews life-giving energy, making the planets go around the sun. We are accompanied by other planets in our solar system: Mars, Jupiter, Venus, Uranus, Mercury, Neptune and Saturn. Earth has one moon, others have none or several. But all are kept in balance with each other. We, Earth and its human inhabitants, contribute nothing to the balance of that energy system.

On our planet the human being has exploited, taken advantage and profited, from nature and its resources. Earth provides sustenance for our survival, renews the sources, fosters reproduction, and goes on entertaining humanity as part of nature. Nature, with her plants and animals, mineral resources, and life-necessity, water, is there for us. Without air, water, sun, food supply, and yes, gravity, we could not exist. How we use or abuse the sources of our survival, with cautious stewardship or with improvident carelessness, is up to us.

We know generally, from school, how our planet evolved. The earth was a burning planet, (ejected from the sun) full of volcanic eruptions with enormous ash clouds covering its greater part. In this harsh and apparently uninhabitable atmosphere, life began to develop over millions upon millions of years, first in the form of flora and then fauna, and we enjoy the benefits today. Plants depended on CO_2, different minerals and the necessary elements and started to grow providing oxygen and food for the fauna. Nature as we perceive it today evolved. We know, however, that

there is more than just CO_2 needed for the development of our planet and its natural endowments. We don't need to go further into the process and the details of development for how our planet achieved its current level here. There are good scientific books available.

Much later in time, around 5 million years ago, the human species, our ancestors, evolved and began to proliferate and flourish. We have developed since then into the modern human race. We improved our life conditions, developed our brain and intelligence, and enjoyed the fruits of hard labor over time. We have reached a point where we should step back and contemplate our goals for future development and determine what we should do with our lives, with our attitudes and with our environment. We created many challenges; some may call them problems, which could at least disturb our planet or possibly damage its natural systems irreparably. Is humanity consciously aware that we could destroy our chance of survival in that natural environment? Have we gone carelessly ahead so far that we have caused irreparable damages to our planet already?

Our scientists should think twice before they make the statement that global warming is caused only by humans. It is a fact that we created heat sinks in cities due to concrete, glass surfaces and asphalt streets and parking areas as well as concentrated pollution. Cites therefore are generally a few degrees warmer than rural areas. Also, cities have increased in size, population and activity. The pollution of fossil-fuel burning machines: cars, trucks and all installations of commerce and industry that use fossil fuel energy, have contributed to local warming. But the claim that it alone has a significant influence globally is farfetched. It is neither proven nor possible to prove. Just by calculating the world's total surface we have to accept that up to 75% is covered by water or untouched nature. That area has the potential to more than compensate for our increased heat

creation in cities. We alone are therefore not the cause of global warming. Putting a guilt trip on the citizen does not work here. There are much greater powers at work.

The world travels through cycles over eons. That's a cosmic law of physics. Two million years ago the first North American glacier started its southern advance. The ice age was now in the making, and this glacier consumed nearly one million years in its advance from and retreat back toward its northern pressure centers. The central ice sheet extended south as far as Kansas; the eastern and western ice centers were not so extensive.*

The first two ice invasions were not extensive in Eurasia, but during these early epochs of the ice age, North America was overrun with mastodon, woolly mammoths, the earliest horses, camels, deer, musk oxen, bison, ground sloth, giant beaver, saber-toothed tigers, sloth as large as elephants, and many groups of the cat and dog families. But from this time forward they were rapidly reduced in numbers by the increasing cold of the glacial period. Toward the close of the ice age the majority of these animal species were extinct in North America.**

250,000 years ago the sixth and last glaciation began. And despite the fact that the northern highlands had begun to sink slightly, this was the period of greatest snow deposition on the northern ice fields.***

100,000 years ago, during the retreat of the last glacier, the vast polar ice sheets began to form and the center of ice accumulation moved considerably northward. And as long as the Polar Regions continue to be covered with ice, it is hardly possible for another glacial age to occur, regardless of future land elevations or modification of ocean currents.****

* (1) from UB. P.699 - §6.
** (1) from UB: P.699 - §8 & P.700 - §0
*** (1) from UB, P.702 - §8
**** (1) from UB, P. P.701 - §5

35,000 years ago marks the termination of the great ice age except for the polar regions of the planet. This date is also significant in that it roughly corresponds to the beginning of the Holocene or postglacial period.* Since then we have had an increasing warming trend on our planet due to these cosmic cycles. We may contribute to the warming of the planet but it will always be locally, not globally. We would not be able to change these phenomena anyway. The natural forces are much stronger than our influences. The only possibility of our causing such change would be annihilation of the planet by a nuclear Holocaust. Do we want that?

The receding of the ice masses was already significant when we first began keeping records of our glaciers in the late 1800's. Each year the ice was retreating even before human pollution began. Except for wood and coal burning, the other forms of human pollution, the use of fossil fuels in cars, industry and commerce, began developing later. We know that the sheets of ice, the glaciers, have moved back at a constant rate over in the last 200 years. They did that without the influence of the so called 'hole' in the ozone layer.

By the way, how can a hole be created in an air mass without using either a huge constant influence or technical installation? As in water, the hole would close immediately. A hole is therefore not likely. That the density of the ozone layer can be thinned is not questioned here. Why this occurs at the poles specifically has yet to be scientifically explained. Could it have to do with the magnetic polar influences? It is true that gases like Freon (Chlorofluorocarbon), used in applications such as fridges, freezers, air-conditioners, and spray cans and bottles (and to a certain degree enormous air traffic) does cause damage to the ozone layer. To what degree is still unclear and not satisfactorily proven by science.

* (1) from UB, P.702 - §8

We react to the laid-upon-us guilt trip and try to save animal and plant species from extinction. But nature changes species every day. Some evolve and others disappear. Our efforts are short lived and in vain. We are not, and cannot be, stronger than nature's law.

Environmentalists' claim that the global warming trend, and its accompanying ice melt, has speeded up since the Industrial revolution, which is actually when our extreme dependency on fossil fuels began. That the air quality decreased from the thoughtless exploitation of natural resources, both renewable and none renewable, is indisputable. Could the normal process of nature and our environmental influence cumulatively speed up the normal process of nature's plan? As said before, we probably have only a marginal influence on the natural process, but we do influence the environment and our quality of life. Employing alternative methods and using renewable sources, such as sun, water, and wind, will curb our negative influence positively in the near future. We know that the natural non-renewable resources like oil and coal are depleting fast and will need to be replaced with other sources or technology. There is, however, a difference between blaming the individuals of the earth and establishing immoral corporate fault (except that corporations, of course, can't be called immoral or greedy because they have no conscience), in their thoughtless exploitation of natural resources, both renewable and none renewable. Taking responsibility for our actions is paramount. We have to act as future-oriented humans and take measures to improve technologies and to use alternative methods. It is up to us to ensure that corporations do so as well.

Besides the challenges of air pollution from burning fossil fuels, we have to deal with our own mental and physical trials. Our physical, mental and emotional environments are as important as our natural and technical environments. They all must be

in harmony, in balance. Without well-attuned synchronization amongst the environments the system cannot work. Unfortunately, governments and their experts tend to deal with the challenges piecemeal, as they become important to re-election. Immediate, total and thoughtful reviews and analyses are vital. Protection measures adopted must be effective to accomplish visualized standards over short, intermediate and long periods of time. Our wellbeing depends on both factors: a healthy environment and a healthy body and psyche.

2. Realities

2.0 Present State of Interaction

Over the last few centuries humans have enjoyed the use of natural resources as never before. Just the discovery of crude oil opened up a wide range of applications. Other significant discoveries were made that helped us in the technical sector of development, and improved our lives. Humans tend to constantly strive to make our lives easier. This tendency has had, and will continue to have, unforeseeable consequences.

We have an inherent tendency to overdo everything. Our unsatisfied craving, a strong force, for material possessions can lead to excessive abuse. Humans have developed into beings who think we need everything today as though there could be no tomorrow. This attitude leads to excessive waste and dangerous loss of regard for our planet's limited resources. It has escalated to the point that we tend not to care anymore. Greed and insatiable thirst for a luxury lifestyle has become the guiding factor. Our lives have only a short span and apparently must be lived to the fullest. That's the source of, and reason for, our impatience and irrationality. We have nothing else to hang on to, because faith and religion are not in fashion anymore. Wealth, power and greed are the main driving forces. To reach that goal is paramount and precludes respect both life and resources. We live our lives like robots, without distinguishing between good and bad. Have we really fallen that badly off the social scale? Do we have a chance to turn the wheel around and become respectful and sensible humans again, with ethics and compassion? Have we gone so far already that no return to a normal life is possible? What are we teaching our youth and why are we complaining if our offspring

are not listening to us anymore? Have we lost our moorings and the values of responsible citizens in society? Think about that seriously. Have we become a wasteful society of physical and mental abusers without respect for anything?

We are at the point at which only sensitive, intelligent and realistic people comprehend that this attitude cannot go on. It is essential that something be done. The resources of nature in the form we know them today will dry up in an unspecified, but short timeframe. According to current experts, environmental damage will soon reach the limits of sustainability and livability.

Our planet's inner magma is approximately 6 to 12 km under the landmass surface. Earth's center, according to experts, is surrounded by magma with enormous heat of several thousand degrees. Positioned in the center of an indestructible gigantic ball which is impervious to the heat, it builds the center of gravity and in this way, with the rotation of the earth, the magma creates the magnetic fields.

The signs are apparently there that the magnetic poles are shifting, reversing positions. The resultant dynamo effect could turn the earth's poles around. The theory, according to current science, is that the result will be the South Pole becoming the North Pole. Will the world turn upside down? Will the sun rise in the west instead of in the east? Could such a situation create a massive danger for humans, fauna and flora much greater than that of our air, water and land pollution? The real consequences are still unknown. What possible changes to fauna and flora could occur in the event that the poles reversed? Would migrating animals like birds, turtles, salmon, and herbivores find their way during migration? Or could that be the end of their existence? As far as science knows and declares, migratory animals might orientate their migration routes through magnetic fields emitted from the center of the earth. Or, do they orient themselves with their senses of sight and smell to find their place of birth and

recreation? Exactly how they perform their migration is still vague. What would happen in a worst scenario with our food chain, so necessary for survival? Does it indicate that the earth is turning toward the next ice age? As far as we know and can count, our planet has gone through 5 ice ages, roughly one every 500,000 years. It takes about 200,000 to 250,000 years to turn a cycle from drought to ice-age around. If we are now at the warming stage we have not yet reached the point of becoming colder again. We will probably encounter more droughts and heat waves that cause the weather to be adverse, even disastrous. Torrential rains could plague on one side of the globe and drought on the other. That's inevitable. The ice at the poles will melt to a determined degree and cause environmental challenges for the fauna and for human habitation at sea level. The ice poles, however, will never totally disappear.

Just a one meter rise in current sea levels will create a real challenge for many port cities. Is our air pollution to blame for this? *No.* It is more likely that nature has acted according to the program of the cosmos and we have nothing to say or do about it. Far more important for us is governmental pro-action; what will we do about rising sea levels? Shouldn't we be seeking advice from such places as the Netherlands, which have dealt with at least some sea-level problems? Rather than laying blame, would we not be wiser to start dealing with the coming problem?

Would we have a possibility of surviving by creating and eating artificial food? Could we do something to prevent possible changes in the balance of our planet? It is not likely that we have anything to contribute to such an event. Does it mean collapse of nature's physical laws as we know them? Some science claims to know that the change in polarity could have positive effects for the whole world. The real answers can be found only in the plan of creation and in our future, which we humans have no part in determining. Apparently the shifting of the poles did

already taken place. Nothing is officially available in regards to reversing polarities that might have happened in the past. Only the future can show us what will really happen. Our scientists can speculate about it but should deal primarily with the current realities of our environmental problems, those that could have significant influence, and elaborate what we should do. Compared with the change of polarity and its possible consequences, our environmental pollution plays only a marginal role. Environmental pollution acts more as a fragmented local issue than as a global problem. If we could destroy our planet we would have done so already. We often act without considering the consequences. Are we able to destroy our existence, our planet? Yes we could, but only with a nuclear holocaust or by chemical warfare and destruction of life on earth.

Have we taken our pollution to the point that nature is incapable of recovering its balance of air, water and land? We know that our planet is covered by a water mass of up to over 75% of the earth's surface. Adding to these water areas, the forest, the agricultural land and all areas capable of transforming CO_2 (Carbon Dioxide), into oxygen, as well as the detoxification abilities of poisons (acid rain); this presents a great potential of transforming toxics into harmless pollution. The oceans, lakes and rivers are nearly as good as the forest in transforming CO_2 into oxygen. Also, the impact of volcanic eruptions affects development of nature over time, because the $CO2$ was needed for the development of the fauna and flora and evolution as it is today.

We have *locally* polluted our environment to the point of a real health hazard. Needless to say many elderly and less healthy citizens suffer or even die due to air quality and poisoning. That is our fault, creating gigantic smog clouds like a clog over the cities. It is caused mainly by cars, machines, industry and other fuel burning (oil, coal) installations. Without wind currents the pollution stays local and accumulates to possibly fatal amounts.

The so-called *'bell effect'* is visible. Whole cities are covered in a dirty cloud of exhaust fumes. Only a small wind current can, however, change the density of the pollution significantly. The polluted air is then transported to water or land and forests and can be cleansed into oxygen needed for survival. Globally, pollution can be managed by nature even when some scientists claim that it produces irreparable damage. Sure we create not only CO and CO2 with the burning and using of fossil and other fuels. Toxins like NO_x, NO_2, etc. are entering our atmosphere and as acid rain are contaminating water and land.

We don't want to go into details about the chemical formulas and toxic agents. We don't need that for our understanding and it would contribute nothing to our comprehension. But nevertheless, these air born poisons are more serious pollution to our environment than some will admit. Acid rains enter into water and soil, contaminating and damaging the elements. Their ill effects could last a long time. We will have to pay the price for their damage. Do these contaminants create irreparable damage to nature, or can nature deal with it over time? Will we, at the top of the food chain, have to pay the ultimate price? Severe health problems to humans and animals could also become a threat.

Is pollution mostly locally significant or has it global consequences? Global detrimental pollution is believed questionable by renowned scientists. They say it is foremost a question of source management. Reduction in emissions reduces the potential danger. The measures of pollution reduction should get priority where the real polluters are concerned. We have a tendency to go after the small individual polluters, each citizen, instead of dealing with the big polluters. But politically it is much simpler to convince the individual small polluter than to go after politically influential industry. We should not put all our efforts into one basket. The measures to be taken should be valid and mandatory for all polluters equally. The degree of reduction

measures has to be justified and sensible. Overzealousness could cause the opposite effect. As with everything in life we have to become the guardians of moderation. Reducing the pollution to zero sounds good but it is neither sensible nor feasible. Any action calls for a reaction. Pollution will always be with us. Are activities aimed at stopping our industrial world from indiscriminate pollution as impossible as stopping volcanoes from erupting? Just contemplate what preventing all pollution would do to the employment pool? As long as we have not developed feasible alternative energy options we have to live with a certain degree of pollution. Opinions are divided about where and how low to set the limits to be acceptable. Science would like to go towards zero, other rationales speak against it. Most of the set limits in our daily dealings are arbitrary and not based solely on scientific facts and essential requirements. We still have a long way to go. Finding a middle ground is a challenge for everybody. But in the meantime we must, primarily, work toward reducing our desires, not our needs, which are the major cause of negative environmental influences. We need to become more efficient in the use of polluting items such as cars, overheating of homes and commercial and industrial facilities, reducing unnecessary air travel, being frugal in all our actions and always aware of possible consequences of our actions. With cyber installations such as the internet we can reduce our air and ground traffic significantly. We can do our business dealing today via internet and don't need to take an air flight to close a deal. The positive impact on pollution and burden to the air and especially in the stratosphere is enormous. That makes sense and is the only sensible solution that requires minimal effort and has the envisioned effect.

Politicians introduced taxes to fight pollution and the results are barely discernible. Why? We can afford all our luxuries and don't even care if the government gets a share of the spoils. The Government is not always using the taxes it collects to improve the

environment. The money goes into general revenue and vanishes (not earmarked). We blame the big oil industries that they gouge the public excessively but in reality the government takes over 53% of gasoline prices as tax. It charges us with additional road, environmental and improvement taxes as well. Governmental administrations find new possibilities for grabbing money out of the pockets of the taxpayers every day. New laws, rules and regulations are invented under the supposedly to protect citizens from harm and pollution. This is pathetic. How could our ancestors have survived without the jungle of restrictions? In defense of the politicians and administrations, it could be claimed that it actually was the ignorant citizen who asked for such measures in the first place. Wouldn't that be the incompetent and irresponsible citizenry that doesn't take accountability for its own actions? And don't the authorities listen to the wheel that squeals the most, without considering the wisdom of the request? In our society we are at the point of acting senselessly and incompetently. We burden our lives with more and more restrictions and our so beloved freedom is gone with the wind. What makes people turn away from freedom? And how can we turn them back to it so firmly that they will never consent to be enslaved again? Nearly all people are afraid of responsibility. A small percentage of mankind reacts to that fear by aggression, that is, they use their fear of responsibility to face it, overcome it, and succeed in channeling it into what used to be called personal success. Our outstanding men of science and arts and in business are examples. A less virtuous percentage becomes famous, or infamous, criminals. The rest of the ordinary population are hounded and distressed by a nebulous but no less frantic dread of responsibility. They instinctively aim to evade it. Change, it seems, is harder to accept the older you get.

Supposedly we could teach humans to fear and hate slavery more than they fear and hate responsibility. If mankind does

not soon come of age, humanity is doomed and will die. It will die a terrible death in desperation and will fall into oblivion. It will destroy itself with all its irresponsible actions and resultant waste of our valuable and limited resources. We have to take the necessary steps into our hands, use fossil fuels more frugally and imagine, for the future, alternative solutions.

The Club of Rome claimed in 1973 that we would eventually run out of our natural resources and what did we do? We went on using our resources as if there would be no tomorrow. It is pathetic how we misuse our resources. Will we end up living like robots, like zombies manipulated without choice? The lawmakers and politicians can and will do that. Robots obey any command. That's exactly their goal, what they are created to do. Why would any government wish to deal with dissident citizens if it can manipulate them to its liking without opposition? Politicians do try to set that stage of total control. Does it not say: *'we will make laws that nobody can abide by.'* The awakening will be the more painful; just believe that. Who do we blame after the disaster? Certainly we don't blame ourselves, do we? Without question we are the culprits. But then it is too late. Can we allow this to happen to our children's future?

2.1 Environmental Attitude

Does it make sense to regard environmental problems globally or should we concentrate our anti-pollution strategies for locally important impacts? Are we even prepared to commence being responsible?

We cause many actual problems with our attitude and behavior. We have a wasteful ignorance that is based mainly on instant self-gratification. The craving to be important, to have everything, to waste and destroy so many things, is caused by

ignorance, apathy, unawareness and the lack of inner contentment. A fatalistic attitude dominates us. Are people not even caring anymore? With such an attitude the environment will, even with all the warnings from scientists, become, locally at least, a real hazard.

Oil became the principal commodity of our modern time. Oil use is practiced in all ways in our lives. This energy source is a valuable item for practical usage toward the amelioration of our existence. But we know that it is a limited resource and is not renewable. Why do we not use it sparingly? For example, cars brought us speed and comfort in mobility that was unknown to humans previously. But, life has developed into a hectic lifestyle. We feel pushed the end of our capacities. The mental and physical breakdown of many fellow humans is a fact.

Our faster work habits demanded more and more efforts to reach the set goals of progress. Self-imposed stress escalated to the breaking point. Increasing workplace absenteeism from overstressed workers and management is proof of that. People become increasingly incompetent, fail in their workplaces and are in need of help. These are consequences of our fast working and living pace. Increasingly, institutions dealing with stress management open their doors to help. These institutions could tell you a long and interesting but realistic story. The damage to our economy and ecology is significant. The populace is become increasingly confused, irritated and apprehensive. It is a sign of our times. We seem to have lost our moorings and our ability to think for ourselves.

When questioned on the street, people don't even really know why they are in such a hurry. They tend to say that everybody else does it and keeping up is mandatory. We could call it the 'rat race syndrome'. Just observe the aggressive and very dangerous driving on our streets. It is inconceivable that people can act so irresponsibly.

Speaking of such phenomena, there exists an experiment with rodents which used a modified environment. The idea was to acquire knowledge of the critical number of population density at which animals would lose their capability of living in harmony. Scientists started out with a couple of mice, provided them adequate space and food and other necessary requirements for survival. The same space and food needed was added as the population increased by natural reproduction. The surprising result was that after reaching a critical mass, still with adequate space, food and peaceful environment, something triggered a mass suicide. The experiment was repeated and the results were practically the same. After reaching the critical point of around 78,000 animals the suicide began. It did not level the population out to a presumably acceptable number, no; they destroyed themselves to the last. And this happened each time, with the same patterns, in repeated experiments. Can we draw conclusions from this? Does it explain a critical mass reaction? Or is it by chance that in every case, peace loving animals reached a critical mass and a negative energy force occurred? And why did it happen at a particular population density and in the same time frame? Would we humans behave in a similar pattern after we reached a gloomy critical number? Science is still looking for those answers.

Judging by the numbers of wars there are in history, it would appear that we go through similar patterns. A lot speaks for that behavior. We pollute our environment with emissions not only from fossil fuel use, but also from the physical and emotional poisoning of each other, as the world becomes more crowded and the space more restricted. We step on each other's toes and we make life for each other difficult. Our personal space in the city becomes congested and we exhibit claustrophobic reactions. Additional to that, there exists between the rich and poor a gap that causes friction and we lose compassion or respect for

each other with each person living only for himself. This really happens; everybody can observe it.

With the luxurious lifestyle of the industrial world, and increasingly in the less developed world, it is inevitable that waste of all sorts is created. The world has difficulty dealing with all the garbage. And there is no end in sight. The good intentions of the individual are becoming a painful experience because the major part of the population does not even care.

How do the 3rd world countries with dictatorships deal with waste? In these places, you find garbage decaying all over the streets. The dictators have neither the will nor the intention to solve the problem. Why do the citizens not solve this problem themselves? Environmentally there is practically nothing done to reduce the pollution. Not a beautiful site. The African and partially the South-American continents with poor nations are a prime example. They apparently do not even care. This is definitely a tough task to solve. Other rather small countries deal much better with the problem but do not reduce the production of waste in the first place.

On the other side of the coin, humanity has a tendency to exaggerate and is going overboard with rules and regulations to reduce the impact. The contribution that individuals make appears to be in vain when compared to the global effort needed. At least their measures bring them local relieve from pollution. Basically they should start with themselves, practicing frugal usage of only necessary items so as to reduce the amount of garbage.

Pollution from commerce and industry in manufacturing nations is still visible and high. Measures to reduce air, water and land pollution are difficult and very expensive to carry out. Can we afford to spend the amount of money necessary to drastically reduce manufacturing emissions, or must we sacrifice environmental quality? Some political discussions are under way.

The USA tries to convince China to drastically reduce its toxic waste. On the other hand the USA did not join in the efforts and recommendations of the Kyoto Accord. Note that the resolutions taken have not shown the expected results. Why? Simply because only a few nations took it seriously. Also, the resolution does not really deal with the most pertinent challenges because the big and strong industries and nations find a way to get off the hook. Nations with high pollution can buy 'vouchers' from other nations with undeveloped, large, unpolluted land regions. So it is no surprise that the US used that excuse. Cleaning our own doorstep is not always very pleasant. Politics and the industrial might hinder and prevent the introduction of necessary measures to ameliorate the environmental situation. Is might always right? It is much easier and convenient to burden the individual citizen with the cost of environmental protection. Politicians count on people who still have a sense of reason and responsibility toward survival and who are prepared to contribute. But, this does not mean that the politicians should ignore the big polluters. They must be held accountable as well. In the end, it is the consumers who pay the bills for all goods produced as well as for the measures for pollution reduction. Why did all these rules and regulations not show positive effects? Simply, because it is not done in unison and not coordinated with the same restrictions for everybody. The political statement that measures for a reduction in pollution would cause loss of employment is just plain scare tactics. By reducing our desire to have everything, and eschewing the idea that riches are admirable, we make it possible to be moderate. The spirit of the individual must be coordinated with communal, national and international strength. We can reduce the need of the worker for a second job by reducing our wants, by being content with less. Only the unnecessary wants, not the needs, have to be eliminated.

With all the intelligence out there solutions can always be found that benefit the cause. Environmental measures call for additional workplaces, new inventions and new installations. That cannot be done without adding room to the employment contingent. The costs have to be offset to the goods produced. We senselessly consume unnecessary goods or buy and waste gadgets, and then object to having to spend a few dollars more per item. As we consume less, our expenditures are lowered as well. This works only if people are prepared to share their workplaces and incomes to the benefit of the whole.

We blame the industry for supplying all that double and triple packaging which is made mostly of paper, plastic or aluminum. It's always an easy way out to blame the other, the producer. In reality, is it not the customer who demands that packaging for food or other items will preserve the items fresh or protected from damage longer? Changes in workplace and home, and the service provided in the superstores, have altered our habits and made it difficult to shop for items that are not already pre-cooked or prepared for fast consumption and are in multi packaging. Most of us seldom feel we have time to spend in the kitchen preparing our food from scratch. Most fridges are filled with unhealthy or pre-cooked food items. No wonder our youth and adults are overweight and are a burden to our healthcare. Just reading the ingredients on the packaging for preservative and chemical additives can make us sick. Certainly not all additives are unhealthy. Bio-food is today the buzz word but in reality we have already reached the point at which we are incapable of producing 100% bio-food. Contaminants found in soil, water and air have reached the point of toxicity at which pure bio, or organic, food is not possible anymore. Producing food under artificial conditions, in airtight decontaminated soil, defies logic.

The cycle goes on and we teach our children this foolish attitude toward consumption of food. The older generation can

still remember that during and after WW II, food items were purchased and carried home in milk churns, jars, bags, or cans. No other packaging was necessary and no garbage resulted. To keep the food items fresh longer they had neither fridges nor freezers. They used much less energy and utilized a different method of preservation, like smoking, natural dehydration and storage in earthen cellars. They used methods that are no longer known. Yet the food was mainly healthy and nutritious. Our parents and grandparents cooked food from scratch. That was a form of food consumption that did not result in tons of garbage. Food items that were not consumed or left over were fed to the animals or composted to enrich the soil. Today we send all these items to waste deposals. Previously we had bio-food out of our own gardens or supplied by local sources. Today, our food is chemically altered or is 'modernized' and is often grown in chemically treated water, hydroponically, or in treated earth, fertilized by concentrated and unhealthy chemicals. The resulting agents in food today disagree with many allergy-sensitive persons. Our children's allergies are increasing manifold. No wonder. Food allergy reactions are becoming more common. We compensate for allergies with chemical medications which could again create digestive problems or other negative reactions that burden our systems. This creates a terrible cycle. However, fridge and freezer are now part of our lifestyle and hard to be without, maybe even impossible. Why do we think we must eat food that is produced thousands of miles away? Why are items like yoghurt now advertised according to what nutrients *aren't* in them, as in 0% fats? See chapter D. *Food Additives, page 312* for more information.

Certainly today we cannot all use the same old methods anymore. We have changed our way of living so much that it has become impossible to do so. We are also not prepared to change our present ways. What we could do, however, is refuse to take

double and triple packaging where it is not needed. We could eat less and choose unaltered food items that will not be detrimental to our health and we would be less in a bind of obesity. The end effect is that we would create less unnecessary waste, (78% of produced food is not consumed and goes to waste according to a German source), reduce costs, improve our own health and, as a bonus, considerably reduce our landfills. As well, there would be more for shared human consumption.

The mounds of garbage produced during the holiday seasons are colossal. But during normal weekdays of the year they are not much smaller. The accumulation of our society's discarded items in landfills and garbage disposal places is unbelievable, and there is no end in sight. Cities and towns that have experienced just one week without garbage collection must deal with enormous piles of it. Rats and diseases follow almost immediately, and the air reeks.

It does not seem to enter the mind of the citizen to create less garbage. It is the problem of the government, not ours, right? By thinking clearly we should ask the question: who is actually the government? We know the answer. How convenient to offset everything to somebody else. The government is an ideal scapegoat. That attitude lies in everything we demand from the government. Yet we find no end to our expectations. But if we expect more services, we also must accept more restrictions and laws. We can't complain if we have to pay for those services or if our freedom or our money are restricted. In a way, we are hypocrites in our behavior. Maybe lots of our fellows disagree but did they ever look at themselves in the mirror? There is a saying that: 'Inherited capacity cannot be exceeded, we are born with it. However, acting foolishly or being feeble-minded is an act of pride and is a self-inflicted and self-induced state of mind and demonstrates irresponsibility'. Ignorance is not bliss; it is plainly the lazy way of circumventing responsibility. We must

take responsibility in society and contribute to its wellbeing. Only together can we overcome difficulties and solve our challenges. Each person must contribute to our obligations no matter how big or small. In numbers is power and together things can be accomplished.

Further, do all the toys for children have to be in such attractive packaging? Kids tend to disregard the packaging and concentrate on the item received anyway. It is we adults who respond to that 'beautiful' packaging too much. In choosing to purchase over-packaged or especially attractively packaged items, we create in our children a cycle of indifference to the resulting garbage. It becomes the norm. The result is that they do not even appreciate the effort to become more moderate and sensible toward the environment. That is our own doing. Nobody else can be blamed for that. Certainly we cannot blame industry or commerce alone; they provide that which we demand and will purchase.

Observing in Google our planet's night sky, with all the lights marking the cities, we can grasp the waste of electrical energy. With infrared cameras during the colder season and especially at night we can observe the heat loss and waste of energy resources. At ground level we can observe the lights of cities from far away in the country. The sky is totally illuminated. Do we really need so much light in our cities, in our environment? We call for the luxuries electricity makes possible, and we view light as necessary to our safety in the streets. We might ask each other, *"What are we doing using our streets after dark in the first place?"* We are becoming as much night persons as day operators. Our forefathers used the dark for its designed purpose, rest. Our hectic work-life-style made us night persons. But at the same time we object to the building of more power plants. We wouldn't need them in the first place if we were more energy-conservation minded. Do we really think we can't live without the overabundance of power that light up the night sky?

Our lifestyle has changed from just daytime labor to 24 hours of activity. We want to enjoy the luxury of day in nighttime conditions. But we have to make the choice between lavishness or the possibility that power resources will run out and force us to be satisfied with less.

What if we soon run out of electrical energy supply due to the stopping of nuclear power plant construction or the continuing waste of energy? Do we have alternative means or do we wait and deal with the problem when it arrives? What about our children's future? Again, do we care what happens to them, or do we use the so called 'Ostrich defense mechanism' putting our heads in the sand? Awakening to reality will be the more painful if we do.

Don't believe that we will eventually find alternative energy sources that can be as easily abused. Definitely, there are known alternative electrical power producing possibilities but before we invest in such alternative options we should be more frugal in using our existing resources. We should actively engage in both at the same time.

2.2 Development and Alternatives

We have developed alternatives to the use of fossil fuels, renewable energy technologies such as accessing energy from the sun, the wind, the waters and other natural sources. Unfortunately, these new technologies are still in their infancy.

Only 30 to 34% efficiency is gained currently from solar systems. The trillions upon trillions of years that an ordinary sun will continue to give out heat and light illustrates the vast store of energy which each unit of matter contains. The actual energy stored in these invisible particles of physical matter is nearly unimaginable. And this energy becomes almost wholly

available as light when subjected to the tremendous heat pressure and associated energy activities which prevail in the interiors of blazing suns. Still other conditions enable the suns to transform and send forth much of the energy of space which comes their way in the established space circuits.

'Many phases of physical energy and all forms of matter are attracted to, and subsequently distributed by, the solar dynamos. In this way the suns serve as local accelerators of energy circulation, acting as automatic power-control stations'.*

These solar temperatures speed up the ultimatons and the electrons enormously, at least those that can continue to maintain their existence under these conditions.

'We can realize what high temperature means to the acceleration of ultimatonic and electronic activities when we pause to consider that one drop of ordinary water contains over one billion trillions of atoms.**

This is the energy of more than one hundred horsepower exerted continuously for two years. The total heat now given out by our solar system's sun is manifestly more than that.

Our planet can further provide enormous energy source potentials such as magnetic fields; geothermic heat; wind power; tidal forces; volcanic heat, steam and pressure, and gravity. We have not yet developed methods to tap into all of these enormous energy sources.

Where will we obtain materials with which to create plastics and other items if oil is no longer available? Currently, we burn or dispose of oil-based materials in rapidly filling landfills, or simply dump our waste into the oceans. Should we not save part of the oil reserves to enable research of other methods of harnessing

* (1)UB, P.172 - §11
** (1) UB, P.463 - §13.

energy as well as of our medical and other research? By applying better and more efficient methods and systems for its use, oil could be made to last for many generations to come. Wasting by burning fuel with our primitive technological methods, such as our heating systems, we don't even know how much we lose of valuable and precious energy. Then, we can list the enormous usage and waste of fossil fuel energy by the military all over the world, and this all to destroy human lives and damage the entire planet. The wars on our globe consume weapons, ammunition, energy and life. In addition to ecological destruction, insanity and atrocities, they cause valuable energy waste.

Alternative technologies must be developed and made more efficient. Waste disposal must use the principle of a recycling system. Unfortunately today, more profit can still be made by using oil than by using alternative sources. Only when alternative solutions are more profitable than oil will the financial powers resort to using alternatives. They own most of the patents of the new technologies and therefore have control over their usage. Developing new technologies is expensive for the common man. Only the oil industry has the means.

The efficiently operating car uses around 17% to 20% of its total energy potential. All the rest is converted, mainly into heat, and dispersed into the air. Add the pollution factor to that limited technology and we have excessive waste and a meager machine. Our inventors and industries offer all kinds of alternative cars and engines and praise their products. The reality is that they are neither efficient nor good alternatives.

The alternative system of the so-called hybrid car must carry a huge weight of batteries, and as a result the gas engine is made less efficient so that the total efficiency of the car is significantly reduced. In addition, the batteries have short life spans and a low efficiency potential in the long term. As well, the batteries themselves are filled with toxic substances for which we have no

safe means of disposal. After three to six years in operation, the batteries must be either replaced or used mostly as dead weight; and the net gain becomes minimal. Battery technology is not yet up to the effectiveness level needed.

The use of solar cells, another alternative technology for cars is commendable but not yet developed to the necessary standard. The cells take too much space and weight for the car to be practical and efficient. Again, the batteries become dead weight and have to be replaced, at high cost.

Industry and commerce want to make good sales. With deceptive advertising they attract the consumer into their shops. It is much more important to emphasize the car's appearance than its technology. People do not even really want to understand the technology, and the jargon used in advertising is only shoe polish. No doubt the car industry knows of, or has, better technical solutions but doesn't want, or is not permitted, to put them out for market. According to Erasmus (5) our world is impregnated by relativism and a constant questioning of human certainty. Every year new and interesting ideas are introduced, but only to be used later, say 20 years down the road. How feeble.

The over-heating or under-cooling of shop buildings in the winter heat and summer cold is an enormous waste of energy and neither necessary nor desirable. However, making the shopper as comfortable as possible is important to sales management. Comfortable customers are more likely to purchase. But acting with comfort in mind as a sales advantage means shops and stores are heated and cooled today beyond the necessary. Also, being over-warm could affect the decision-making abilities of customers negatively. The merchants' goal is sales. That's understandable. Whole forests are cut to make sale flyers for the consumer. Most of these papers go into the waste disposal without much attention given them. Only a minute amount of such papers are recycled. There have been protests in North America against cutting the

forests to protect fauna and flora, water reserves and nature as such. These protests were directed at the wrong address. The customer should be blamed, not the loggers who are merely satisfying public demand. We have a totally confused society that has lost its sense of reality. Everything has, however, two sides of the coin. The logging of massive areas has proven to be beneficial to other fauna and flora to which food and light were previously not available.

The earth's surface is covered over 75% by water. Yet, human demand for potable water in cities is increasing toward a dangerous shortage.

A serious shortage of potable water supplies, and of increasing distances involved in distributing it, is developing. Did our city planners have the foresight to provide potable water for the increasing demand of growing populations? Many parts of North America are already at the critical point with their water supply systems. The waste of potable water, the only water in the cities, is continuous. We sprinkle our lawns and beautiful parks, wash our cars and fill our swimming pools or other facilities with clean drinking water; this is plain foolishness. We should be able to use the pure water only for essential needs, drinking and cooking. The problem could be solved. Technologies are established and readily available. The good news is, that there are a very few "green" buildings in operation now. A good example is the new daycare facility at Simon Fraser University. It is an ecological experiment. The change is happening, but way too slowly.

In our usage of water we create waste water which runs to sewage water treatment plants. The cleaning process can bring it nearly to the quality of potable water. Here exists a great potential to return this cleaned water as a non-potable source back to the dwelling houses, industry and commerce for re-use. We can sprinkle our lawns with non-potable water, we can wash our cars with it, and we can utilize it in different workplaces and for

cleaning and all sorts of activities. This alternative would call for a separate water distribution system. This is unfortunately possible only in new cities without a massive overhauling of old water mains, but city planners have other things on their minds. In the future, where will they find potable water or water to sprinkle lawns, gardens and parks? The water tables are already low in many places and cannot be stressed more or they will collapse. Restrictions of water usage are already an option enforced in many places. That can, however, not satisfy the increasing needs of city expansion. Populations will increase, especially in the cities, and water demand increased accompany that growth. This is inevitable. So is the shortage. Where will we get the supply?

Our oceans' water reserve is an immense pool to draw from. Most of our rain comes by way of condensation and precipitation from the oceans. We have the technology to supply drinking water from saltwater treatment plants. Cities close to the sea could easily solve their increasing water demand with that method. The technology available has not been made publicly understandable, but everybody is aware of the possibility.

We already have around 1 billion people living without potable water today. Predictions from reliable sources are that we could soon have over 2 billion people in the world who must live without potable water, in shacks, with no sewage system, subsisting in hunger. There are at present about 18,000 children alone who are ill from having to drink unsanitary water (in 3rd world countries) and who very well might die from hunger, dehydration and malnutrition. And we in the western world waste so much food and water while we live in opulence. We have no excuse for our deplorable lifestyle. We are too insensitive to comprehend that we live as humans together and are here in the world to support and help each other. The more we humans understand and adopt the will to help the less fortunate the more

each of us will become serene. We will at last have a worthwhile purpose in life.

2.3 Personal Luxury

Do we really know why we purchase two, three, or even more cars for our use alone? A research study in Switzerland (shown on TV in 2010)* revealed four main reasons people give for owning a car. They are: *necessity, prestige, commodity, and self-gratification.*

In a city the *necessity* is really questionable. With transport services provided by cities, such as trains, buses, taxis, and carpooling, the need for a car just to go to work is doubtful. There are always exceptions to the rule. But can we afford that luxury? A simple calculation shows that the purchase costs for the car, insurance and parking, added to the tax burden of streets and traffic control, are too expensive. That does not take potential accidents into consideration. Add those and the costs become 'exorbitant'. Suddenly, public transportation becomes significantly more attractive. Rural areas, however, have a different story. Public services are not as readily available. The need for private transportation is obvious. The need for a vehicle to go to work is unavoidable. At the periphery of a city the worker could switch to public service to avoid crowding the city streets and parking lots. There are nations, Germany and Switzerland for example, that do provide public transport service to remote areas, but this is more the exception than the rule.

Prestige is another reason. Could it be that, lacking self-confidence and self-esteem, some people compensate for their shortcomings with multiple cars, or better cars than the neighbors', in order to feel equal or superior? Definitely the car has become

* other TV stations in Europe reported these findings in 2010/11 as well.

a status symbol for many. Neighbors or other acquaintances seemingly admire this new possession and the owner of that new toy gets a boost to his self-esteem. But it is a deceptive satisfaction. It lasts for only a short time. The game continues. We have, regrettably, much more than we need to live contentedly. Let's try not to feed this endless cycle of consumerism, insanity and immorality in which this "modern and advanced" society forgets and ignores the less fortunate. Look around you. Be thankful for all that you have in this "transitory" lifetime. We can live with much less and be happier than we currently are.

In thinking of *commodity and self-gratification*, there are certainly people who use their cars for working and also for their free time entertainment purposes. A car or truck provides the ability to do a lot of work that could not be done otherwise. These are not the car users mentioned above. The critic goes specifically to car owners who purchase their cars for personal gratification only.

How can the human live with the endless crawling lines of cars that take hours to go to work and return home? We don't need to be reminded of the stress and costs involved. Hour after hour we waste our precious time sitting in a car instead of enjoying the family or free time at home. Also, we breathe the exhaust fumes of all the other crawling cars, and that is not beneficial to our health either.

Our cities are designed with commercial buildings (office buildings, shops; luckily new shopping centers are built at the outskirts of the cities) in the center of the city and dwelling units at the peripheries. This forces the working populous to commute. Dwelling developments are moving farther out into the rural areas as lack of space necessitates, thus increasing distances for commuters even more. In the cities, streets have not kept up with increased traffic demand. Retrofitting cities with the necessary transport services is a nightmare today, and

very costly. The whole problem is out of control. We try to catch up but are always behind. Is all we can do just Band-Aid politics? Certainly not. Citizens must be prepared to foot the bill for such solutions as rapid transit, either below or above ground. Would it be a feasible solution to revitalize the centers of the cities with dwelling units? The distance to the work place would be short and convenient. It would also create a balance and a reduction in travel distances as well as less crowded streets, less air and noise pollution. The parking problem would also be reduced. But this solution definitely also has negative consequences. Weekend traffic going in and out of the cities would increase. With a good public transportation system city dwellers would either not need cars at all, or would need just one car for weekend get-away. The personally beloved freedom to drive around would still be available.

Comparison of the two options: living in the center of the city, with resultant crowded population, crime concerns, inner city retrofit costs, and separation of people from a natural environment; or choosing extended rural development with its consequent loss of farm land, large waste of fossil fuel, air and noise pollution, street and bridge maintenance, and mental stress due to commutes, shows that in regard to total emissions, the city-dwelling proposal would reduce the traffic and therefore environmental pollution significantly.

2.4 Commerce and Industry

There also exist possibilities for reducing commercial and industrial use of fossil fuels in the existing heavy truck transport system. Our highways are overcrowded with semi-trailers and trucks of all shapes and sizes. The environmental (streets, air, water) strain is high, and there is enormous damage to the roads

as well, putting additional strain on the taxpayer. The costs caused annually by heavy truck damage to the roads goes into the billions. Transport of materials and goods could be effected using the railway container system (huckaback system) for long hauling. Energy efficiency would rise significantly even when using diesel train engines instead of electric engines. This method would cause far less pollution and reduce the amount of damage to our roads. The distribution of cargo is easily manageable with container systems which are efficiently loaded onto trucks for the short haul to the end-user. This would still employ some of the transporting crews but we would have far less pollution and less cost.

The other side of any argument is that it can cause difficulties to the employment sector. Changing the way we transport goods will affect the degree of employment and the livelihood of the entrepreneur. It is a fact that certain work positions will no longer be necessary. But, services come and go all the time and the inventive entrepreneur will find a way for his employees to survive.

2.5 Efforts by Organizations and Governments

There are many efforts made by private organizations to prevent further damage to our environment. However, Band-Aid measures are always prone to failure because they do not solve the problem at its source. Proposals that reduce pollution of the environment have to begin at the source to be justified. The measures proposed must demand that a degree of reduction be accomplished and that the envisioned goal of a healthy level is not exceeded. When the citizen has not the necessary scientific knowledge he sometimes feels that standards set by others are

not attainable. Emission standards must be realistic and spread over a defined time period. The goal is reduction of emissions to a sensible level and not political self-aggrandizement. Other than a few politically motivated scientists, the majority of scientists offer realistic limits and valuable solutions.

Setting limits is always colored by arbitrary decisions. For instance, noise and noise reduction limits in car engines were set and the result proved that, except for a few broken exhaust pipes or mufflers, they were not the principal noisemakers. Instead, the real noise producers were discovered to be the tires of cars and trucks on highways. All the noise restriction on the car engines itself has given marginal benefits. Apparently we have to live with the tire noise, as setting standards for the tires is hampered by safety concerns on the road. Changes of road conditions through the seasons are a factor that cannot be ignored. The tires must be adapted to street conditions and the current season for safety reasons.

Along many highways the government has built noise abatement walls and earth walls that are mainly unattractive. The view to the countryside is taken away and the driver feels enclosed. The noise from passing traffic remains high and disturbing. Could better solutions have been found? Designing the road away from urban areas would be one achievable solution. The demanding parameter at the turn of the century was, however, that highways and freeways should connect the cities and reach into their centers. Now we realize that this was not the smartest move.

The planning of public traffic systems needs to be overhauled and other priorities need to be set, priorities that take better account of the environment. Socio-psychological studies from the Federal Polytechnic Institute and the University of Zurich found, in a study of the correlation between streets and living quarters, that besides air pollution, noise is a central reason of stress and illness.

If we choose to live a more respectable and understanding way of life, alternative solutions can be found that satisfy nearly everybody. Solutions being used today are mostly Band-Aid alternatives.

A good solution would be to overhaul the choices of road layout and design. Unfortunately, that's no longer possible in many cases. We have to accept these facts and look for other solutions. What is left to do? Reducing the traffic is desirable but the conditions mentioned above must be met. Personal driving with greater awareness of reducing energy consumption is another option. Reducing excessive driving habits that guzzle unnecessary fuel consumption makes total sense. Avoiding aggressive driving and senseless passing of other cars to gain a minute or two is one of the possibilities for reducing consumption. The side effect is that this could also prevent fatal accidents. Passing in the way, for example, that some European drivers do, borders on insanity.

Will raising the price of fuel cause people to think more positively about reducing their fuel consumption? At the onset of a price hike people grumble, but tend to accept (do they have a choice if they need their cars for daily obligations?) the appalling price gouging. But there exists a price limit at which the common citizen cannot use his car anymore. The oil companies know that and set the price hikes for gasoline in increments, fully aware that they have to adapt to the reaction of the consumer to drive less. Going steeply up with the price gives them the leeway to come down a few cents and the citizen always fall for that. The oil companies know that we are dependent on the fuel and take, therefore, advantage of our vulnerability.

2.6 Alternative solutions

We can definitely find other options for reducing our consumption of fossil fuels in cars. As mentioned before, cars have to be made more efficient. Manufacturers must not rest on the current record of 17% and 20% efficiency. We still depend on the four stroke combustion engine technology from German inventor and engineer Nikolaus Otto from 1876, which effected great progress in engine development for cars at the time. But it's ludicrous to rest on technology from that century. Can we not improve the Otto Engine? Do we not have advanced metallurgical techniques for improving the combustion system today? Can we not introduce new innovations that make use of the car more environmentally friendly? Certainly some progress was made to improve the gasoline burning engine from 17% to approx. 25% fuel efficiency. Improved combustion techniques and basic after-burners could reduce environmental pollution drastically. High efficiency diesel oil engines are another solution. Then there are alternative fuels such as hydrogen fuel that have practically no emissions. The oil industry doesn't like that thought though; not quite yet. Technologies are in place and have only to be used. Iceland has a working system of hydrogen fuel, according to TV sources. Methane and other lighter gases like Propane are valuable options. They consume even less fuel. Former US President W. Bush ordered research into the possibility of using hydrogen fuel technologies. But, it never materialized. Was it a political maneuver and only lip service to silence the questioning public? The technologies are in place; not much research is needed. Distribution can only be effected by combining with existing gas stations found today all over the continents. As long as the oil industry is not willing or prepared to do so, nothing will happen. We could convince them by refusing to use so much gasoline and supporting alternative hybrid systems. We can assume that the

oil industry is in possession of the relevant patents and that closes that chapter. What a shame.

Apparently gasoline prices are still far too low to force us to drive less and adopt more economical driving habits. Price is normally based on supply and demand. That is, however, not the case with gasoline. The price is normally set according to the maximum possible consumption habits of the drivers. This sounds incredible. Market research sections of the oil companies check and use customer consumption reaction to the introduction of price increases. Their price increases are set to a false high. If customers reduce their consumption due to affordability concerns, oil companies lower the gas prices but never return to the original price level. And don't believe that this is not reality. We the consumers indirectly set the prices. In fact indirectly, our excessive use of fuel makes us as guilty as the oil companies. Humans have a tendency to accept, after the first price shock and its accompanying anger, to quickly forget (our short memory) and that's another factor that the oil might are using to their advantage. The government does not move a finger to intervene. Why should they? They take a nice piece (53%, CDN) of the cake.

All comes down to our behavior and attitude. Nobody else could be so vulnerable and easily manipulated. The main reasons are our need for self-gratification and our belief that we deserve to have luxury. We work hard for it, right? As long as such an attitude is at hand we have no chance to deserve a say in that price matter.

Politically we have to persuade politicians and industry to allow hydrogen to be used as alternative fuel. The car industries (who are the real owners?) must adapt car design to that technology. Furthermore, the oil industry has to be committed to adding hydrogen fuel stations to the existing fuel system all over the world. That solves one of our environmental challenges. More

steps have to be taken and adapted, such as alternative energy technologies to reduce the pollution of our surroundings. Not easy tasks either, like all measures outside the norm. Changes are only reluctantly accepted. If we want to reduce emissions we must take steps also against our fear and anxieties. We can do it.

The world opened up to international travels through the development of fast air traffic. It is possible to fly in a short time to all corners of the world. That further opened trade around the globe. The disadvantage is that this pollutes our stratosphere significantly and could devastate the protective ozone belt of our planet. The side effect is the spreading of all kind of viruses and diseases. Again, politicians make citizens feel guilty for destroying this belt with their car pollution. By mental manipulation and scare tactics an effective method is employed. In reality the culprit is a combination of all emissions together. It is also a fact that traveling became affordable and people are using that service to the utmost extent. Flights are ridiculously cheap but taxes are excessive. The governments make more money through taxation than the air companies do through their fare rates. To maintain their customer bases and stay in competition, the air companies calculate to achieve every last drop of savings from their costs. An example of this is that a flight captain receives an average annual salary close to poverty level, as per (5) Moore. Do we really need to go all over the world for our entertainment and joy? Right, we work for it and we deserve it. Instant gratification has no space for common sense. Observing the air flights over the globe in 24 hours, we can see unbelievable traffic in our skies. It seems the sky is jammed. Do we want to reduce flights per day or do we need this immense traffic in our air space? We have to ask the question seriously. The answer should become clear. Who must reduce the frequency of flying and who sets the justification level? One thing is certain; the governments would lose thereby millions

upon millions of revenue. The air companies are adaptable and can cope with reduced traffic. That doesn't automatically say that their profits would diminish. That's a tough decision for us, the imperfect and vulnerable fellows.

As enjoyable and exiting as it may be to watch a Formula One or other fast car race they defy justification. You may argue that they make only diminutive air pollution. In spite of that they burn great amounts of fuels; for what? Do we watch such races for the emotional kick of pure excitement? You may argue that we cannot reduce all our pleasures and still be content. That's correct but what if we run out of fuel in the world; what then replaces that event? Being frugal with non-renewable resources does not mean relinquishing all pleasures in life. We only have to set clear priorities. Each measure used contributes to total emissions. The sum of all inter-actions decides the limitation of operation and not individual exploitation alone.

2.7 Social Behavior

We could endlessly recount examples of the inconceivable behavior of mankind in regard to the environment. The following few should give an idea of what problems we face and must deal with.

Abuse of the environment is a fact even when it may not appear to cause long-term damage. We need to find a middle ground to operate effectively. Humans tend to go to extremes to satisfy their needs and wants. If we in our western world complain about life, we should think about how people in third world countries suffer hunger and thirst and have neither roof nor bed to sleep in. They don't have all our luxuries and gadgets. Should we not concentrate our efforts towards a better life on this planet for everybody? Are our social and compassionate feelings,

and a vision of a fulfilled life for everyone, not the satisfiers we crave?

Atheists, and specifically nihilists, will argue that each of us is here for his own self. Help will be given only by feeble religious people and altruists. Any action of value toward others is a figment of a pitiable imagination and is therefore futile. They believe that we do not even exist.

"Nihilism is an act of pride. You are so secure in rational and intellectual analyzing, beginning with the death of God and descending to the last details of owns reset biology that you arrogate to yourselves powers of judgment that you don't really have". (1) Saul Bellow.

Bellow the quote elaborates the quote:

'.....that materialism, atheism, is the epitome of ugliness, the climax of the finite antithesis of the beautiful. Highest beauty consists in the panorama of the unification of the variations which have been born of pre-existent harmonious reality'.* (1).

It is a fact that for human life has become much more than living the life of a primitive animal. We are gifted with a brain, and free will, and should use those gifts. Without using our given capacities we could not make progress in science and culture. Certainly we are at a crossroads of destiny. We must be vigilant not to destroy that which our forefathers have painstakingly struggled and worked to achieve. With our tendency to go overboard and our desire to have everything now, we do not give the necessary attention to possible consequences. We have reached a point that calls for a new thinking of what we want, what we need, to live in peace and tranquility. We know the overabundance of the industrial world and what that gives us. We are becoming pleasure-seeking weaklings. The downfall of every

* (1) UB, P.646 - §5.

indulgent behavior is that it has negative repercussions like the devastation of our habitat and our physical and mental condition. Not correcting all this wrong behavior leads to consequences that we don't really want, or do we?

The influences of our actions are manifold. Noise is detrimental to our wellbeing. Noise can cause stress, mental health conditions like anxiety and depression beyond our control. We become slaves of our own invention and we suffer. How easily that could be remedied. By employing more common sense, consideration and understanding of the powers we have to keep the noise to an acceptable level, be it in our backyard or in public places, and behave accordingly, by using all noise reduction technologies available, we can make the environment for everybody more pleasant. Without having to go into all the possible technologies and comparing each measure against the other we can assume that all noise reductions have one goal, creating a better atmosphere. Stress levels, mainly psychological reaction, will become a less significant burden. Technologies are for the most part in place and can be engaged. Noise that causes anxiety by disturbing the neighbors, unwanted noise from radios, TV, toys, gadgets and behavior is another source of aggravation. By using common sense and respect for the rights of others, we resolve many unnecessary disputes and provocations. We can live as a social unit together, even in congested places, if we practice respect and consideration for each other. That is vital.

It is almost unbelievable what noise and disturbance we can create. The entertainment industry has engaged all its might to convince the consumer to acquire products for common use that produce unreasonably loud noise. Cyber technology went even further. Today everybody is, in one way or another, a slave of these gadgets. They isolate the individual in a bizarre world of Virtual Reality and absorption. Contact with reality and with other humans is lost. Why we engage in such non-realities is

obvious. Reality as we have created it up to today is brutal, scary, unbearable and unforgiving. There appears to be no way out so we escape from our responsibilities and obligations into a world of utopia. That escape numbs the pressure upon our minds. By avoiding reality and ignoring our duties we create an even more brutal truth. The 'ostrich method' shows that we have become weak and we are lost. We need help to find the way. Our youth are born into this escape syndrome and they don't know any better. We have a tremendous obligation to teach our future generations that man cannot avoid reality, cannot continue with the attitude that everything is fine. We know better. Humans today have an inclination for an artificial lifestyle in which they exchange responsible with irresponsible behavior. A fatalistic attitude is developing. This is expressed in drug and alcohol abuse as well as in the rising numbers of suicides of both young and old citizens. They could not face the pressures of reality any more, and opted out. This should not be; we can do better. Each life lost is sad.

Living in our modern world brings so many difficulties due to the high-speed life we endure. Everything seems beyond our control. We must take back the control. That's easier said than done. So many obstacles cross our way. If we take measures, they must be taken in coordination with all problems and solutions. Apparently insurmountable obstacles must be attacked.

Drugs, alcohol and smoking are addictions with detrimental consequences. We don't need to give details of the possible and sometimes fatal consequences. There are preventive organizations such as, 'Detox' Centers and Alcoholics Anonymous centers. These are prepared to help those who struggle against addiction.

We should first concentrate our efforts on preventive measures. So far, we have used Band-Aid measures that have proven to be mainly ineffective. What can we do? The fact is that we will never be able to eradicate addiction because greedy people want to make

money, lots of it, no matter the consequences. Government laws and measures have mainly lost their battle. The drug industry is too strong. If we wanted to go beyond the real drug lords, and they are not who we are made to believe, we would have to go after the Untouchables. Who are the Untouchables? They are those protected people who aren't elected, but who rule the world. Do the Financial Might rule the Drug Lords? Are these 'lords' cronies of the FM and are protected by their henchmen, the CIA; is that possible? That task is too difficult to touch. What other possibility do we have? Well, here's a risky proposition. We could legalize all drug trafficking and consumption. Can we already hear the vicious protests from all corners and opinions? Certainly, if the drugs were free for everybody consumption would initially rise steeply. But, after a short time use would drop drastically. We should compare the drug problem with the alcohol problem of yesterday and the enactment of prohibition. We can see similar tendencies. Legalizing drugs would not eliminate all drug abuses but would keep the problem at a lower level than it is today. A welcome gain would also be that the crime rate would drop significantly. We would save a lot of jail space and costs (US has one of the highest incarceration rate in the civilized world) and the government could maybe deal with the drugs as a taxable sale item. All the costly anti-drug agencies could be closed, another achievement. You will probably argue that our youth is not protected. Are they protected today with all those laws, laws that are more political self-aggrandizement than really effective? Proof is seen in the current increase in illicit use of drugs. Why? Something forbidden by law is more attractive to youth, who are unwilling to face reality.

For our youth, and we were also young once and know the difficulties we humans face, it is a steep climb to becoming strong. Only the week and meek turn to drugs. We will probably always have week humans. It is up to us to help and guide them.

The problem is that we don't have time, or we don't want to spend time, with our kids. The *"Here take some money and leave me alone."* attitude is the wrong way to deal with them. They deserve better and they are our future. We claim to love our kids but do exactly the opposite. By not spending time with them we are the ones to blame. They are lost and reaching for an illusory world available in drugs. At least in drugs they feel, for a short time, 'protected' from reality. And so the cycle of dependency continuous and becomes vicious. Once in the hold of drugs it is hard to get away.

We have to search earnestly for solutions that can best prevent the use of drugs. Definitely not the ones we have put into law. They just made the problem worse. Alternative and out-of-the-box ideas bring us to a freer and more logical solution. The saying, "if you can't fight it, join it," has some merit. If we cannot eliminate the problem we should at least give it a fair chance to solve itself. We are basically hypocrites hiding behind laws and avoiding responsibility. We, the adults, must grow up and become accountable. It is easy to employ the ostrich mentality and let the government or somebody else deal with the challenge. We want to be left to indulge in self-pity.

Certainly, and luckily, we have many people out there who really love and care for their offspring. Rarely do we encounter kids with drug problems in such families. The kids have a real home and loving, caring parents. Not parents that make thousands of rules and regulations, no, they are parents who really live a life of truth. No self-deception, no lies, just plain realism and fairness. Should our society not be like that? It all comes down to the brotherhood of man.

Nothing in life is guaranteed or forever. We live in a dynamic age of development, and changes are often necessary. Those who do not accept this fact, who lash out in anger, only create more anger with no positive result. People all over the world hate each

other because their opinions and feelings for business and politics and how to run it differ from each other. Why do they willingly hate and eagerly try to destroy? Are they so fearful that they cannot allow freedom of thought and expression to take place? Friction is caused simply in dealing and working with each other. With empathy, compassion and respect for each other we don't feel threatened. The possibility of losing our income is certainly frightening. In a sensible community there is always a solution and help will be readily available. For that we have to become a united and compassionate society in which nobody lives only for himself. What a satisfying accomplishment we could make in such a society.

2.8 Understanding, Attitude and Actions

The most important action in starting all endeavors is forming the understanding, will, self-control, tenacity and stamina to do the job. Finding people with the same attitude, plan and will is the second step.

An important task is encouraging one's neighbors and other citizens to join the effort to make the environment more livable and less stressful. This is achieved through discussion and working in small steps toward solutions in your immediate environment at home and at work. Such projects as reducing air pollution through reduced driving by using public transportation and carpooling to work, avoiding excessive noise, reducing needless electric power use and so on are other good starters.

The next personal project could be changing or converting one's car to hydrogen or propane fuel. If we all did this, the oil companies would have no other choice than to join the better way. There are good and relevant guide-booklets, published about all environmental projects that can be very helpful. Reducing all

wasteful use of plastic, aluminum and other household items should also to be envisaged. Double and triple packaging has to be discouraged. Unnecessary items must be removed from our wish list. Only really needed items should be purchased. There are many such projects that can be undertaken without great sacrifice. The positive effect is unbelievable. By example, one's influence becomes powerful in encouraging others.

The next step is politically more difficult. Convincing people to change old ways of doing things in public works, commerce and industry is a challenge. Planning departments have to be convinced that the use of potable water for such things as sprinkling grass in public parks should be abolished. The same rule applies to our own gardens and car washing. In planning new subdivisions, the town or city and developers should be required to install two water systems, one for potable and one for non-potable water. Over time, dwindling potable water supplies will necessitate this action. Without such action, taxpayers will be faced with the extreme costs of trucking in potable water from distant sources. Not to imagine what it would do to dwindling fuel reserves and increased air pollution. Nobody in his right mind would support such a situation.

Unhealthy additives in drinking water like Hyper-chlorine should also be abolished. Also, the general disorder and chaos present in today's society has to be dissolved.

Finally, get involved with serious environmental groups and become involved in valuable causes that encourage coordinated efforts and anti-pollution procedures and which include different disciplines. In numbers there is strength, and in these groups is the necessary will and support.

The danger of such endeavors is that over time they lose stamina and their efforts run out like sand. We should remind ourselves daily that it is we who forge our children's futures.

Believe that anti-environmental protection forces are out there to destroy everything of value. Those are the evil forces that are not able to think beyond the immediate. Meet them with respect and compassion because that's what they don't know. That way they are placed at a loss. They have no love for the next generations and are so unhappy or manipulated that they do not realize that they are the lowest level of society. If we orient our efforts toward such elements we will soon be joining their destructive ways. There is a common saying: 'join a loser and you become automatically a loser'. Negative forces will argue that our environment is fine and nothing is wrong. Sure, if you want to live in a stressful, polluted, and infected environment, then go ahead and waste, pollute and be merry. But if our life has more meaning and value and we want to live in good mental and physical health, free from stress, we must gear our actions toward improving the environment and our lives. By being frugal, avoiding unnecessary endeavors, and refusing to waste our already endangered resources, we are in control of our destiny. Only then can we act. We must start making necessary changes at the source of all troubles, our own activities. Never count on 'what the other does'. Each one must take imperative action.

In many administrations there are forces that honestly invest all their resources and knowledge to fight an uphill political battle. Scientists put forward positive and constructive proposals, but unfortunately they come from separate disciplines and therefore their arguments lack strength. They are frustrated by the interest groups of industry and commerce. The negative argument is always cost. But any measures *employed in phases*, in increments, become financially manageable. We know the offset of such investments.

Environmental groups start out strong and effectual. Over time their activities diminish, probably due to changes of leadership or their members' complacency. Fresh forces must be recruited to

continue the task at hand. These groups have achieved admirable results in certain places, but the task is not done yet. Relief from the negative impacts of air pollution, noise and stress is far from achieved.

Our honest and truly representative politicians must get involved. They must put aside their conditioned attitudes and behaviors and act effectively to save our environment. To lobbyists, the message must sound loud and clear; it is not only our environment and lives at stake, it's theirs too. We are in this obligation and situation together.

The belief that we have other solutions at hand if oil and gas resources run out is possible but even so, we could make our place unlivable in the meantime. If that happens new ways won't help us because we will have run out of healthy people. It will then be too late. What we are talking about here is all the stored nuclear bombs and chemical warfare weapons. If an accident were to occur, as has happened in the past, at a nuclear power plant one could also occur at any of the enormous military arsenals. The problems of permanent disposal or storage of nuclear waste and redundant weapons are by far not solved. We have a potential time bomb at hand. Did you know that many weapons are stored at the bottom of some neighborhood lakes? Luckily, nothing of devastating consequence has happened yet. For well-educated terrorists, building a nuclear or chemical bomb is not only theory. We have uncounted potent plutonium, uranium and chemical substances around, out of control of the nuclear and chemical watch commission. Don't give to anybody, neither to governments, dictators or private enterprises, the possibility of using that time bomb. Be vigilant and oppose all efforts to deceive you. It is our and our kid's lives that we put at high risk.

2.9 Annihilation of our Planet

All nations with nuclear and chemical arsenals should destroy every weapon once and for all. Sure, the Americans and the Russians, the current superpowers, talk publicly about their agreement to reduce their stocks of such weapons. When they have control over all nuclear sources and procedures, they have worldwide control over all nations, or that's what they claim. To the non-insider this is a praiseworthy move. It is, however, only lip-service. In reality more weapons, further advanced and sophisticated, are being built every day; this is a fact. Rumors circulate that on the black market the buying and selling of nuclear elements such as uranium are out of control. Why do we need such weapons? Existing arsenals are already so big that they could *destroy the planet several times.*

According to our politicians, that will not happen. But we cannot trust the politicians or the dictators never to use them, unless they no longer exist. They intend to use them. Otherwise it would make no sense to build them in the first place. The notion that such arsenals are only to scare away a possible foreign military attack is ridiculous. If the opposing nation had a similar arsenal, such scare tactics would be ineffective anyway.

The cold war of the 1960's and 80's between the then superpowers was supposedly to avoid a war. This is pathetic. They had no real reason to attack each other; they only wanted us to believe the possibility of such a disaster. They could build bombs to their hearts' content and that would keep employment high, a politically advantageous situation. We know from the nation's budgets that over 75% of American employment is in military or war-related activity, when all supplies and indirect technology and invention are included in the count. Observation of the military budget of the USA confirms this account. What happens when we reduce war-related expenditure drastically?

Will we have thousands upon thousands of unemployed workers? The world has over 7 billion inhabitants. They must be fed and they must have shelter. We need to set our priorities not to maxim employment and profit, but to moderate and profitable levels for everybody. That does not mean abolishing free enterprise. Only the distribution of wealth can be ameliorated. Excessive gouging must become a thing of the past.

'Materialism, and atheism, are the maximation of ugliness, the climax of the finite antithesis of the beautiful. Highest beauty consists in the panorama of the unification of the variations which have been born of pre-existent harmonious reality'.*

2.10 Behaviors of People in Power

Unions, labor leaders and individuals speak the "magic words"; *Security, Equality, and Freedom,* but only in order to enslave people. It is clear how some evil men like dictators bend and enslave their fellows. They weaken the strength of human belief in a Supreme Being, which gives to people a sense of personal dignity and value. Leaders find it necessary to eliminate this sense of personal dignity and value in people, these 'hazards', because men of dignity and value will never become slaves to their leaders.

The same system is used by governments; they decree that no religious teachings or discussions are permitted in schools. They attempt to solve the unsolvable problems and chaos they have created in their own nations by pressuring other nations and blaming.

* (1), P.646 - §5.

"The people forget their factionalism, their local antagonisms, and their political differences, their suspicions of each other, their religious hostilities, and band together as one unit. Leaders know that, and that is why so many of them whip up wars during periods of national crisis, or when people become discontented and angry. The leaders stigmatize the enemy with every vice they can think of, every evil and human depravity. They stimulate their people's natural fear of all other men, or nations. Attacking another nation, then, acts as a sort of catharsis, temporarily, on men's fear of their immediate neighbors. This is the explanation of all wars, all racial and religious hatreds, all massacres and all attempts at genocide". (3) T. Caldwell.

Taking away the pillars of morals, ethics, dignity and values leaves the citizenry totally confused, lost and afraid. Faith can, however, never be obliterated.

No wonder our society has lost its moorings and nearly everybody lives for themselves. A nation has to have values and faith, or its society will slide into confusion and materialism, greed and lust for power will become the principal goal. Nations will inevitably die from destruction of their values. Rome and other Empires went through that phase of self-destruction and inevitably they made space for other powers to move in. To the FM that is of no concern of theirs. It doesn't matter which citizens or nations will be destroyed.

2.11 Behavioral Changes

We need to free ourselves from all negative and destructive behaviors. Too much grief and despair are their consequences. Elections of our representatives should be conducted with less

emotion and mass hysteria and more common sense. Election days have become like a circus. People become so overwrought and fanatical that no argument would cause them to think. Fanaticism becomes so strong that some could kill. That is scary. Let's liberate ourselves from such unhealthy behavior and employ our senses. Trust, love and compassion are liberators of such biases and fetishes. They help us to succeed in our endeavors and to solve our daily challenges. Nothing has more power than these positive attributes.

Many of us spend much time and thought on mere trifles of living while overlooking the more essential realities of everlasting import. We fail to achieve those very accomplishments which are concerned with the development of a more harmonious working agreement between us and our fellow human beings.

A devoted and determined effort to realize a harmonious destiny is wholly compatible with a light-hearted and joyous life and a successful and honorable career on earth. Co-operation with our fellow human does not entail self-torture, mock piety, or hypocritical and ostentatious self-abasement. The ideal life is one of loving service rather than of fearful apprehension.

"But the great difficulty of finding new and satisfying representation is because modern men, as a group, adhere to the scientific attitude, eschew superstition, and abhor ignorance, while as individuals they are intrigued by mystery and venerate the unknown. No faction can survive unless it embodies some masterful mystery and conceals something worthwhile but unattainable. Again, the new idea must not only be significant for the group, but also meaningful to the individual. The forms of any serviceable representation must be those which individuals can carry out on their own initiatives, and which they can also enjoy with their fellows. If the new faction could only be dynamic instead of static, it might really contribute something

*worthwhile to the progress of mankind, both temporal and spiritual. Although transgressions of negative behavior are sooner or later followed by the harvest of punishment, while men certainly **eventually do reap what they sow,** still you should know that human suffering is not always a punishment".**

'*Moral consciousness is just a name applied to human recognition and awareness of those ethics and human values which demand that man abide in day-by-day control and guidance of conduct. To enjoy privilege without abuse, to have liberty without license, to possess power and steadfastly refuse to use it for self-aggrandizement; these are the marks of high civilization. Though capital has tended to liberate man, it has greatly complicated his social and industrial organization. The abuse of capitalism by unfair practice does not destroy the fact that it is the basis of modern industrial society.***

'*Through capitalism and invention the present generation enjoys a higher degree of freedom than any system that ever preceded it on earth. This is placed on record as a fact not in justification of the many misuses of capital by thoughtless and selfish and custodians.****

"*But there are economic abuses which many times have to be condemned. The unfair exploitation of the weak, unlearned, and less fortunate of men by their strong, keen, and more intelligent fellows is deplorable. Throughout the vicissitudes of life, remember always to love one another.*

* *(1) UB, P. 966-§4*
** *(1) UB, P.1115-§6*
*** *(1) UB, P 777 - §3*

212

*Do not strive with men, even with evil men. Show mercy even to those who despitefully abuse you".**

'Show yourselves to be a loyal citizens, upright artisans, praiseworthy neighbors, devoted kinsmen, understanding parents, and sincere believers in the brotherhood. It cannot be emphasized enough that trust, love, compassion, sympathy, kindness and devoted concern for the wellbeing of our fellows is vital. These are the only forces that satisfy and make us strong and happy. To realize our destiny, man must accomplish the task of achieving perfection. The effort toward maturity requires work, and work necessitates energy. Where does the power to accomplish all this come from? The physical things can be taken for granted, but it is well said, "Man cannot live by bread alone." With the possession of a normal body and reasonably good health, we must next look for those lures which will act as a stimulus to call forth man's slumbering energy, the ability to accomplish great things for mankind. How best can we awaken these latent powers for good which lie dormant in our souls? One thing is sure, emotional excitement is not the ideal reason for action. Excitement does not augment energy; it rather exhausts the powers of both mind and body. With devotion, loyalty, wisdom, and effectiveness the path can be found to follow, always stimulated by the activities of those who well know how to do their work, and who so thoroughly enjoy doing it'.***

'Do not fear the dangers of human forgetfulness and ignorance, do not be troubled with doubts of failure or by perplexing confusion, do not falter and question your status and standing, for in every dark hour, at every crossroad in the forward struggle, the mind will always find the way.*

* *Interpretation of (1) UB; (P.291 - §4)*
** *Interpretation of UB, (1), P.777 - §3*

Society becomes increasingly peaceful by finding truth and love for the environment. The individual, while no less independent and devoted to his family, has become more altruistic and fraternal. Achieving the social state desirable we can advance in a rational way and live in search of satisfying our inner craving for happiness. In the day-by-day life of mortal man, virtue is realized through the consistent choosing of good rather than evil and such ability is evidence of the possession of a moral nature. The course of achievement is quantitative, qualitative, and experiential—intellectual'.

'But inherent in this capacity for achievement is the responsibility of ethics, the necessity of recognizing that the world and the universe are filled with a multitude of differing types of beings. We have a choice to live with our fellow men or each for himself. Humans are basically noble, faithful, and loyal, notwithstanding their tendency to fall into error through fallacies of personal liberty and fictions of self-determination. There is no material reward for righteous living, but there is profound satisfaction, the consciousness of achievement, and this transcends any conceivable material reward. Humans do have the tendency to grab and hold onto material rewards. That's not far off from the hamster syndrome. Too often we pin our hopes on material satisfiers which cannot really gratify'.

'By a partnership technique we nearly quadruple our attainment and accomplishment possibilities. Humor should function as an automatic safety valve against the high pressure of monotony and serious self-contemplating in the exhaustive struggle for developmental progress and noble realization. 'Humor also functions to lessen the shock of the unexpected impact of fact or of truth, rigid unyielding fact

*and flexible ever-living truth. The mortal personality, never sure as to which will next be encountered, through humor swiftly grasps—sees the point and achieves insight—the unexpected nature of the situation be it fact or be it truth'.**

*'The pursuit of happiness is an experience of joy and satisfaction. However, thousands upon thousands of men and women have become humanly dislocated; they are anxious, restless, fearful, uncertain, and unsettled. As never before in the world's history they need consolation and stabilization. What we are becoming day by day is of infinitely more importance than what we are today. Progress is necessary for the development of self. The wise man is able to distinguish between means and ends; otherwise, over- planning for the future sometimes defeats its own high purpose. The meaning of life is its adaptability; the value of life is its forward progression'.***

Reaching a desired level of understanding, value, and harmonious life achievement, steps can be initiated with clear vision for an environment that gives us the values desired. No more agony and despair. The challenges for a better environment are mainly materialistic and technical in nature and therefore non-emotional. They can be adapted to the utmost level of validation. This prevents directives and measures that are over-zealous and not justified. Moderation is always a good adviser.

The task at hand should be solved with clear vision and determination. Time is a valuable and important factor. The less we waste with unnecessary squabbles and egotistic actions the better and more competent we will be. Nobody can be perfect. We must live within our means and capacities. To solve the task of technical inadequacy we have the scientists at hand.

*　　(1) Interpretation of UB, P.549 - §5
**　(1) Interpretation of UB

Their knowledge and experience are too valuable to ignore. Application of superior intelligence to environmental adjustment and adaptation will result in achievement of clean air for all living creatures, flora and fauna.

*and flexible ever-living truth. The mortal personality, never sure as to which will next be encountered, through humor swiftly grasps—sees the point and achieves insight—the unexpected nature of the situation be it fact or be it truth'.**

*'The pursuit of happiness is an experience of joy and satisfaction. However, thousands upon thousands of men and women have become humanly dislocated; they are anxious, restless, fearful, uncertain, and unsettled. As never before in the world's history they need consolation and stabilization. What we are becoming day by day is of infinitely more importance than what we are today. Progress is necessary for the development of self. The wise man is able to distinguish between means and ends; otherwise, over- planning for the future sometimes defeats its own high purpose. The meaning of life is its adaptability; the value of life is its forward progression'.***

Reaching a desired level of understanding, value, and harmonious life achievement, steps can be initiated with clear vision for an environment that gives us the values desired. No more agony and despair. The challenges for a better environment are mainly materialistic and technical in nature and therefore non-emotional. They can be adapted to the utmost level of validation. This prevents directives and measures that are over-zealous and not justified. Moderation is always a good adviser.

The task at hand should be solved with clear vision and determination. Time is a valuable and important factor. The less we waste with unnecessary squabbles and egotistic actions the better and more competent we will be. Nobody can be perfect. We must live within our means and capacities. To solve the task of technical inadequacy we have the scientists at hand.

* (1) Interpretation of UB, P.549 - §5
** (1) Interpretation of UB

Their knowledge and experience are too valuable to ignore. Application of superior intelligence to environmental adjustment and adaptation will result in achievement of clean air for all living creatures, flora and fauna.

3. Proposed Actions for Solutions

"A moral society should aim to preserve the self-respect of its citizenry and afford every normal individual adequate opportunity for self-realization. Such a plan of social achievement would yield a cultural society of the highest order. Social evolution should be encouraged by governmental supervision which exercises a minimum of regulative control. That state is best which co-ordinates most while governing least."*

It is imperative that each society, through democratic election, establish a reliable and honest government capable of accepting responsibility. Dictatorship through lobbies is no longer tolerable. By working in unison with government, industry and commerce, the citizenry must be the main force behind coordinating and controlling the implementation of proposals for legal adoption. If necessary, legislative actions must be approved by the people. There cannot be any more "blank cheques" to any special interest group, politician, or administration. They are elected or set in place to do what we decree.

"Justice makes a nation great, and the greater a nation the more solicitous will it be to see that injustice shall not befall even its most humble citizen.*"It is the sacred duty of a magistrate to acquit the innocent as well as to punish the guilty. Upon the impartiality, fairness, and integrity of its courts the endurance of a nation depends".*

Only a society that represents the will of the people has the character to be respected. Only with a united, nationally

* (1) UB, P.1462 - §1

representative organization can destructive and aggressive intervention from lobby-power be prevented.

Every member receives the same responsibility of decision making. The social structure is thereby kept integrally balanced. We have to apply superior intelligence to environmental adjustments and adaptations. Remember that natural justice is a man-made theory; it is not a reality. In nature, justice is purely theoretical, wholly a fiction. Nature provides but one kind of justice—inevitable conformity of results to causes. Whenever fairness and justice require an understanding of how a contemplated policy or procedure would affect us, experts are at hand to present their recommendations; they are always present to speak for those who cannot verbalize for themselves. No doubt the manufacturing industry has skilled and clever engineers who will find better and more efficient solutions to current energy consumption. We have to support these efforts by providing research grants.

We also need to:

- Mature, and become responsible citizens, the first step.
- Become compassionate, honest, loving and empathetic, the next step.
- Become involved in meeting environmental challenges
- Unite in efforts to elect reliable and honest representatives.
- Insist that the will of the citizen is respected and executed.

4. Lifestyle Choices and Consequences

After WW II our economy, our lifestyle and our demands have increased manifold to the point of over-abundance. Our hunger for more has become insatiable and our wastefulness enormous. We seem to have everything and this has made us complacent and lazy but still greedy for more. For us, nothing is good enough or important enough. What goes on in the rest of the world seems unimportant. Our main concern seems to be a full stomach and a thick purse. The only other thing that matters is to be better off than our neighbor, to have more and better things to show off. As long as we live like this we are speeding up our own downfall into a sense of sorrow for our existence. The inevitable result of total self-interest and self-service is the sense that nothing has real value anymore. We become materialistic slaves with no goals of recognizable value. But today we are still not prepared to live a life of common sense and moderation. *Have we become pleasure seeking weaklings?*

We supply our young people with all available gadgets. Can we imagine a world without all these toys and possessions? Is our young generation happier than the elderly who managed without all these electronics? Observing how our youth communicate with each other today we see that direct conversation suffers. They often talk only through electronic devices, even when they are a few paces apart or across a table from each other. The electronic industry has found a lucrative niche and through suggestive advertising reached admirable success. Science and technology have progressed but humans can barely keep up. Could the apparently necessary become the undesirable, a waste of time and money? Have we produced a mountain of waste due to the rapid changes of electronic devices?

Because of electronic communication, people seem to expect to be able to build relationships based on self-provided information. Much of this information is either wishful thinking or downright dishonest on the part of the provider.

A few years ago the car industry had as many car models together as each manufacturer has today by itself. Mountains of unusable cars in the yards reinforce the argument that we are a wasteful society. Where will that end? Will our children's' children have to suffer for our stupidity? Do we care? We want to live a life full of self-gratification. We give lip-service to concerns regarding waste and pollution, but continue in our patterns. We cry wolf but play sheep. But, we are the makers of our own destinies, even when we disregard the signals pointing to a more moderate life-style.

That doesn't mean we have to go back to the 'good old times'. We just need to reconnect with our roots, come to our senses and become reasonable, moderate. Wastefulness has to become a thing of the past. We don't need multiple cars or disposable dishes and cutlery, the list could go on. If we do not reduce our wants the oil industry will do it for us. Gas prices will climb to astronomical heights. Crying for more income will not do the trick either. Inflation and taxes would just kill/eat that again.

5. The Sensible Way

We live in a wasteful time and many of us do not even realize it. The Garbage Mountains rise to a critical point. Besides our daily waste of our household and commercial items we have to deal with atomic waste as well. Our demands for energy made electro-plants necessary. Do not expect that government or industry will call a halt if they smell profits. It is we who call for the energy due to our over-consumption, and consequently we are the culprits. It is unbelievable how we waste our energy and our resources and pollute our environment. A view from the satellite via Google shows you how the world is literally lighted up during the night. Shopping malls are either overheated or, in summer, too cool, the streets are illuminated to create daytime situations and the list goes on. Common energy reducing efforts are not really effective. The intensions are good but the execution lacks seriousness. Compared with rates of misuse and waste, these efforts are only a drop on a hot stone. Multi-car mania has to be reduced to necessity and driving kept to a minimum. The enormous consumption of natural resources has to be reduced to an optimal minimum. The ideas are all there. It's up to us to become serious and avoid complacency. This requires a real effort from each of us.

The food sector is in a dilemma as well. We waste so much sustenance. As we should realize, we have many people in the world that go hungry. Food supply will soon become a shortage if it isn't already. We object to genetically altered food. But going back to an organic food supply is just a figment of imagination. A long time ago we ran out of agricultural land. As long as we waste food a return to biological organic food will not happen. The land just cannot supply it without artificial help from fertilizers and genetic manipulation. We blame the food industry for feeding

221

us with garbage food and we are actually the initiators and the guilty. We even insist on it. What a contradiction. Experiments were made in different food stores. Biological food items were placed side by side with 'standard' food items but without labels. Which food item do you think was going strong? What is your guess? It is we who make choices and the industry is following the populous' decisions. The altered food looks better, particularly fruits. That should not be an excuse but we tend to associate good looks with better quality. There's a controversy building in the Okanagan, B.C. Canada, right now. A developer has genetically modified an apple that won't turn brown when cut. He's about to get permission to plant an orchard block. But it's right beside an orchard that is certified organic (is this even possible?). Who will make sure the bees don't get "carried away" with their pollinating and thus permanently harm the existing orchard, or the environmental pollution doesn't contaminate the "organic" land?

The numbers of items in a shopping mall with double and threefold packaging boggles the mind. All this packaging goes to the dump. Whole forested areas have to be cut for our demands. Not to forget the tons of oil-based products like plastics that cause even greater problems in both production and disposal. The blame is again put upon the forest or oil industry. How pathetic. We demand more and more and accept blame less and less. People are not bearing the responsibility; we attack others and never look into our own mirrors. Why should we? We can save the forests and oil reserves by not buying items with such excessive packaging. Aluminum foils are another problem. Just the amount of energy needed to produce these packages is mind boggling. Aluminum consumes enormous amounts of energy in its production and recycling. We could go on endlessly listing examples of waste of valuable resources.

We were talking about all the wrongs of our society; finance, politics and industry. Reality teaches us that we always look to blame the other, the people in charge of power. They are not innocent; they contribute their part to manipulate you into the way you choose to live. We are reactionary and are easily manipulated when it comes to stomach and material possessions. We love to be spoiled and dwell on it. We tend to forget that there are humans elsewhere who suffer due to less fortunate circumstances. Instead of wasting so much, why not be reasonable, sensible, and contribute to reduce the suffering? We can only win doing that. Our inner craving can be satisfied only by altruistic behavior, respect and compassion for humankind. Being moderate, reasonable, more sensible has always paid off. It satisfies us more than any extra whimsical and unnecessary gadget. Material things have never really satisfied. They become a burden for us and to acquire them we have to work hard and endure additional, but self-inflicted, stress. All the lamenting and complaining is self-made pain. We have to get out of this *rat race*, this destructive cycle. Only then will we become really satisfied and happy. Less will be more. Greed and insatiable wants will never fill the mental gap. They invariably leave us poor in feelings and spirit.

The following chapters are guidelines toward improving our societies and environment with proposals and settings of priority.

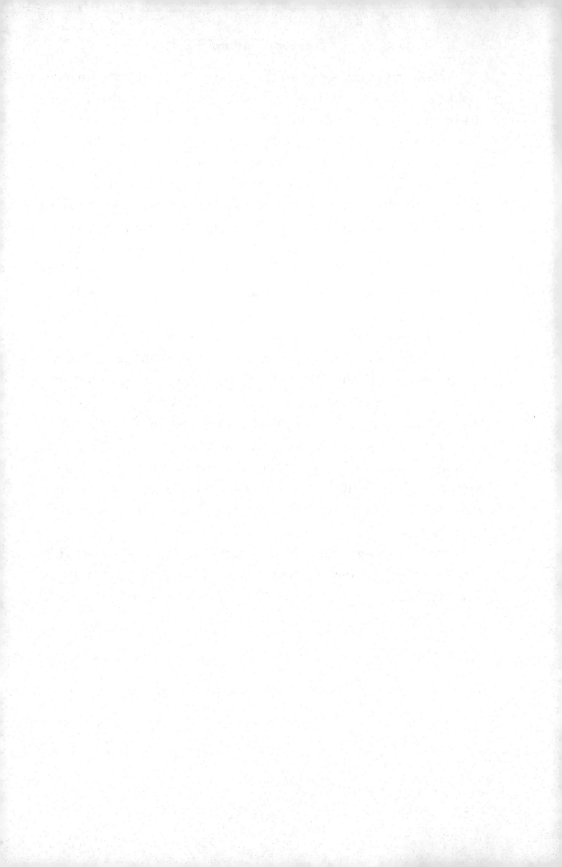

6. Environmental pollution

A. Air pollution

Primarily, the energy efficiency of 17 % to 20% in Otto engines has to be significantly ameliorated. If technologies are limited, the search for other fuel-burning technology must follow. Diesel engines pollute the air as well and should be improved. There are statements made by a Volkswagen manufacturer in Germany claiming that we can drive 100 Km on one liter (1Lt) of diesel oil, which amounts to 225 miles per US gallon. That seems to be far-fetched but nevertheless welcome. Today the average car gets only 25 to 30 miles per US gallon. Diesel engines today can already go over 55 to 60 miles per gallon.

An interesting introduction from General Motors, in February 2011, of an 'autonomous driving vehicle' for cities, promises less pollution, lower noise levels and the use of minimal parking space. Ideas for cars for the future are on the drawing boards or are already built and street-proven vehicles, but have no chance of being produced for general use because their gasoline or diesel consumption is minimal. Here the oil companies have the final word. They run the show. This autonomous car from GM is already advanced to the point that it could run successfully on our streets but unfortunately it will not be made available before about the year 2030. We can deduce from this statement that around 2030 or 2035 the oil supply will run out for general use by the citizenry or will be at an extremely low level. The important oil companies already know the approximate date of the end of crude oil supplies. They have the data on world oil reserves. Needless to say, they keep us in the dark and feed us the utopian fiction that oil reserves are endless. On the other hand, they use

scare tactics that the oil is running out soon to manipulate stock market price. What is really the truth? Even a kid could figure out that oil resources are not endless. Therefore we must use the still available fuel very sparingly.

Because of the limited availability of resources, existing development of hydrogen engines should be supported, advanced and implemented. We don't want to be dependent only on the oil companies' whim. Applying hydrogen technology, air pollution becomes practically nonexistent. But we cannot rest on just one idea. An idea is only a theoretical plan of action, while a positive decision is a validated plan of action. A stereotype is a plan of action accepted without validation. As we said, the strong act, the weak argue, over declarations. Remember, every action will receive its reward. A life with less air pollution serves everybody. Our health will be protected and appreciated. Nature becomes more inhabitable for both fauna and flora.

An engine operated by propane, or other light natural gases, produces much less air pollution than gasoline or diesel-oil engines. The technologies are in place and ready to be implemented. But, propane suppliers have to put the necessary infrastructure in place where it is missing. Engine producers have to provide engines not only for the automobile industry but also for use in all possible applications. We have to apply superior intelligence to environmental adjustments and adaptations.

Employing alternative energies is a promising adventure but the technology is trapped by the enormous need of batteries for energy storage. The life span of batteries is still short and replacement costs are too high. Also, batteries are highly toxic, and require careful disposal. Solar-cell technology has the same problem: energy storage. An interesting proposal was forwarded recently (2011) where fixed installed solar-cells in buildings would supply energy for engines. For cars that need to be driven during the day this represents a challenge for recharging the batteries of

the car. Under the next heading, B. *Electrical Pollution*, we take a closer look at these possibilities.

The most effective strategies, however, are to avoid unnecessary driving and flying, and to avoid air cooling and heating installations. Overheating and overcooling of stores has to end. The consumer will still make his purchases and will complain even less regarding not being in a heating/cooling 'comfort' zone. In fact, it is suggested that stores actually over-heat the air in order to numb consumers' thought processes and thus encourage impulsive buying. The reduction in energy consumption from these two life-changes would be significant in regards to pollution reduction and cost factors. It would also influence consumer item prices.

The consumer dictates by his purchase habits what is needed and what his wants are. Manufacturers normally produce only items they anticipate selling. Overstocking is not cost efficient. Energy consumption to produce these items is massive, and pollution is significant. Here the consumer can do his part to reduce environmental pollution. Western governments criticize the Chinese for their enormous air, land and water pollution. They do not, however, mention that we should consume fewer whimsical products, most of which are manufactured in China. It is always easier and more convenient to blame others. We have to refuse to buy items of no real value or purpose. We can easily do without them. This would also result in much less garbage. Plastic items are especially expensive and difficult to dispose of, and their production requires huge energy consumption and its resultant pollution. In addition, toxic fume pollutants from plastic manufacturing are expensive to eliminate. It is not sufficient to build higher exhaust chimneys. The actual level of toxic gases has to come down. What that would do to our environment is obvious.

Nor does using other fossil-fuel energy sources such as coal for producing electrical power represent a good solution. The

environmental impact is significant. Burning coal causes similar air pollution to that of oil. Mankind recognized the harm caused by coal-burning engines many years ago, and it is mainly used today for the production of electrical power.. Around such plants the environmental impact is visible for large distances downwind.

Our forests are a welcome renewable source of energy, but this resource is not used intelligently in every sector. For instance, the use of wood pulp for paper used in brochures and advertising flyers is definitely a waste of the resource. The paper is of high quality and discarded immediately. While many citizens now recycle such papers rather than sending them to the landfills, this also is wasteful since the recycling itself requires further use of energy. We don't really know what happens to the collected paper material. Is it recycled as the companies promised? We would not have to ask loggers to cut down all these trees if we would not waste so much ourselves. Protest efforts against logging would be better used against our wasteful behavior. Quit those unfair 'save the forest' slogans against the logging industry. Rather, use your efforts to sensitize fellow citizens against misuse of the resource. We can reduce energy and air pollution manifold by: first, reducing the amount of energy used in paper production; secondly, the amount of transportation energy used in distribution; and thirdly, reducing the energy cost of disposal of the wasted products. The collection, transport, disposal and burning thereof add to air pollution. It is a totally avoidable waste. We can reduce the use of pulp products drastically. Again it is only we who can do something against it.

"The contemplation of the immature and inactive human intellect should lead only to reactions of humility".

Conclusion/Suggestions:

Car pollution

- Choose and use only those cars which minimize fuel consumption
- Adapt car engine sizes to the needs and not wants
- Drive frugally with your car and think before driving; avoid unnecessary driving
- Drive sensibly and be energy conscious
- Purchase alternative-energy cars such as those which use hydrogen, propane, solar energy, etc.

Air traffic

- Avoid unnecessary flights, use the internet instead for meetings, discussions and sealing deals
- Combine, rationalize as well as justify, flights for business and pleasure.

B. Noise Pollution

We are plagued by all kinds of noise pollution. Every day we are bombarded with noise from all sides of the spectrum. Those who live along or in the vicinity of streets or industrial and commercial installations are burdened physically and mentally with noise that reaches the limit of personal sensory acceptance. Some have even suffered mental and physical breakdowns as a result. The need for hearing aids is on the increase. No doubt, noise protection strategies have been implemented successfully, such as the provision of ear protectors in industry and commercial sector workplaces and the muffler systems in cars and trucks. However, in our daily lives we make no effort to reduce the noise around us. Loud radios, TV and other electronic devices do their part in straining our senses. We give little attention to the right to privacy

of the individual or of his sensibility. Many inconsiderate actions such as using high volumes on radios and TV's, loud partying at night, and loud muffler systems on vehicles, could be listed that prove the point. Again, it is we who make the unnecessary noise pollution that can harm our health and sanity. We cannot blame others for our own actions.

The car industry has accomplished the task of reducing noise levels to an acceptable level with the exception of a few. The blame for vehicular noise emissions rests more with tire manufacturers. The problem is, however, manifold: road conditions, high speed, even sanctioned speed limits, driving habits and so-on make it difficult to find an all-encompassing solution. Tires have to meet safety standards for different road conditions. Wet, icy or snowy roads can be a real danger for drivers and passengers. Tire manufacturers must take these conditions into account and they do so. The consequence is that the noise level increases exponentially due to tire profiling adaptable to conditions. Also, on highways and freeways, tire noise increases according to speed. Great efforts have been made to reduce the impact of noise emissions in residential areas. Unfortunately, noise-abatement walls increase noise levels for the occupants of the vehicles by reflecting the noise back to its source. Wind noise should not be overlooked either. Unfortunately, all the efforts made by manufacturers and construction companies to reduce noise cannot take fully into account the human factor of behavior. Further, fuel consumption increases with speed. Combining both speed and noise, we have a bad polluter. Only the individual driver can determine the degree of understanding and consideration. Our attitude toward reducing noise is paramount. We can make a difference here as well. Whenever fairness and justice require an understanding of how a contemplated policy or procedure might affect us, experts are at hand to present their recommendations. We must listen to the professionals. We are not restricted due to

lack of knowledge. We cannot use that excuse any longer. There are many more noise sources, but the above reflection presents the idea. The challenge focuses in our direction. We create and produce the cause of noise emission and it is we who must take steps accordingly. Nobody else can do it for us.

Be loyal to the dictates of your highest convictions of truth and righteousness. Let our senses be the guiding spirit of the future. There is no nobler cause than to be compassionate. Give to life your highest values by being fair and honest. Apply your intelligence to the fullest extent of your inherited capacity. Show consideration that you may receive consideration and be a part of a responsible, rational considerate society.

Noise abatement is easy to accomplish. By applying common sense and showing consideration of the right for peace and quietness of each individual, we accomplish a great deed. Supporting all valuable efforts that bring relief from noise pollution is mandatory.

Conclusion/Suggestions:
- Apply common sense and avoid unnecessary noise pollution that can harm our health and sanity.
- Reduce personal unnecessary action and noise pollution such as using loud radios, TV's, and machines. Refrain from making loud noise after-hours.
- Utilize cars with low engine and driving noises.
- Support the good noise abatement solutions forwarded by private environmental organizations or government.
- Be vigilant in your assessment and action.

C. Waste pollution

On our planet we produce products and items that we must dispose of later. Some is natural compost. Biodegradable items decompose over time and turn into valuable soil. More are products made from fossil fuels, such as plastics. These products need another process for their disposal.

1. Compost utilization

All natural waste products, such as those made from vegetable matter, fall under the category of compostable. Disposal of waste products from kitchens and restaurants offers good opportunities to compost. We know biodegradable matter decays and produces valuable side products like rich garden soil and methane gas, also called bio-gas and compo-gas. Many restaurants supply their biomaterials, as food, to pig farms. Others dispose of the matter in their compost containers and, after it is decomposed, use it for their gardens. These are all known and well established procedures.

Collecting these bio-compost products in communal containers and depositing it in landfills is another way. Unfortunately potential benefits from landfills are seldom used. Benefits like compo-gas. Technological inventions make the extraction of biogas a reality. There are landfills that extract such gas in great quantities. Another way is to build compo-gas facilities (installed in Switzerland with great efficiency, see Appendix (10) that produce efficient biogas. Besides collecting the gas from compost, the remaining decayed material can be used as fertilizer and topsoil. According to the size of the plant facility, the extracted bio-gas can serve as supplier of energy for an electro plant or as heating energy source for a big

city. Such plants already exist and they prove to be very efficient. Costs are paid-off in a very short amortization period. Besides the benefits of gas and fertilizer such a plant represents a very good investment.

2. Plastic and non-renewable items

We produce so many items that are problematical to effective disposal. Recycling these items as an alternative is a costly proposition and requires high amounts of fuel or electrical energy. We must first drastically reduce our use of all kinds of aluminum, plastics and other basic oil products. Aluminum requires high energy consumption to extract from bauxite. We really don't need all that packaging or those containers for our daily chores. Installations to burn wasted plastic items are costly and represent a danger to our health. In Europe there exist installations to sort, collect and dispose of this waste in huge quantities in facilities constructed specifically for that purpose. They are, however, very expensive to run and they burden the environment with toxic exhaust fumes if no specific afterburner systems are installed. One way to utilize certain plastic waste is to sort, clean and make chips in a chipper to reuse in plastic manufacturing plants. Such a product might not be suitable for containing food or drink, but the quality is definitely good enough for other designated usage, such as grocery bags.

3. Household items

We are becoming a throw-away society with no regard for the waste that we cause. Go to a waste collecting place and observe what we dispose of: items that could be reused. We have to think in terms of exchange and not demonstrate false pride and the attitude: "we can afford it, we worked for it".

We say that professionally repairing items is a thing of the past. Labor costs are too high and it is less expensive to replace used items with new. That may be so, but is it wise? The ingenuity of people is invigorating, and sending discarded (but still in working order) or un- needed items to less unfortunate brethren are an act of common sense. That doesn't mean we should send our garbage to less fortunate fellows. No, we have to give only items that we can live without but are still functional, even if they are not of the newest and most sophisticated sort. The list is long and comes from our daily actions in the kitchen, the shop, entertainment, hobbies etc. Luckily, organizations like churches and flea markets exist already with recycle programs. Instead of throwing them into the garbage, bring them to these organizations.

Unused wood items also go to the dump. Is it shame, or false pride that keeps us from taking items we need from the pile to use for different projects? Re-use is the headword here, and serves many purposes. We have, unfortunately, the ingrained social attitude that taking from such a pile is pitiable. This is far from reality. Rather, it shows common sense and courage. It shows that we are not being influenced by faulty social morals. We have to stop the insanity and become human again, humans who are down to earth and not in the clouds of utopia.

Certainly we could list thousands of items that can be saved or reused. But the idea is given. We only have to adopt the principals and we will find solutions that make sense.

We have too much wealth. While this sort of wealth is not identical with individual high earnings, it still shows that many people pretend to be rich and burden their credit cards to the maximum. There are nations that

have people with an average individual debit and credit card amounting to as much as US $ 43,000. They are virtually bankrupt just because they don't want to miss being competitive with their neighbor. What insanity.

Conclusion/Suggestions:
- Utilizing all possible avenues to increase optimal usage of items is environmental efficiency.
- Compo-gas is a means of recuperation
- Reuse or donate still-valuable items and help organizations distribute them to less fortunate fellows.
- Plastic items must be recycled to reduce oil consumption and air pollution drastically.
- Do not throw everything into the waste basket. Contemplate what could be done with it. Become frugal and use common sense.
- Abandon false pride and any sense of social inadequacy. Don't let your false pride stand in the way of doing the right thing. We are in this world together; together we can solve our environmental waste.

D. Annotations

- The Kyoto Accord
 The accord stipulates that countries with air pollution that is far below the set environmental limits can sell their contingent (air pollution certificates) to nations with high pollution factors. This enables these nations to meet the stipulated pollution limits.
 Switzerland has difficulties in reaching these limits and is considering compensating by buying such certificates.

That defeats the purpose of reducing emissions from different sources of pollutants locally nationally and globaly. Further, it does not solve the real problem of concentrations of toxic gases or environmental impacts in agglomerations like cities. An example is Canada or other nations with low population density but large land and water area. Such nations are allowed to sell their certificates. But their waste pollution has not diminished.

However, in the big cities like Vancouver, Toronto or Ottawa and worldwide in cities there is often terrible smog which covers the city during no wind movement, causes the greenhouse effect and toxic air pollution results. This is not a global problem, it is a local problem. But allowing the sale and purchase of certificates doesn't help the environment. Somebody might call that hypocritical and pathetic. No wonder the USA didn't sign the accord and Canada withdrew from the Kyoto accord in 2011.

If the forum intends to solve the problem of global pollution it has to set clear and realistic rules and pollution limits without including softening loop-holes. The effort should be concentrated on reduction of pollution at its source. The forum needs to disallow current wasteful methods of using natural resources, and reward the development of better technologies and alternative methods/solutions. 'Otto motors should become an engine of an obsolete technology'.*

- The words of St. Jerome
 "If you walk laden with gold, you must beware of a robber. We struggle here on earth that elsewhere we may be crowned"

* From the free encyclopedia

Also known as Sophronius,* Jerome was a medieval church scholar, first a hermit and then a secretary to Pope Damasus in the 380s. From there he went to Palestine and devoted himself to study and writing. He wrote ecclesiastical histories, exegeses and translations, and is credited with shaping the Latin version of the Bible (called the Vulgate) from Hebrew and Greek texts.**

- 2011-12-01

 Mass interception of entire populations is not only a reality, it is a secret new industry spanning 25 countries.

 It sounds like something out of Hollywood, but as of today, mass interception systems, built by Western intelligence contractors, including for 'political opponents' are a reality.

 Today WikiLeaks began releasing a database of hundreds of documents from as many as 160 intelligence contractors in the mass surveillance industry. Working with Bugged Planet and Privacy International, as well as media organizations from six countries – ARD in Germany, The Bureau of Investigative Journalism in the UK, The Hindu in India, L'Espresso in Italy, OWNI in France and the Washington Post in the U.S. Wikileaks is shining a light on this secret industry that has boomed since September 11, 2001 and is worth billions of dollars per year. WikiLeaks has released 287 documents today, but the Spy Files project is ongoing and further information will be released this week and into next year.

 You can download torrent archive containing all released files from here.

* Name at birth: Eusebius Hieronymous. Read more: http://www.answers.com/topic/st-jerome#ixzz1iKakkTZI

** From the free encyclopedia

The Guantanamo Files: 779 classified prisoner dossiers revealed from the world's most notorious prison

- 2011-04-25
 In thousands of pages of documents dating from 2002 to early 2009 and never seen before by members of the public or the media, the cases of the majority of the prisoners held at Guantanamo — 758 out of 779 in total — are described in detail in memoranda from JTF-GTMO, the Joint Task Force at Guantanamo Bay, to US Southern Coand in Miami, Florida.

 These memoranda, which contain JTF-GTMO's recommendations about whether the prisoners in question should continue to be held, or should be released (transferred to their home governments, or to other governments) contain a wealth of important and previously undisclosed information, including health assessments, for example, and, in the cases of the majority of the 171 prisoners who are still held, photos (mostly for the first time ever).

 You may also download whole GITMO site from torrent.*

- Jesse Ventura: Conspiracy Theory"; 23.03.2012 OLN 21:00Hrs – 22:00hrs: "Water Conspiracy". In his televised documentary he expresses concerns and steadfastly declares that the multinational corporations steal our water with the approval of our elected government and that they have total control of our resources. He goes on:
 Water is like black gold, even more valuable. By controlling the water supply by privatization of the water the Multinational Corporations they control the world. Individual multi nationals like NESTLE (Great Lakes) or

* From the free encyclopedia

T. Boon Pickens, (Texas), Bush family (senior and junior) take control and power over the water supply by buying the water rights. Thereby they have the right to decide who gets water to what price and who has to die of thirst.

Selling bottled water with big profits, and by adding chemicals like viola or psychotic (mind delay/mind controlling) chemicals into the bottles. Bottles contain many poisons (uranium, lithium or fluorites) in plastic that can and will kill the unborn child or make the male sterile.

This multinational giant corporations bribe our politicians and corrupt governments to receive the sole water rights.*

"If you do not believe that just wait until it is too late. Can we take that risk?" (Comment done by the Author).

- Mathieu Roy: documentaire : survivre au progrès.
 He goes on to explain that:
 "Today, as the Romans before experienced the decline dissolving of the Empire, we are also going to hit the wall and still we continue this course of destruction".

 Progress is a two sided sword which shows the best and the worst of human. Our imagination allows us to invent technologies that can prolong our life expectancy and others that accelerate the destruction of the only place where one can live: Earth.

 Developing a global awareness – also between young and old citizen- to encounter the difficulties and be able to survive, to elevate the level of morality, and lead from words to action is required.

 Government will not do anything except they are forced by the citizens to change.

* From OLN TV, 23/03/2012, 21:00Hrs.

As Cicero and Seneca know and warned what was going on in Rome (as we well know the Roman Empire did collapse/dissolve) so does our government know but they do nothing to change the course towards a healthier direction.

China thinks the way of glory and prosperity and the way to happiness is to increase production and consummations of goods. America does that already over 50 years without having the citizen happier, content or free, actually the opposite is true.*

The dumping of all our garbage far out into the seas is appalling. How can a government accept such thoughtless actions? Who will pay for the consequences, the killing of marine live, plants and the cleanup of our shores?

* Survivre au Progrès. 1ˢᵗ of December 2011 ; L'Actualité. Vol. 36, #19, Page 50 (Free translation and interpretation by the Author).

7. Challenges for Alternative Solutions

A. Electrical pollution

In the past, our society has believed that we needed nuclear power plants to meet our increasing electrical power needs and at first glance, we appear to be right. But by reducing our power consumption we could alleviate the need. The possibilities for energy savings are endless. As mentioned above, electrical waste is unnecessary and costly.

The danger involved with nuclear power plants is real. It is a lucky twist of fate that only three nuclear power plants have caused disasters so far.* Just to read about how many people were harmed or killed is terrible and it could happen again. A serious scientist cannot guarantee that it will not happen. The possibilities of failure are endless and human error is also a great threat. We do not even need to mention possible terrorism. All these influences are out of our control and disasters can happen fast. There have been incidents in power plants and research facilities here that were fortunately discovered early enough to avoid nuclear disasters. We don't know when or where another could happen. Is it not better to be safe than sorry?

The need for nuclear power plants is not a given if we are prepared to adapt our behavior. We have options that could make such plants obsolete.

Germany pledged to close all nuclear Power Plants within a short time period. Nature provides us with so many power options like solar, geothermic layer, tides, magnetic fields and

*　　Three Mile Island, USA; Chernobyl, Russia; Fukushima, Japan; due to the Tsunami in 2011 **the last nuclear** power plant disaster occurred.

wind as energy sources. We only have to adapt our technology to the specific sources. More and more we recognize the potential of these energy sources and installations are under way. Solar cells, wind and solar collector facilities are gaining in popularity, especially in warmer, sunnier regions. Unfortunately, according to scientists in the US the technology is not very advanced. Solar cell facilities have an efficiency value of only 31 to 34 %. Windmills have a much better coefficient, but do emit noise and are to some an eye sore.

The idea of utilizing solar cell technology to charge the batteries of cars seems to be a good proposal. However, the time to recharge the car is best done during the day and in the evenings, when many cars are in use. At night we don't get the benefit of the sun so we would have to store the electricity gained during the day in bothersome, inefficient and toxic battery systems. There is a better solution. All energy collected during the day from solar cells should be transferred into the public power system and returned at night for recharging car batteries. Batteries are troublesome and toxic, and need to be significantly improved, made smaller, lighter and more durable.

It would make sense to transfer the electricity over and above what we need for our own use during the day into the main electric power lines system. Power companies would pay for our surplus. We conclude, from the night tariffs, that an energy surplus exists during the night and a shortage during the day. During the day power companies would welcome that extra supply to meet the high demands of industry and commerce. By joining in that effort of increasing solar cell installations for nearly every household over time we could help avoid the construction of multiple nuclear power plants. If all homeowners joined the movement to install solar collectors, where enough sun is available, and power companies paid for homeowners' surplus, we could easily avoid the construction of additional nuclear plants.

California and other States build huge solar-cell and windmill installations for their increasing electrical demand. They have large desert areas and the environmental impact is minimal. But we don't need deserts to build massive solar plants. We can do it by utilizing areas of roofs and non-aesthetically consequential places. Electrical power could be channeled into main electrical power lines without costly installations. In North America electric power plant entrepreneurs are already committed by law to accept all electricity produced outside their plants and compensate for it. The cost of building and installing solar cells would be drastically reduced due to mass production and any auxiliary costs would be made up over time through the power companies' payments.

The only thing we must prevent is the oil companies getting the patent for cell technology. If this were to happen these companies would gain control. Who owns the patents will decide when and who can utilize the technology. We must support independent and small enterprises that have good solutions or products for reducing negative environmental impacts. At first, they may not be perfect but that's true of all new inventions and technologies. Over time, if we allow engineers to be inventive, improvements will follow. Again, it is up to us if we want to improve our environment and our lives.

Electro-magnetic fields are a source of health risk. By installing high-power lines away from living space, the danger can be held to a minimum. Also, emissions from cell phones and electronic items could potentially have ill effects on our health. Scientists continue to say they are convinced that there could be ill effects. But, maybe they don't want to, or are not allowed to, tell us the real effects because the consequences would be devastating to those in power. We should avoid all excessive use of potentially dangerous electronic items.

B. Nuclear pollution

The scariest part of all is environmental endangerment. It remains a fact that the world's military nuclear arsenals are readily available and could be employed on the whim of a political leader. Such an act would be insane, but it is possible. What can we do? The only possibility we have is to insist that the arsenals are annihilated. That will be a tough sale because of the excuse that the "enemy" also has those weapons and we must be protected from possible attacks, right? As it plays today we have no real adversaries, only created or fictional ones. That's done to enable manufacturers to produce war materials and for governments to spend billions or trillions of tax dollars for the war industry. These companies are powerful because they are owned by the financial powers.

The world is plagued with over 43 wars at the time of writing. That does not account the unrest in the Middle East. Weapons, ammunition and transport vehicles have to be supplied to nations of unrest and the cycle goes on. The environment is, besides the human tragedy, the victim of the insanity. Are these fighting people aware that they are not fighting for their cause of democracy or freedom but rather for the change in power by corrupted, power hungry dictators? It really doesn't matter what face is in power; the system never changes unless we are prepared and willing to elect leaders who respect the will of the people more than the wish to fill their own pockets.

The threat of a disaster accompanies such instable and corrupt leaders (dictators). The environment is a secondary concern for them but for us it is vital. The destruction of valuable human stock and genes and of animal species is a loss forever. We live in an environment in which fauna, flora and humans must live in harmony. Destruction of even a part of it can have lasting effects. Wars are predestinated for that purpose. It is we who can prevent wars that the powers want us to conduct. This is a global

problem and we have to educate the people, awaken them to the corrupt manipulation that convinces them. It is not ourselves that we should fight for. We should rather put our efforts into environmental battles to save our planet. Nuclear threat is real and scary. A nuclear war will obliterate our planet if we give that possibility to insane politicians or dictators. We have to take away that right of the leaders. Such decisions cannot be made by one person alone. For that matter nobody should be able to make that decision because the weapons should be scientifically destroyed before that insanity could happen.

Conclusion/Suggestions:
- The problem of preventing a nuclear disaster is a challenging and demanding task. Convincing the government – who is actually the government? - to drastically reduce or even obliterate the military nuclear arsenal has first priority.
- Reminding our representatives of their duty to fulfill the wishes of their constituents should be obvious.
- Convincing other nations regarding the danger of obliterating humanity and reminding them that this is not the way humanity should end. This can convince even the hardest fanatic.
- The real problem with all this is that we cannot trust our leaders to be reasonable and honest. If Hitler, Stalin or Mussolini had the bombs at hand they might well have used them to fullest extent.
- America is the only country to use nuclear bombs against innocent civilization. If we can't trust the western government how can we trust other nations? The priority is clear.
- We don't know what hysterical and insane leaders will enter the world scene.
- Not having these weapons in store in the first place will prevent a total disaster.

- To prevent any nation from building nuclear bombs the nuclear raw material must be protected against misuse.

C. Alternative Solutions

1. Tidal current power

Tidal currents are potentially a great power source that we should make use of, especially for coastal regions. Give the engineers the chance to research and we will receive valuable alternative power production. They will find a renewable power technology with lasting potential.

2. Geothermic power

In Iceland the government made use of thermal heat from volcanic sources a reality. Entire cities are heated and provided with power. Geothermic heat is free and does not decrease over time. The inner magma of our planet is an enormous pool of energy. Again, we must give engineers and researchers a reasonable chance to find even better solutions and valuable options. We can do it.

Conclusion/Suggestions:
- Making the most of tidal and geothermic energy is mandatory.
- The technologies are for the main part in place. They can only be improved.
- Proactively involving ourselves, supporting good research, takes the decision-making power away from the currently ruling financial powers.
- Alternative power producing options precludes the building of further nuclear power plants.

3. Magnetic power

The whole world works on the principles of magnetic power. As described earlier, magnetic fields of our planet and the cosmos around us work on the principal of magnetic attraction and de-traction. We have only to tap into this power source and we are in business. It seems farfetched to utilize magnetic power. But for our clever and intellectual researcher this would be a satisfying challenge. We can soon expect results from researchers if we give them the support and opportunity. Finances could be funded by donation from our pockets. The more we participate the more chance there is that we will quickly receive viable solutions that will not be subject to the financial powers' dictation of how and when the new technology can be used.

4. Gravity power

Not a lot of thought has been directed towards utilization of gravity power. It is also a source of unimaginable potential. The search should be concentrated on these four potential power resources. The will and knowledge is out there.

Conclusion/Suggestions:
- Gravity and magnetic powers have great energy potential for utilization.
- The technologies are not yet fully established.
- Engaging efforts toward the utilization of such powers is rewarding.
- We have to gain control over the technology and use of these alternative power sources.

D. Food Additives

Food additives are a danger to our health and should be disallowed. More and more such additives and preservatives are incorporated in our daily food items. The result is an increase in numbers of human allergies. There are already too many allergies caused by food alterations and preservation to be listed. Pharmaceutical prescriptions may fight the effects of these additives but not the cause. But, the pharmaceutical industry makes millions from them. The negative consequences to the human body are terrifying. Is the increase of cancer a result of those medications and additives? Only time will tell, but by then it will be too late for many sufferers.

We must insist on reducing the number of chemical additives in our food. Our health suffers from their invasion of our bodies. Even animals bear the consequence and often die from such manipulation. Natural food has become a rarity. How do we solve the dilemma? Foremost, we can refuse to accept such manipulated food items. Secondly, we need to waste less food so that the agricultural industry can supply enough for us all without chemical genetic alteration.

Over the years citizens all over the globe have consumed meat that was contaminated from:

a) PBB (poly-bromide biphenyl), a cancer agent
b) TSE (transmissible spongiform encephalopathic disease) causing in humans Creutzfeldt-Jakob disease; proteins that enter our brain and destroy all the cells. This is also known as mad cow disease.
c) There are similar diseases causing heavy reaction that we do not even really know and cannot deal with, primary or secondary reactions from contaminated meat. The list could go on. Only time will tell what will happen. New diseases will suddenly appear. Chemical agents that

are fed to the animals are a lethal danger to humans and animals alike. And what are we doing feeding meat products to herbivores in the first place? That's how this problem first came into the food chain. They include waste from slaughtered cows in the food pellets given to the next batch.

We know that our food and medicine could be poisoned. According to Dr. Rema Laibow in Jesse Ventura's interview (6) the possibility of a government-forced vaccination which contains squeline exists. The result of such a vaccination will be a pandemic and will trigger genocide. Does the government plan such drastic measures? According to Jesse Ventura (6) and David Icke (8) the government is responsible. The Bilderberger concludes that the world population number is 500 Million citizens too high. Drastic measures (soft killing instead of additional wars) are considered in order to curb the population explosion. Is that really what they think? That means that governmental introduction of diseases that call for vaccination could become reality. By vaccinating people against introduced disease the government could force people to also take a vaccination which contains agents that cause infertility in the population. Is the plan to enforce the vaccination with 400,000 soldiers already in place? (5).

Other Additives

Today we are often confused and concerned about chemical additives with potential toxicity, and rightly so. They can be found in food, bottles, cosmetics, paint, toothpaste, sunscreens and more. Anti-bacterial agents are found in clothes, soaps and tissues. Unsurprisingly, our bodies are increasingly reacting to such additives with allergies, intolerance to certain foods, higher rates of cancer and increased susceptibility to all kinds of diseases. We spend billions upon billions for cancer research and on the other hand allow additives that can cause health problems. Therefore, all labels should by law indicate the chemical contents and reveal

JAMES BURK

the degree of toxicity and health risks. The main ingredients in food and medications are regulated by a majority of governments. The only question is: can we trust all governments to regulate all chemical ingredients so that they are really safe for us to consume or to utilize?

We should, however, be even more alarmed and concerned with chemical particles, that are not regulated, in our food and products; *Nanoparticles* such as *titanium dioxide* and *zinc oxide*. To date, practically nothing is governmentally regulated. Science, however, claimed decades ago that Nanoparticles, because they are so minute, can cause health problems by penetrating deeply into the lungs, skin, blood, brain and into the placentas of pregnant women. According to Alex Roslin* "the government officials don't seem interested in his (Schiestl) findings".

Did not Jesse Ventura warn us about the possibility that government officials are restricted in their duty, persuaded to ignore the danger? The question is: is this the alleged 'Bilderberg Society's plan' to influence the chemical industry toward using 'invisible poison' to reduce the planet's population of approximately 500 Million people, for whatever reasons they may have real?

That is *really scary*. What can, what should we do?

Firstly, we must put political pressure on government to prohibit the use of *Nanoparticles*, especially *titanium dioxide* and *zinc oxide* in any product for consumption until research proves beyond any doubt that these Nanoparticles are safe for human use and consumption. I am convinced that there are definitely more unhealthy chemical agents in our foods than we know.

Secondly, we must inform ourselves regarding all ingredients in all products and make conscious decisions and, if justified, *refuse* to buy and consume items containing Nanoparticles or other chemical agents. Unfortunately, the manufacturer is not

*

required to mention the content of Nanoparticles in his products, as yet.

Thirdly, we must demand that all products be clearly marked with all their contents as well as any other possible dangers to our health, in the same way as are medical prescriptions and over-the-counter health products. We have to recognize that the list of ingredients will become longer and only a few will be able to fully understand the substantiation and implications.

Lastly, we must demand from the government that the lists of substances in foods and products should be separated between 'good and bad' ingredients. Chemical 'mumbo jumbo' must be avoided; not everyone is a chemist. If the pharmaceutical industry doesn't want to list all ingredients it should be mandatory to list those items that could endanger our health. Such a measure would give us the choice to use or refuse these products.

Our health is paramount to us and the government as our "agent" must be vigilant to prevent unhealthy products from coming on the market. We cannot expect that the general population has the basic knowledge to fully understand the question of toxicity and chemical effects on our health. The experts (scientists) have to become trustworthy and honest. Our health and wellbeing should always be on their agenda. Can they do that? Will they?

Conclusion/Suggestions:
- Reducing concentrated fertilizer is a first step toward removing concentrated chemical substances from our food.
- Food processing plants must exclude additives for safeguarding the food and use natural methods to maintain their freshness. The know-how is available. Manipulated or chemically altered food items must be off the shelves.
- The effects of genetically altered food are not clear and represent in certain instances great danger.

- Feeding herbivorous animals with chemically altered food, contaminating it with animal parts, is unethical, dangerous and damaging to our health and that of the animals. Feed producers have made herbivores such as the cow become carnivores (meat eater). Chickens are fed all kinds of powdery substances that could have toxic agents, and anti-biotics in low quantities that do not show the effect immediately. Later down the road we react and suffer the consequences.

- Injecting cows or other animals with growth hormones or other medications/vaccines could be dangerous to human consumption.

- In his cynical way M. Moore, (4) explains in his book how we arrived at that situation.

- We are at the top of the food chain and take the brunt in the end. The consequences are quite clearly visible in our rising disease.

- Stop the insanity of eating food items that are not actual food. (Often referred to as 'food products'.)

- Avoid food or drinks that are stressors to our bodies and our wellbeing. Some known super drinks proved even to be deadly.

- Eat only food that keeps you healthy and happy. Don't always trust publications that are not proven by reliable research. We don't really know how much our food, medicine, and vaccinations are aimed at disaster instead of being treatment against illness. Allergies are only one of many possibilities. Read the important information on the product label and you realize the danger that is lurking.

- There are definitely more such incidents happening that we are not informed of. That's a scary scenario.

- Write to your representative and insist on a clear and decisive answer.

- Don't be satisfied with loose explanations that do not clarify the issue.
- We the people have the power to act against the wrong-doers and when we do the result will be that they will back up and either cancel, or at least justify their actions by more thorough research.

E. Genetically Altered/Modified Foods

We know since the beginning of time nature has regularly performed gene modifications in flora and fauna and continues to do so. The effects are beneficial for all species on earth. Our scientists started to copy nature and sped up this process through intensive research of genes and DNA. Even ancient man has provoked mutations and modification of the fauna and flora by cross-breeding and cross-fertilizing. But that did not require the insertion of genes from different species. Through molecular biology scientists select instead and artificially introduce a precise gene, into the DNA. They choose those genes which correspond to a desired characteristic currently lacking, in the hope that it will integrate. To believe that the modified plant will react differently because the same mechanisms of the genome are at work is without reason. The idea of GM is mainly the employment of natural molecular biology. But nature and science both end up by mutating the genes in a host plant which will show the desired characteristics.

'Genetically modified foods (GM foods, or biotech foods) are foods derived from genetically modified organisms. Genetically modified organisms have had specific changes introduced into their DNA by genetic engineering techniques. These techniques are much more precise than mutagenesis (mutation breeding) where an

organism is exposed to radiation or chemicals to create a non-specific but stable change. Other techniques by which humans modify food organisms include selective breeding; plant breeding, and animal breeding, and somaclonal variation.' *

'Commercial sale of genetically modified foods began in earnest in 1996. Typically, genetically modified foods are transgenic , corn, plant products: soybean canola, rice, and cotton seed oil. These may have been engineered for faster growth, resistance to pathogens, production of extra nutrients, or any other beneficial purpose. Animal products have also been developed, although as of July 2010 none are currently on the market.[2] In 2006, a pig was engineered to produce omega-3 fatty acids through the expression of a roundworm gene.**

Researchers have also developed a genetically modified breed of pigs that are able to absorb phosphorus more efficiently, and as a consequence the phosphorus content of their manure is reduced by as much as 60%.'***

We understand that we already have a high number of GM fruits and animals parts (see appendix) in our food chain. Colelucine (a potent toxin) was used successfully to achieve seedless fruits like water melons, grapes, oranges and the like. Others were treated with radiation to achieve new fruits like 'pomelos'. (11). Today half of all plants are cultured and modified by this method of insertion or deletion of genes.

As with most everything humans do, there exists always the possibility of excess. But between the government and the science community should be an understanding that research should be

* http://en.wikipedia.org/wiki/Genetically_modified_food - cite_note-4
** http://en.wikipedia.org/wiki/Genetically_modified_food - cite_note-5
*** From Wikipedia, the free encyclopedia, 2012
 Note: see also 10. Appendix

able to be done without interference, rules and regulations of the government. The results of the findings should, however, be, before implementation, discussed regarding their validity, possibilities and consequences. These wishes from the scientists should be listened to.

'Genetic modification involves the insertion or deletion of genes. In the process of cisgenesis, genes are artificially transferred between organisms that could be conventionally bred. In the process of transgenesis, genes from a different species are inserted, which is a form of horizontal gene transfer. In nature this can occur when exogenous DNA penetrates the cell membrane for any reason. To do this artificially may require transferring genes as part of an attenuated virus genome or physically inserting the extra DNA into the nucleus of the intended host using a microsyringe, or as a coating on gold nanoparticles fired from a gene gun. However, other methods exploit natural forms of gene transfer, such as the ability of Agrobacterium to transfer genetic material to plants, and the ability of lentiviruses to transfer genes to animal cells.

Introducing new genes into plants requires a promoter specific to the area where the gene is to be expressed. For instance, if we want the gene to express only rice grains and not in leaves, then an endosperm-specific promoter would be used. Thecodons of the gene must also be optimized for the organism due to codon usage bias. The transgenic gene products should also be able to be denatured by heat so that they are destroyed during cooking.*

Do such GM's not contain a high risk of contamination of wild plants or insects? But as Nina Fedoroff (11) explains a gene

* From Wikipedia, the free encyclopedia, August 2012

is not a fish implanted in a vegetable, and therefore merely an institution.

The European Union has spent $ 425 Mill. to study the bio-safety of the organic modified genes with the result that these foods are not more dangerous than the non-modified cultures. The National Academy of the USA and the Royal Society of Great Britain express the same opinion. Since 1975 there are rules by the government of the United States in place that regulate the permission process and the limitations of GM in food production.

The enrichment of food items with vitamins could save millions of mal-nourished children in the world. For instance rice is already enriched with vitamin C since 10 years ago but the big corporations hinder the rice distribution. Nations with a high number of citizens are practically forced to allow GM into the food production due to the shortage of food. At a continuous rate of population explosion (in 2025 there will be 10 to 12 billion Inhabitants on this planet) we will definitely run into an essential food shortage without intensive methods of producing nutrition. Natural catastrophes like draughts, heat waves, and storms will undoubtedly increase the severity of food shortage. Only GM plants can be made to survive such catastrophes.

What will be easier to process, the starvation of billions of people due to the food shortage or acceptance of GM food items that have none or only marginal negative effects on humans?

Conclusion/Suggestions:

There exist multiple solutions:
- Support research for even better and safer methods of dealing with GM in fauna and flora.
- Reduce the waste of food in affluent societies for the benefit of the needy.

- Introduce programs to help curb population explosion with such methods as family planning programs, and *promote* education to help less educated citizens reduce their numbers of offspring.
- Prevent the big corporations from dictating what kind of food items can or cannot be distributed to the consumer. The small enterprises should have the same possibility to introduce and distribute food supplies by accessing scientific knowledge and approved methods that fall under the regulations of the government and are today only available and affordable by the big corporations. That would reduce the unjustified high consumer food cost.
- Scientific research should not be hampered by restrictive rules and regulations that prevent science from finding better solutions.
- Results of new discoveries should be publicly presented with all the positive and negative aspects of the findings and given the reasons behind government approval and permits of implementation.
- Force governments to inform the public of all past and future knowledge and educate them regarding the implications and reasons for the acceptance of food for consumption.

F. Psychological and Mental Limits

We encounter mental poisons of fear, anger, envy, jealousy, suspicion, intolerance and apathy daily, without thinking that this negativity is also a part of our environment. Our mental health can deteriorate to the point of mental illness. The penalties of this condition are an increase in healthcare costs and absence from work as well as suffering. A great number of people are influenced

by this negativity. A positive attitude and atmosphere in our environment is necessary for our wellbeing. Joy and happiness are the outcome of a good life.

Even the evildoer enjoys a season of grace before the time of the full ripening of his evil deeds, but inevitably there must come the full harvest. Injustice done to your fellows will come back upon you. The creature cannot escape the consequences of his deeds.

Conclusion/Suggestions:
- Become a positive and compassionate human being who brings only joy and happiness to all.
- Remember, every positive act shall receive its rewards. Evil results in sorrow and pain.
- Ennobling and inspiring association finds its ideal possibilities and rewards. If you can build up such trustworthy and effective attitudes towards mankind and associations the world will become a glorified social structure, the civilization of a mature humanity.
- Even though such a society would not be perfect or entirely free from evil, it would at least approach the stabilization of maturity.

G. Anticipation

We live in an age of turbulence and uncertainty. We are, however, aware of our environmental difficulties. But we feel powerless, and as a result we demonstrate apathy.

A society is only as strong as its weakest link. The people have to be made aware of chances to ameliorate their environment, enrich their lives, and achieve happiness. Power must be returned to the people and all institutions, governments and politicians

must serve the people's agenda, not their own. The government is and should always be the extension of the people's will. Only then can governance by the people, for the people, be fostered. Citizens must take back the right to decide their future and the future of their children. Too many decisions that stray far from the wishes of the people are taken by government and administration.

To change this situation and our failing system, reliable leaders who can implement positive change with lasting effects by using the power of the citizenry must be selected. Our existence has to have a free and livable environment. Manipulation and atrocities must be replaced by justice, compassion and liberty. Today these attributes are only given lip service. Honesty, real justice, love for each other and reasoning must become the guidelines of a new society. This is no utopian dream. It is the citizen who must make the final decisions for the future, not any super power.

Humans have to grow up and become responsible citizens with only the wellbeing of other humans in mind. Whenever fairness and justice require an understanding of how a contemplated policy or procedure would affect the future, there should be chosen honest leaders at hand to present their recommendations; they should be present to speak for those who cannot be present to speak for themselves.

We need to attack the task at hand with tenacity to reach reasonable goals of better environment.

We need an environment which will diminish material waste, reduce wasteful fuel consumption, avoid unnecessary noise pollution, and reduce driving and flying and all other unnecessary activities that pollute and burden the planet with toxins and other waste. It is the business and duty of society to establish a fair and peaceful opportunity to pursue self-maintenance, participate in self-perpetuation, and enjoy some measure of self-gratification; the sum of all three constituting human happiness.

Begin in small groups and let it grow worldwide. It does not benefit only us; everybody will have a better physical, mental and spiritual environment.

As soon as we have a solid, fair and honest government, as soon as we have become responsible citizens, we can begin in seriousness to make changes to our environment and to the political and financial world we live in. This includes rejecting the way powerful industry and finance manipulate our actions.

Our environment includes, besides technical pollution problems, conditions which affect our mental and physical wellbeing. To be well and happy we need a healthy environment. Avoiding mental pollution is, besides air, land and water pollution, the most important factor in our endeavors to live healthy lives. If we really want total health, we have to put all our will, forces and tenacity into efforts to succeed. It is not an easy task but who says life is easy?

Conclusion/Suggestions:
- We must change our wasteful habits. Garbage mountains must disappear.
- We must steer our ship in a more moderate and less destructive way.
- Avoid self-serving behaviors.
- Avoid abhorrent behavior, express shock at atrocities and alleviate misery.
- Practice love, respect, trust, compassion, altruism, and unconditional help for others. These are the only attributes that make us happy.
- Adopt the goal of making our world, our environment, healthy and livable.
- Live in peace and harmony.
- Practice what we learned from our religions and our convictions.
- Work to live the gift of life in optimal conditions.

- Become healthier, happier and fulfilled.
- Reject anything that might lead us off the path of righteousness because that is what we crave and what will satisfy.
- Make our total environment of paramount importance. Treat it with respect and utmost consideration.

H. Energy Facts and Conservation Ideas

Oil Prices 1861 2007

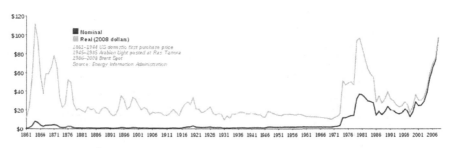

Long-term oil prices

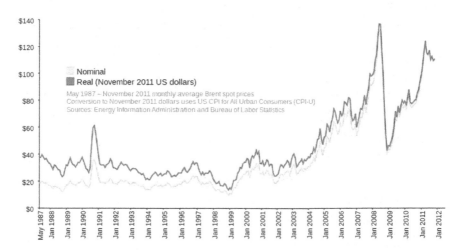

USA Oil Price graphics

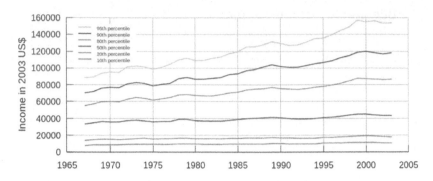

Distribution of household income

In the United States of America from 1967 through 2003. Numbers are normalized to 2003 United States dollars. The data source is DeNavas-Walt, Carmen; Bernadette D. Proctor, Robert J. Mills (08 2004). Table A-3: Selected Measures of Household Income Dispersion: 1967 to 2003 (PDF). *Income, Poverty, and Health Insurance Coverage in the United States: 2003* 36–37. U.S. Census Bureau. Retrieved on 2007-06-16.*

Conclusions/Suggestions for drivers:
- Demand improving the energy efficiency of the Otto of engine, (German invention of a combustion engine; invented 1876).
- Utilize diesel oil engines which use less than 4 liters of oil/100 Km.
- Invest in 'autonomous vehicles' if they provide better consumption.
- Support and invest in development of hydrogen vehicles.
- Use existing Propane and other light gases.
- Support all efforts for alternative technology even when they are not yet perfect.

* From the free encyclopedia

- Consider questioning hybrid systems regarding battery disposal.
- Insist that private home-produced solar energy surplus be bought by the power companies.
- Insist that solar energy technology improve from 34% to approx. 80% efficiency.
- Avoid unnecessary driving.
- Invest in alternative solutions like compo-gas.
- Become frugal in using fossil fuels, non-renewable resource products. Fuel is the biggest part of a car's running costs.
- Do not carry junk in the trunk; extra weight increases fuel consumption.
- Keep tire pressure up to specifications. Low pressure increases gas consumption.
- Reduce speed to conserve fuels.
- Drive smoothly, at even speeds, to conserve fuel. Avoid sudden speed changes or unnecessary revving of the engine.
- Remove roof- top carriers and racks if they are not needed. They cause aerodynamic drag, increasing fuel consumption.
- Consider leaving for work before or after rush-hours to avoid fuel waste.
- Car pool wherever possible. (approx. 20% cost cut per person)
- Avoid idling the motor unnecessarily. Idling a cold engine causes harmful deposits that reduce efficiency. It is better to start the car and drive slowly off. The engine warms up better and faster and if done properly no ill effects occur.
- In choosing a car, check and analyze all alternative solutions like electro-engines and propane engines and decide for the least environmental impact.

- List all your fuel saving ideas following the above mentioned suggestions. There are environmental societies as well as the government with brochures which can help you. Writing it down enables you to make your own decision on a list of energy saving measures.

Other suggestions:
- Insist on reducing the use of air conditioning units in all applications.
- Refuse to accept advertising pamphlets and brochures.
- Use and waste fewer pulp products.
- Use common sense to reduce all actions that cause unnecessary pollution.

I. Conclusion

Confusion, powerlessness and apathy are rampant in our current society. Governments and politicians thrive on such uncertainties. They make no effort to instill help into our thoughts. Rather, they see the opportunity to keep us in check. We are in their power. We have no part in the decision making.

For too long, governments and politicians have managed the business of state according to the interests of the financial powers. Certainly they speak of freedom of the individual, of prosperity and wellbeing. But the more they try to convince us of their good intentions the further they stray from the truth. It is not shameful that we have lost our personal freedom through manipulation? If we deny that such intrigues exist in the world we should count on our fingers the real freedoms we have. No cheating is allowed. Freedom is what our forefathers have called for. But, realistically everything is legislated. Every move is regulated and restricted in both business and private sectors. Nothing can be

done without the state having a say in it. That is pollution of the social environment.

In the USA the manipulative machinery is so strong that even docile people are manipulated into hysteria so that they don't even know they are misused. In elections such manipulative tools are obviously used and are well documented.

There is no error greater than self-deception which leads intelligent beings to crave the exercise of power over others for the purpose of depriving others of their natural liberties. The golden rule of human fairness cries out against all such fraud, unfairness, selfishness, and unrighteousness. Only true and genuine liberty is compatible with the reign of love.

Only by changing our attitudes and goals in life can we be successful in establishing our children's future. By applying trust to each other, giving and receiving, we set our standards at an intelligent level. We cannot, however, afford to go to extremes either.

If you observe Gore's work in regard to global warming it becomes clear that he is confused. As delicate a matter as the global warming effect should not be presented in such an erroneous way. Serious scientists disagree with Gore's presentation. Checking all data from over one hundred years proves that our globe warmed up significantly due to normal cosmic cycles. If you do not believe that statement, consult the internet and search for this German scientific source: (Technischer Überwachungs-Verein, Deutschland) TüV.

Blaming the man on the street for temperature change is typical. And for that Al Gore received high recognition? Locally, environmental pollution is visible, as are smog and vegetation loss due to acid rain, for example. Another example is heat pooling in cities; what is referred to as the 'heat sink' from concrete, asphalt and glass buildings, air pollution and the absence of wind. Yes,

locally that's unhealthy. Globally, however, the earth's flora, its plant life, needs our CO_2. Seventy-five percent of the earth's surface is covered by water. Earth's remaining land surface has a high percentage of forested and agricultural area as well. What we must be aware of, is the growing pollution of the oceans and the destruction of our forests. If they are decimated, then air pollution will become a definite global issue.

The politicians loved Gore's crusade. It gave them further possibilities for introducing new laws that only penalize the citizen. The big polluters can go on polluting without being labeled guilty. This is no surprise. Make a smoke-screen and nearly everybody goes for it.

K. Our Future

We go through life without realizing what we are doing to our environment, which includes not only the natural world and the space in which we live, but also that which affects our mental health. The package is too large for us to deal with. We have made our lives too complicated. We seem to have lost all sense of compassion and love for each other. If you reject that statement and think that humans do love each other you may have a point. Animals have certain reproductive affection as well as we, but humans are capable of genuine love for each other. Only humans are capable of genuine love, trust and compassion for each other. However, negative forces are hard at work to destroy that love, a trait that is unknown in the rest of the animal kingdom.

Developing understanding is part of maturing and becoming valuable citizens. Without empathy, trust and love for each other we will destroy our-selves. Our environment is a valuable and essential part of our being. Destroying our room to exist gives us little chance to survive. There are so many challenges we have to

deal with. Putting our heads in the sand and letting governments or dictators do the job turns us into robots and zombies who have nothing to say and who accept unquestioningly everything that is dictated to us. We are subject to the whims of those in power. But, they introduce laws and restrictions that we should not accept. We become slaves of our own indecision. We have never been wholly liberated from the slavery of custom. Moneylenders, the banks, make themselves kings by creating a standing army of debtors. Today thousands of people allow personal ambition to enslave them to debt. Involuntary slavery has given way to a new and improved form of modified industrial servitude. Our modern society is in reverse. The threat of standardized industrial slavery and personal stagnation is rampant. *'Labor is ennobling but drudgery is benumbing'. *(1)*. Industry, war, slavery, and civil government arose in response to the social evolution of man in his natural environment. Nothing in human history is designed to excite more pity than this picture of man's abject slavery.

A Slave attitude: '.... .. may, resigned to submission to tradition and authority. Or it may be satisfied with slight attainments, just enough to stabilize daily living, and therefore becomes arrested on an adventitious level. Such people believe in letting well enough alone. Others progress to the level of logical intellectuality but stagnate there in consequence of cultural slavery. It is indeed pitiful to behold giant intellects held so securely within the cruel grasp of cultural bondage. It is equally pathetic to observe those who trade their cultural bondage for the materialistic fetters of a science, falsely so called. Then there are those that attain freedom from all conventional and traditional handicaps and dare to think, act, and live honestly, loyally, fearlessly, and truthfully.'**(1).

* (1) ,UB, P.786 - §8 6
** (1) UB, P.1114 - §2

If you enjoyed the inspiring satisfaction of knowing truth and love then you might employ your powers of speech to liberate your fellows from the bondage of darkness and the slavery of ignorance.

Suppression, abeyance and conformity to the rules of power make the citizen subject to their will. Education, magic, medicine, art, literature, law, government, morals all become slaves to the whim of power. We are betrayed into the tyranny of political and economic slavery. Nobody wants that, or do they?

We have to free ourselves from dictatorship and become responsible human beings who have a decisive role in all matters of our existence. Our environment must become clean in all sectors in spite of uncertainties and hindrances. Life is a constant challenge and difficulties are part of our endeavor. Those who are strong act in spite of difficulties. Tenacity is necessary to reach the goals of self-maintenance and freedom. Setbacks will accompany the task but the strong and determined win in the end.

A healthy environment is vital for survival and for a happy life. We are designed to conquer all difficulties. Together we can and we will do it. Peace, love and happiness are the most important factors for us and our environment. They hold negative impact to a minimum. Our planet can become livable in the future for us and our children's children.

8. Final Thoughts for Parts 1 and 2

We have to recognize the political, economic, and environmental dilemma that we face. Unless we do, we will not be able to achieve our own and our offspring's future as we envision: free of oppression, having freedom of speech and expression, having equal rights for everybody, and having enough food, clean water, work and good health for all. That's an ambitious plan, unrealistic you might say, but if we don't try, certainly we will not succeed. Do we realize that we are basically egotistic and unwilling to give up our luxury for our fellow humans in need? No, that is certainly not true of everybody; we have many good citizens out there who would spare nothing to help people in need.

One way to accomplish this better world is to stop buying unnecessary gadgets and 'wants', restricting ourselves to only the really needed items. A second worthwhile target is reducing our waste and environmental pollution. Thirdly, finding alternative solutions to preserve our natural resources is essential. We cannot be concerned with only our life span; we must provide a viable future for our offspring.

The above statements are probably bold and futuristic in some ways. However, we know that we have to pause and consider what we really want in life. There will be forces that reject and attack all recommendations and suggestions passionately. The question remains: why? What motivates such opposition to building a better world? Is the opposition afraid of progress, or of losing their current wealth and power? Who are they really?

Reading the newspaper and following on TV all the appalling happenings around the world, it becomes obvious to us that something is wrong. Seeing all the evil, the atrocities, pain and suffering, especially of the common citizen, but also of the animal kingdom, we have to realize the disaster we are in. The main

causes are: politics, greed, lack of compassion, lack of self-esteem and self-worth. Also, we should include the conduct of religious leaders, who should have only love and compassion for mankind and instead encourage fanaticism and hysteria, mob psychology. There are more.

We know there are forces on our planet that enslave, torture and destroy groups, societies and entire nations. Does that happen without design and orchestration? We know that politics is used to cause misery and pain in this world. But politics as such is not the culprit; it is the men and women behind them who must take the blame and face justice.

It is a fact that we have in this world the very rich and their opposite, the very poor. The gap between them is widening daily. As the mighty become stronger, the poor lose what little they have, and even their human dignity comes under threat. Sure, we can find a middle stand, neither rich nor poor per se. But, their numbers are dwindling. Some copy the ways of greed and quest for power, but only a few are successful, and they quickly add to the numbers of the rich.

It is an indisputable fact that the citizenry is easily manipulated, conditioned and led. Could it be that the main reasons for this are: our belief in the superiority and infallibility of the mighty, our naïveté, our political immaturity? Are we like lost sheep, which must be controlled? That is just not a fair assessment of the citizens of this globe. Advanced societies do exist and they should help each other to accomplish an even balance between them.

Is it not our prevailing attitude that, as long as events do not concern us directly, such as recessions that cause loss of our work and income, or environmental pollution that affects our health or the health of our family, we tend to ignore, or pass over lightly, reports of other problems in the world? If the consequences of our thoughtless actions occur only far from us, do we really care what happens in other parts of the world? If we continue to live

each for himself only, without concern for the wellbeing of others, does that not lead to the destruction of society? By thus living selfishly we work perfectly into the hands of the manipulative power. With that attitude of ignorance and apathy we deserve nothing better than to be destroyed. It is our choice!

"Imagine no possessions, I wonder if you can". John Lennon, of the Beatles, poses this question in his song in which he questions if the human being is capable of living without possessions. "The driving force of greed and jealousy is often a wish for an overabundance of possessions. Could such negative human attributes be replaced by a life without such a need?"

Quotes from Rainer Langhans and former stock market journalist and Michaek Mross.(10).

In many of my discussions with people of all walks of life I had to realize that they had another mindset. They are convinced that everything is fine in our society, that they have a good income and always have food on their tables and a roof above their heads. They can even afford to take some beautiful holidays in far flung destinations. That is, as such, respectable and good. Unfortunately they do not realize that they are surrounded by less fortunate citizens. In times of plenty, poverty is deplorable. Governments act mostly with lip service, although in many nations a welfare system is in place. How is it that we still have so many people on the streets living in deplorable conditions, that children and adults suffer hunger and thirst and live in shocking conditions? Private organizations do a wonderful job to help. They even go beyond their means to help. But they are always short on funds and some must close. In a rich society and nation as we claim to be there should be no need to help the poor and unfortunate via private organizations. It is the duty and obligation of nations to care for their less fortunate citizens.

We have to recognize the political, economic, and environmental dilemma that we face. Unless we do, we will not

be able to achieve our and our offspring's future as we envision: free of oppression, having freedom of speech and expression, having equal rights for everybody, and having enough food, clean water, work and good health for all humans. That's an ambitious plan, unrealistic you might say, but if we don't try certainly we will not succeed. Are we basically egotistic and unwilling to give up our luxury for our fellow humans in need? No, that is certainly not true of everybody; we have many good citizens out there who would spare nothing to help people in need.

The above statements are probably bold and futuristic in some ways. However, we know that we have to pause and consider what we really want in life. There will be forces that reject and attack all recommendations and suggestions passionately. Why? What motivates such opposition to building a better world? Is the opposition afraid of progress, or of losing their current wealth and power? Who are they really?

Reading the newspaper and following on TV all the appalling happenings around the world, it becomes obvious to us that something is wrong. Seeing all the evil, the atrocities, pain and suffering, especially of the common citizen, but also in the animal kingdom, we have to realize the disaster we are in. The main causes are: politics, greed, lack of compassion, lack of self-esteem and self-worth. Also we should include the conduct of religious leaders, who should have only love and compassion for mankind and instead encourage fanaticism and hysteria, mob psychology. There are more.

We know there are forces on our planet that enslave, torture and destroy groups, societies and entire nations. Does that happen without design and orchestration? We know that politics is used to cause misery and pain in this world. But politics as such is not the culprit; it is the men and women, the politicians, who must take the blame and face justice.

It is a fact that we have in this world the very rich and their opposite, the very poor. The gap between them is widening daily. As the mighty become stronger, the poor lose what they have left. Even their human dignity comes under threat. Sure, we can find a middle group, neither rich nor poor. But, their numbers are dwindling. Some copy the ways of greed and quest for power, but only a few are successful, and they quickly add to the numbers of the rich.

Confusion, powerlessness and apathy are rampant. Governments and politicians thrive on such uncertainties. They make no effort to instill help into our thoughts. Rather, they see the opportunity to keep us in check. We are in their power. We have no part in the decision making.

Governments and politicians have manipulated the business of state according to the interests of the financial powers too long. Certainly they talk about freedom of the individual, about prosperity and well-being. But the more they try to convince you the further they stray from the truth. We have lost our personal freedom through manipulation. And that is shameful. If we deny that such intrigues exist we should count on our fingers the real freedoms we have. No cheating is allowed. Freedom is what our forefathers have called for. But, realistically everything is legislated. Every move is regulated and restricted in both the business and private sectors. Nothing can be done without the state having a say in it. That is also environmental pollution.

In the North America the manipulative machinery is so strong that even docile people are manipulated into hysteria so that they don't even know they are misused. In elections such manipulating tools are used and can well be documented.

There is no error greater than self-deception which leads intelligent beings to crave the exercise of power over others for the purpose of depriving others of their natural liberties. The golden rule of human fairness cries out against all such fraud, unfairness,

selfishness, and unrighteousness. Only true and genuine liberty is compatible with the reign of love.

As mentioned several times before only by changing our attitude and goals in life can we be successful in establishing our children's future. By applying trust to each other, giving and receiving, we set our standards at an intelligent level. We cannot, however, afford to go to extremes either

For the United States, Michael Moore (4) on Pg. 48 proposes a list of suggestions for changing the corrupt political systems found there today. The principle of these recommendations, as incomplete as they are, can be used in all countries where a corrupted democratic or a dictatorial system exists. As an example he put forward a priority list of services and grants that were cut by Bush or other presidents that are typical and synonymous with the way we are manipulated, offended and misused. It is a fact that we the honest taxpayers have to pay the bill for all the actions our government takes without our permission. The upper, rich echelons, about 17%, pay no taxes at all. Then there are companies that have the knowledge to record their accounts so that we the taxpayers even have to foot the bill for their manipulations. What does the tax bureau do? It throws in the towel and gives up. Really? Or is it rather that they must leave these companies alone? Over the years the tax rate for the rich has come down by 10% and the common rate went up by 13%. As we know, the common person will be taxed to death.

There is no error greater than the self-deception which leads humans to crave power over other humans for the sole purpose of depriving them of their liberties and rights. These deprived humans should cry out against all such fraud, unfairness, selfishness, tyranny, oppression and unrighteousness. It happens all over the globe.

We could go on and list many injustices on our planet earth. Just to name a few: millions of humans around the globe die from

aids; in America 12 million children are malnourished; in the State of Texas people, sometimes (as proven in the past) innocent citizens, still face the death penalty in gas-chambers.

Following is a list of a few unbelievable facts:

- Dictators all over the world torture and destroy innocent people, humans live in poverty, without sufficient food or water and innocent children are the worst treated.
- Our society contributes to the misery of all with our selfishness and lack of love. We condone torture. We seem to have lost all empathy for others. We must return to human dignity and love for each other.
- Don't deny reality, we are to blame. The industrial world lives in unimaginable luxury and lets the less fortunate live a life of misery.

You may claim, and rightly so, that the above inventory of facts and conclusions are cruel and negative. But I could not give you the facts in a camouflaged form. Reality is sometimes brutal. Some will refuse to accept reality and might even brand it as heresy. I cannot change minds that are totally blocked and that permit no new thoughts to enter. To forestall misunderstandings I must point out that the problem is global and not specifically North American. Just look around and you will confirm that the world is full of dictators that enslave their people; control, manipulate and brainwash their citizenry.

For the open minded, however, I offer a new perspective on the working of our society. I offer some possible alternatives to ameliorate our problems and some suggestions of what we should do to change unsatisfactory conditions in less fortunate countries. Their living and political conditions are also our concern. We have to come to the agreement that the world should be a place of peace, freedom, love and respect for each other. No more wars between nations, between humans and brothers and sisters, can arise. In a war or conflict the citizen will never win, (19teenst and

275

20^{thiest} century was horrible). Why sacrifice everything for a false hope? History proved that we must become of age and consider our goal and form our future for our offspring diligently. Only then will we have peace, tranquility and happiness. It is not a meaningless phrase to say that we should love our neighbor as we love ourselves. Only together can we achieve great heights. We are the makers of our destiny on this planet.

Leitmotivs and words of wisdom:

"There is no error greater than self-deception
which leads intelligent beings to crave the
exercise of power over others for the purpose
of depriving others of their natural liberties.
The golden rule of human fairness cries out
against all such fraud, unfairness, selfishness,
and unrighteousness. Only true and genuine
liberty is compatible with the reign of love".

"Respect, tolerance, compassion, peace, freedom and
love are a gift that we have to cherish and to guard".

Archbishop Dom Helder Camara said:

"When I fed the hungry,
all people praised me for my good works.

When I asked why they were hungry,
they called me a communist".

Problems of our society:
"Society is concerned with self-perpetuation, self-maintenance, and self-gratification, but human self-realization is worthy of becoming the immediate goal of many cultural groups.

Pleasure-want has long since superseded hunger-want; the legitimate social aims of self-maintenance are rapidly translating themselves into base and threatening forms of self-gratification. Self-maintenance builds society; unbridled self-gratification unfailingly destroys civilization.

Almost everything of lasting value in civilization has its roots in the family. The family was the first successful peace group, the man and woman learning how to adjust their antagonisms while at the same time teaching the pursuits of peace to their children.

Self-maintenance builds society; unbridled self-gratification unfailingly destroys civilization.

One of the great hindrances to the progress of human society is the conflict between the interests and welfare of the larger, more socialized human groups and of the smaller, contrary-minded asocial associations of mankind, not to mention antisocially-minded single individuals.

The more complex civilization becomes, the more difficult will become the art of living. The more rapid the changes in social usage, the more complicated will become the task of character development. Every ten generations mankind must learn anew the art of living if progress is to continue. And if man becomes so ingenuous that he more rapidly adds to the complexities of society, the art of living will need to be re-mastered in less time, perhaps every single generation. If the evolution of the

art of living fails to keep pace with the technique of existence, humanity will quickly revert to the simple urge of living--the attainment of the satisfaction of present desires. Thus will humanity remain immature; society will fail in growing up to full maturity. Now human society is plunging forward under the force of the accumulated momentum of all the ages through which civilization has struggled.*

* Passages from (1) UB

In closing I would like to add to my essay the questions from *Chuang-Tsu* that speaks out what I tried in pain to express:

...Great truths do not interest the multitudes,

and now that the world is in such confusion,

even though I know the path,

how can I guide?

I know I cannot succeed

and trying to force results

I shall merely add to the confusion.

Isn't it better to give up and

stop striving?

But then, if I do not strive

Who will?

9. Bibliography to part 2

(1) Urantia Book*, with page reference
 ISBN 0-521-86479-8; the book is available in many
 languages.

(2) Saul Bellow

(3) T. Caldwell. Page 299: Dear and glorious Physician

(4) Michael Moore, Stupid White Men;
 ISBN 3-492-04517-1-0

(5) Erasmus von Rotterdam, Dutch Humanist

(6) Jesse Ventura, "The Conspiracy Theory", OLN
 June 11,2011 or J. Ventura Conspiracy Theory: 2012
 Apocalypse 2/6 Video
 Pindz's video about Jesse Ventura Conspiracy Theory
 2012 Apocalypse, documentary on Disclose.tv
 www.disclose.tv/action/
 viewvideo/37137/J__Ventura_Conspiracy...

(7) David Icke, Interview on OLN June 11, 2011; David Ike
 has written several books

(8) Julian Assange, WikiLeaks: www.wikileaks.org

(9) Michaek Mross

(10) David Suzuki, Nature of Things; on Thursday the fifth of
 January 2012, 18:00 – 19:00 hrs MT

* Note: Urantia Foundation in Chicago; URANTIA BOOK; urantiabook.org

(11) Nina Fedoroff, president of the American Association of the advanced science and Prof. of the State University of Pennsylvania as well as at the University of King Adballah, Saud Arabia.

In her 20 years of plants, fruits and vegetable research, especially implanting the modified genetic genes says that the government should avoid interfering with research of genomes.*

* L'actualité, Magazines du Québec, Août 2012, Pg. 18 : Q+R : Quelle bombe dans notre Assiette ? by Valérie Borde.

10. Appendix

1. The Kompogas®-System

From waste to resource recycling.
The complete environmental cycle.

Kompogas completes the environmental cycle
The fermentation of organic waste in Kompogas facilities produces CO_2 neutral biogas from a renewable source. Such organic waste is widely available in significant quantities. The bulk of this is made up of green waste from local authorities, garden and kitchen waste from households and catering and food waste from industrial and commercial operators.

Replacing fossil fuels
In a Kompogas facility, the gas produced from the fermentation process is converted to green power and heat via a packaged combined heat and power plant. Five times the greenhouse gas emissions would be produced if natural gas (a fossil fuel) were to be used to power the same packaged combined heat and power plant to generate the same volume of power or heat.

Replacing chemical fertilizers
The production of chemical fertilizers reduces natural nutrient resources and results in dangerous CO_2 emissions. The use of 'digestate' from the Kompogas facility as a natural fertilizer can save on the use of chemical fertilizers.

Potential for the environment

In Switzerland, a total of approximately 1.6 million tonnes of organic waste can be fermented per year. In contrast to a conventional disposal system for organic waste, the recycling process in a Kompogas facility completes the environmental cycle. The environmental benefits of the Kompogas process have been confirmed by environmental audit studies.

An environmental innovation that leads to success

Using resources to add value

The vision started with the idea of finding a way to use the organic waste produced by affluent societies sensibly. This original vision has now been made a reality: more than 300 towns and cities recycle their green waste and other organic waste in Kompogas facilities. This allows them to dispose of organic waste in an environmentally responsible manner while benefiting financially.

Energy from organic waste

Kompogas has been producing biogas from municipal and industrial organic waste for over 19 years. It is used to generate green electricity and heat, and can also be used as a fuel. The fermentation residues are returned to the soil as organic fertilizer for agricultural use, which closes the material cycle.

Process

Kompogas is a technology in anaerobic dry fermentation and made a reputation for itself as a plant operator and manufacturer.

Today, over 50 Kompogas plants worldwide generate CO_2-neutral biogas. In this process, customers are supported from the initial project idea, through financing and implementation.

History

The success story started in the 1980s of using organic waste for energy. The process was improved continuously in the following years. The resulting Kompogas process has now been used for 20 years.

Milestones in the company history

Turnover and employees

Kompogas generates a turnover of $54 Mio. Their expertise ranges from operating and maintaining plants to process technology, mechanics, electronics and environmental technology.

Successful cooperation ventures

The Kompogas process allows companies to reduce their yearly CO_2 output by over 27 000 tons.

Technology

The patented Kompogas process is based on dry fermentation of organic waste. This process produces CO_2 neutral biogas. Kompogas plants make the most of the potential energy stored in organic waste.

Depending on the type of organic waste, between 600 and 1000 kilowatt hours (kWh) of energy can be generated from 1 ton of waste. Approximately 900 kg of natural fertilizer are created as a byproduct.

Operation

Kompogas plants are produced in modular units. Thanks to this modular concept, the customer can match the size of their plant to the planned annual fermentation capacity. The plants that have been constructed to date have capacities of between 5000

and 300 000 tons per annum. Another feature of the Kompogas plants is their compact structure, which makes them suitable for retrofitting to composting plants. Over 300 towns and cities have their organic waste recycled in Kompogas plants. In doing so, they save money and the environment.

Biogas as a flexible source of energy
Biogas can be used in accordance with the operator's requirements. It can be burned in a combined heat and power plant. This generates green electricity and heat, which can be fed into the public supply grid or local heating network. Alternatively, the biogas can be treated for use as fuel.

2. Definition of GM and GMOs

Genetically Modified Foods (GM foods or GMOs, genetically-modified organisms).

For detail information consult:

Genetically Modified Foods: Harmful or Helpful, Released April 2000; by Deborah B. Witman

http://www.csa.com/discoveryguides/gmfood/overview.
php/review.pdf
© Copyright 2000, All Rights Reserved, CSA

Health and drinking water
The appropriate governmental department ordered chlorination of all potable water supplies for many regions. Assuming they applied Cl2 + H2O >>HOCL +HCI which means they added

Chlorine to the water to form Hypochlorous Acid + Hydrochloric Acid to kill microorganisms and react as disinfectant.

According to the US President's Council on Environmental Quality they state clearly: *"There is increased evidence for an association between rectal, colon, and bladder cancer and the consumption of chlorinated drinking water"*.

Many citizens also react to chlorinated water with *lung inflammation* and difficulties to breathe.

The main problems with chlorination are the by-products "chlorinated hydrocarbons" known as trihalomethanes (THM's). The THM's form when chlorine reacts in drinking water with naturally occurring substances such as decomposing plant and animal materials.

The risks for certain types of cancer are now being correlated to the use of chlorinated drinking water. Suspected carcinogens make human body more vulnerable through repeated ingestion. Research indicates the incidents of cancer are 44% higher among those using chlorinated drinking water. Is it not ironic and even scary that the government orders chlorination, the very process by which we clean our water of infectious germs, water born diseases, bacteria and viruses, as well as amoeba, that can create cancer causing substances from otherwise innocent chemicals in water?

Cancer of the kidney, bladder and urinary tract are common and on the increase. Up to 63 new carcinogenic compounds can be created in drinking water when chlorine is combined with methanol, carbon disulphide and other substances.

The chemical element chlorine is a corrosive, poisonous, greenish-yellow gas that has a suffocating odor and is 2 1/2 times heavier than air. Chlorine belongs to the group of elements called halogens. The halogens combine with metals to form compounds called halides. Chlorine is manufactured commercially by running an electric current through salt water. This process produces free chlorine, hydrogen, and sodium hydroxide. Chlorine is changed to its liquid form by compressing the gas; the resulting liquid is then shipped. Liquid chlorine is mixed into drinking water and swimming pools to destroy bacteria.